Hawaii

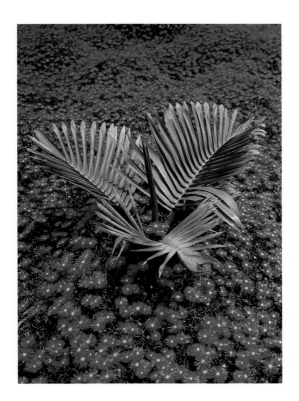

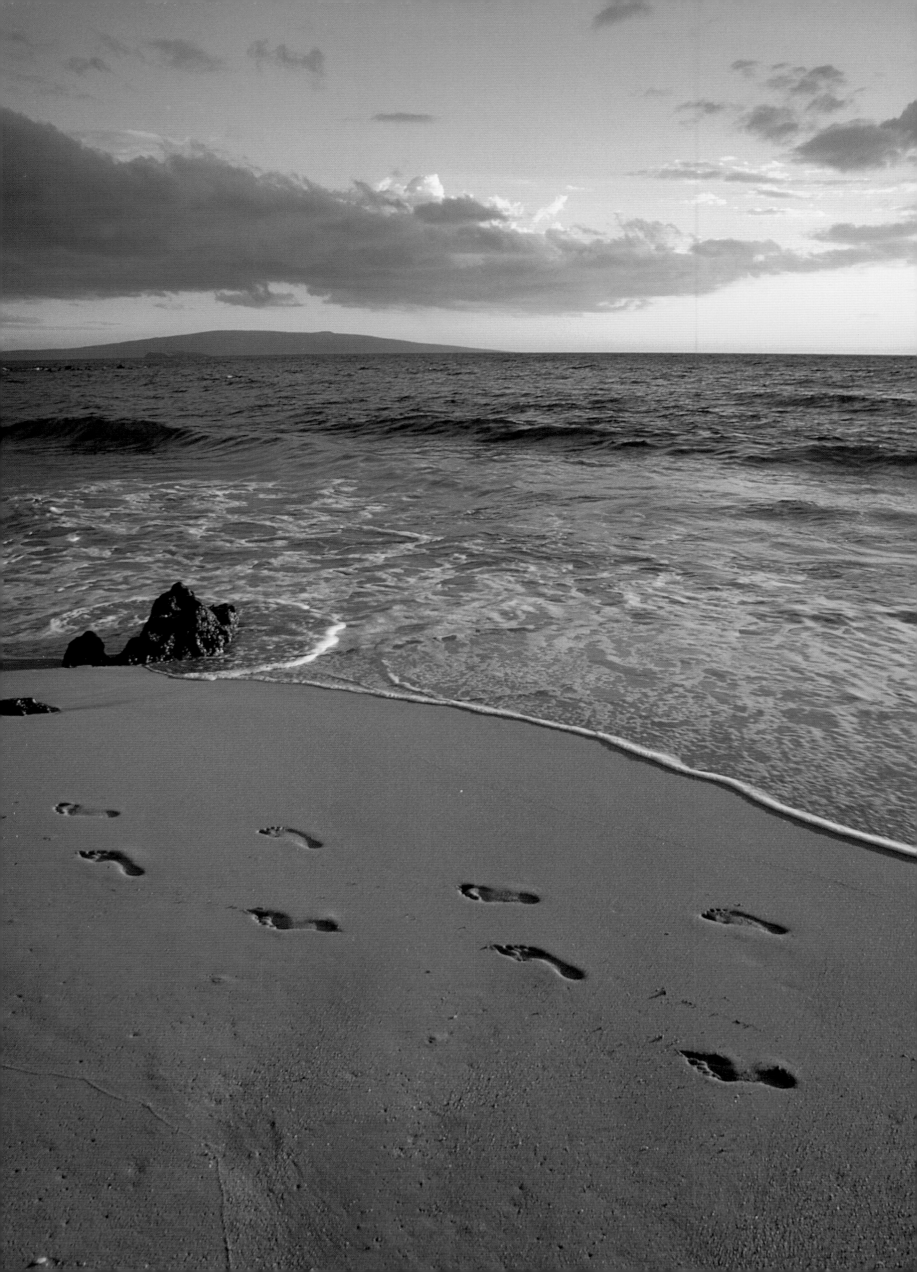

Hawaii

CLIFF & NANCY HOLLENBECK

GRAPHIC ARTS CENTER PUBLISHING®

International Standard Book Number 1-55868-313-5
Library of Congress catalog Number 97-70193
Photographs and text © MCMXCVII by
Cliff & Nancy Hollenbeck
Compilation of photographs © MCMXCVII by
Graphic Arts Center Publishing Company
P.O. Box 10306 • Portland, Oregon 97296-0306 • 503/226-2402
All rights reserved.
No part of this book may be copied by any means,
including artistic renderings,
without permission of the publisher.
President • Charles M. Hopkins
Editor-in-Chief • Douglas A. Pfeiffer
Managing Editor • Jean Andrews
Production Manager • Richard L. Owsiany
Cartographer • Manoa Mapworks
Book Manufacturing • Lincoln & Allen Company
Printed In the United States of America

◁ ◁ A palm branch emerges from the brilliant purple carpet of lampranthus blooms—called *akule kule* flowers by Hawaiians.
◁ With a distant view of Niihau Island, the beach at Polihale State Park is one of Kauai's best, both in size and variety of seashells.
▽ The colorful bird of paradise flower is a relative of the banana.

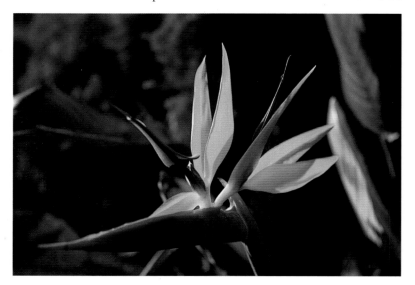

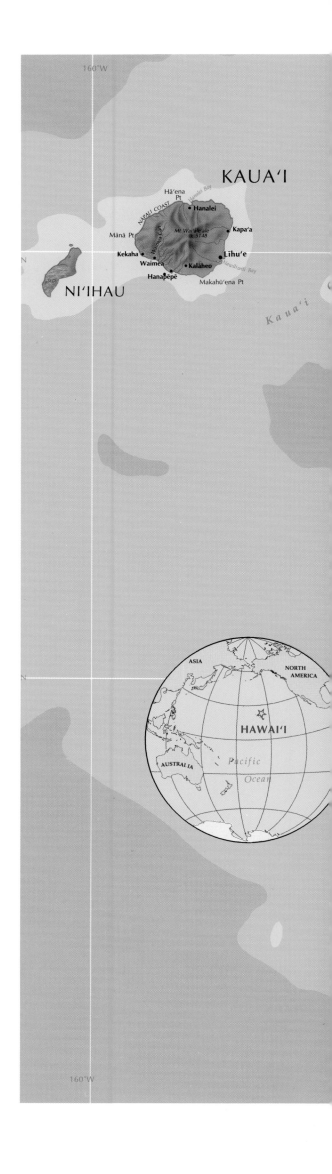

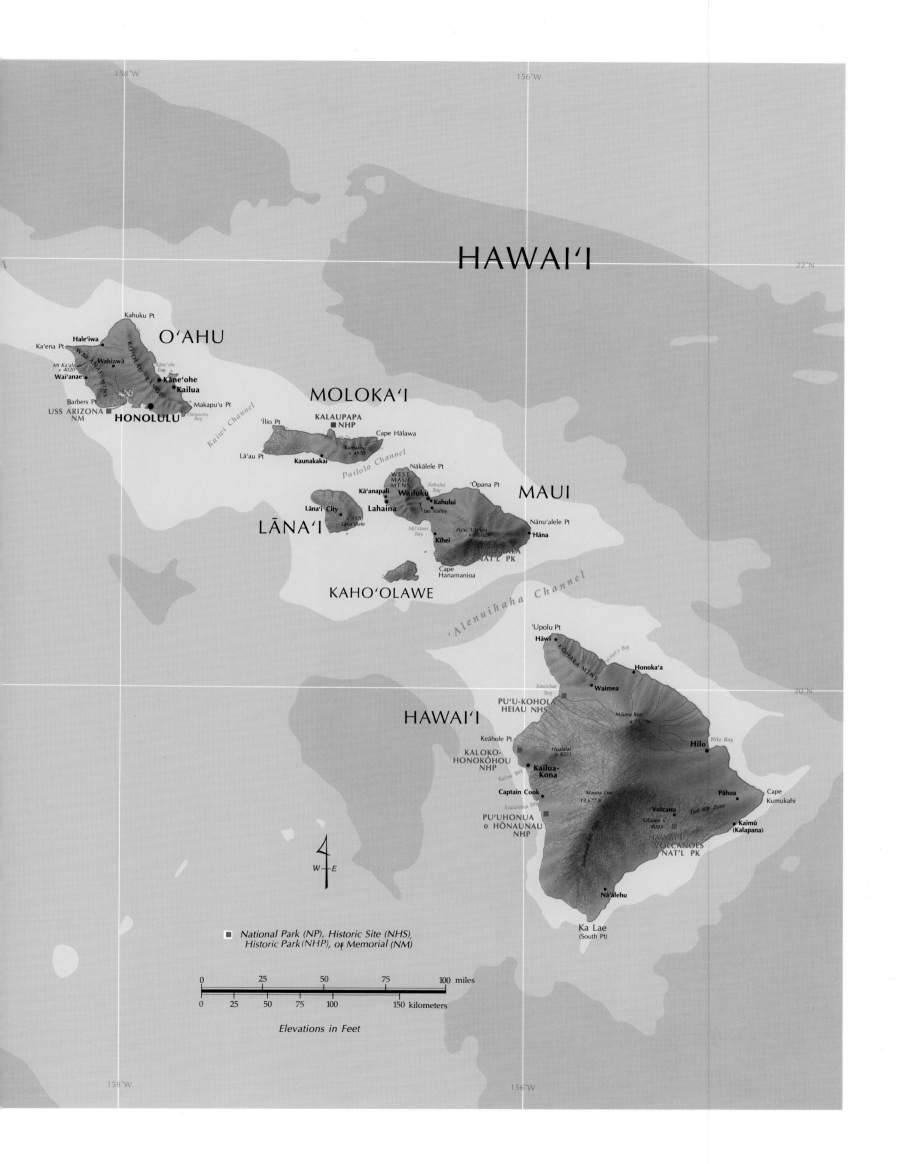

HAWAI'I

O'AHU

Kahuku Pt
Hale'iwa
Ka'ena Pt
Wahiawā
WAI'ANAE MTNS
Kāne'ohe Bay
Mt Ka'ala x 4020
Wai'anae
KO'OLAU RANGE
Kāne'ohe
Kailua
Barbers Pt
Makapu'u Pt
USS ARIZONA NM
HONOLULU
Hanauma Bay

Kaiwi Channel

MOLOKA'I

'Ilio Pt
KALAUPAPA NHP
Cape Hālawa
Lā'au Pt
Kamakou x 4970
Kaunakakai

Pailolo Channel

Nākālele Pt
WEST MAUI MTNS
Kahului Bay
'Ōpana Pt
Kā'anapali
Wailuku
Kahului
MAUI
Lāna'i City
Lahaina
Iao Valley
LĀNA'I
Lāna'ihale x 3370
Pu'u Ula'ula x 10,023
Nānu'alele Pt
Mā'alaea Bay
Hāna
Kīhei
HALEAKALĀ NAT'L PK
Cape Hanamanioa

KAHO'OLAWE

'Alenuihaha Channel

HAWAI'I

'Upolu Pt
Hāwī
KOHALA MTNS
Waipi'o Bay
Honoka'a
Kawaihae Bay
Waimea
PU'U-KOHOLA HEIAU NHS
Mauna Kea x 13,796
Hilo Bay
Keāhole Pt
Hualālai x 8271
Hilo
KALOKO-HONOKŌHAU NHP
Kailua Bay
Kailua-Kona
Captain Cook
Kealakekua Bay
Mauna Loa 13,677
Pāhoa
Cape Kumukahi
PU'UHONUA o HŌNAUNAU NHP
East Rift Zone
Volcano
Kīlauea x 4093
Kaimū (Kalapana)
HAWAI'I VOLCANOES NAT'L PK
Southwest Rift Zone
Nā'ālehu
Ka Lae (South Pt)

W—E

■ National Park (NP), Historic Site (NHS),
Historic Park (NHP), or Memorial (NM)

| 0 | 25 | 50 | 75 | 100 miles |

| 0 | 25 | 50 | 75 | 100 | 150 kilometers |

Elevations in Feet

158°W 156°W

22°N

20°N

At a time when few things or places
can truthfully be called unique, and
paradise is more of a mental than physical
reality, the kaleidoscope of peoples and
the natural beauty of the Hawaiian
Islands is like no other place on earth.

What you see here, in text and pictures,
portrays some of our favorite aspects of
Hawaii and represents only a small sample
of the many wonders on each island.

Hawaiians taught us the way of the *Ohana;*
our visions are now yours to enjoy.

Me kealoha o palekaiko Hawaii.
With our love for the paradise of Hawaii.

CLIFF *&* NANCY HOLLENBECK

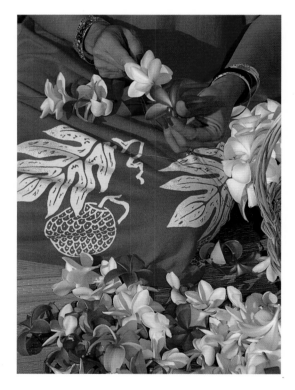

△ Plumeria flowers are threaded into a lei.
▷ A colorful Hawaiian lady makes *haku* head
leis in front of Kawaiahai Church graveyard.
▷▷ Golden sand lines the clear, warm waters
of Kaanapali Beach on the island of Maui.

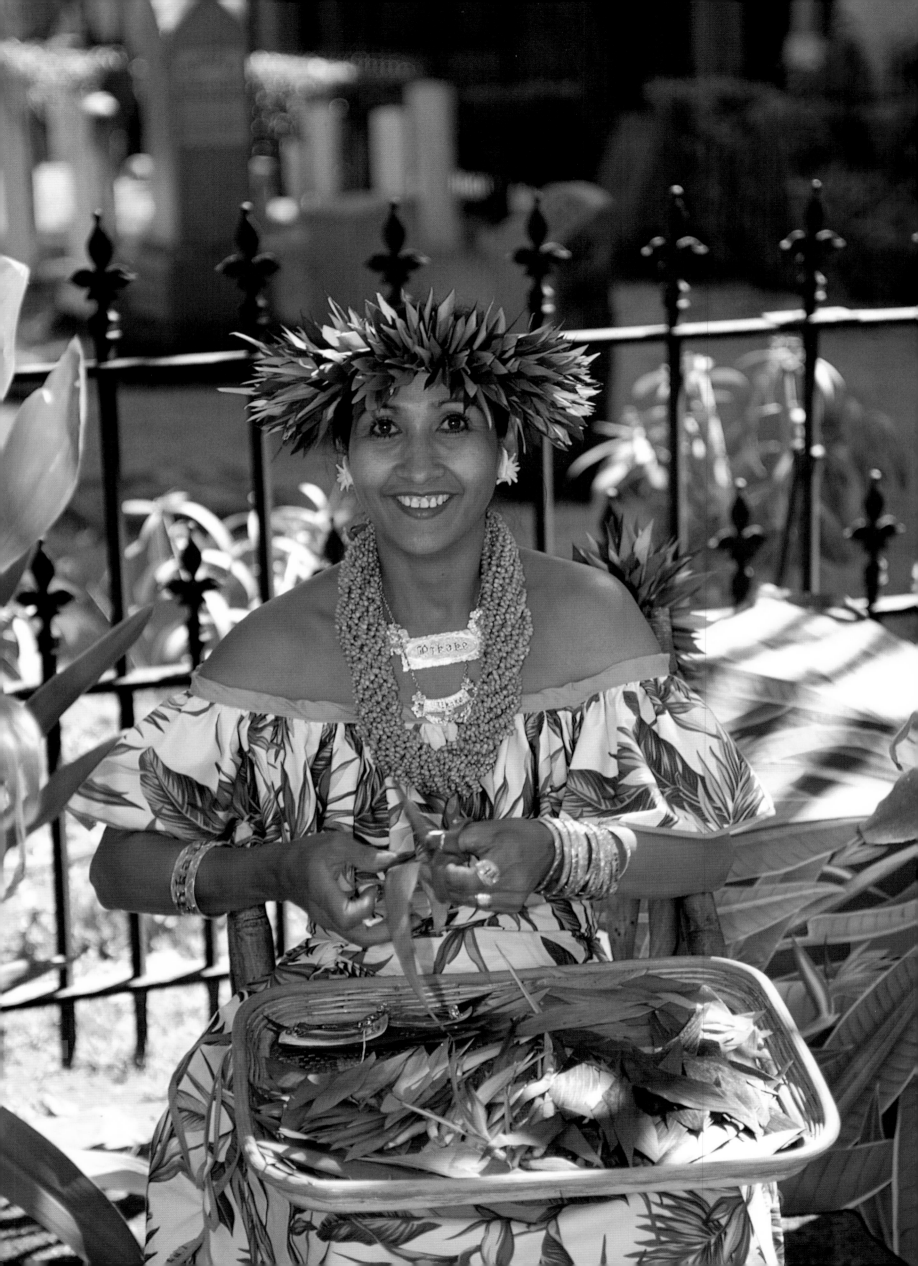

Overview

In double canoes they came, more than thirteen hundred years ago, searching northward into an unknown sea. Sailing on strange winds, paddling through doldrum calms, braving high seas and storms, they persisted in their quest for new land. . . . While other men sailed within the comforting presence of continental coasts, Polynesians faced the open sea without fear as their own and only world. Sailing now under the stars of the northern sky, reaching across powerful northeastern trade winds, they came upon a chain of Islands of tremendous size, far larger than any they had known. When their canoes touched sand Man's history in Hawaii had begun.

Through these words from the Prologue of *Voyage: The Discovery of Hawaii,* author and Living Hawaiian Treasure Herb Kawainui Kane describes the first Hawaiians and their quest for paradise.

Despite innumerable outside influences, two elements from that voyage of discovery have survived over hundreds of years: the *Ohana*'s spirit of *Aloha* and the incredible paradise they discovered. Early Hawaiians had a belief: "We will share what we have with you, and you must share what you have with us." It was the heart of the *Ohana*. The *Ohana* is generosity given without restraint or hidden purpose. Hawaiians call it *Aloha*. The most important word in the Hawaiian language, *Aloha* means dozens of things, including hello, welcome, greetings, good-bye, farewell, or I love you.

Each island was individually controlled by its own hierarchy of kings, chiefs, and nobles. Life, including food, marriage, work, gratification, and privilege were subject to their *kapu*, or rules, and of course, the *Ohana*. The only higher authority, which was often interpreted by the royalty, came from their gods, which numbered more than two hundred.

Europeans were the first recorded outsiders to explore the islands and experience the spirit of *Aloha*. Captain James Cook's visit to Kauai's west coast in 1778 was the beginning of a series of events that would shape the islands since the Polynesians' landing a thousand years earlier. Cook named them the Sandwich Islands—after the Earl of Sandwich, his sponsor and the First Lord of the Admiralty—a name that endured into the next century.

Following their usual custom, the natives shared their exotic foods, balmy weather, beaches, and beautiful women with Captain Cook, a man they thought was a god, and his men. The Europeans, however, paid little attention to the native culture or rules of *kapu*. A year later, when Captain Cook visited the islands again, stopping at Kealakekua Bay on the Big Island, the locals quickly recognized that they had made a mistake in thinking he was a god. Cook was killed during a dispute over missing property.

Ten years later, a warrior named Kamehameha began a decade-long campaign to unite the islands under his rule. He successfully used European warfare technology to capture all the islands except Kauai, aided by advice from two English seamen who fired cannons mounted in his canoe. Because of the treacherous channel, the attempts by his fleets to invade Kauai were thwarted. Turning to threats and diplomacy, Kamehameha eventually obtained Kauai's surrender to his rule, and all the islands became a united kingdom.

The early 1820s were conceivably the most influential period in Hawaii's history. Following the death of Kamehameha the Great, the *kapu* system of governing was abolished. Then, as if in answer to the need for spiritual guidance, Christian missionaries arrived and immediately set about filling the void. They established a written Hawaiian language—enabling the Hawaiians to record their ancient oral histories—and introduced hymn singing to help teach their religion. Sadly, the missionaries also denounced bare skin, chants, and the ancient hulas, which were outlawed for many years.

During this time, the sandalwood trees were cut and traded into extinction, leaving the islands hungry for new economic resources. Again, fate stepped in with the business of whaling. Honolulu and Lahaina were among the world's most profitable ports. With whaling came liquor, prostitution, and disease. Missionaries spoke

◁ *Located in downtown Honolulu, Liliuokalani Botanic Gardens provide tranquility in the midst of hectic city life.*
△ *Bougainvillea, a native of Brazil, brightens the islands as they bloom in winter, spring, and early summer.*

against these vices, but their admonitions fell on deaf ears. Even King Kamehameha III rebelled by drinking, gambling, and dancing the hula. In less than a generation, the whales began to disappear, and Hawaii was again hungry for a source of income.

Before outsiders arrived, Hawaii had no private land ownership. Everyone had access to all lands except those protected by royalty. King Kamehameha III opened up ownership of the land to all, but because Hawaiians did not understand this concept, most land was acquired by businessmen, immigrants, and second-generation missionaries. Today, about half of Hawaii is government-controlled. Three-quarters of the rest is held by fewer than forty owners.

Sugarcane and pineapple became big business. Because the native Hawaiians did not care for the hard work, the growers began to import laborers from China, later turned to Japan, the Philippines, Korea, and Portugal.

Hawaii entered the modern political world with the passing of King Kamehameha V, who left no direct heir to assume power. Prince Lunalilo was elected king, but he served only a year before he died. The resulting chaos brought strong calls for annexation to the United States. The calls went unheeded by the new King Kalakaua, who preferred his own government.

In 1887, Caucasian businessmen and missionary descendants led an armed uprising that forced the king to accept the "Bayonet Constitution," which allowed only land owners and well-employed men to vote. Political control shifted to the white minority.

King Kalakaua died during a visit to San Francisco in 1891, leaving Lydia Liliuokalani as Hawaii's first reigning queen. She attempted to restore the power of royalty and the rights lost by the native Hawaiians as a result of the Bayonet Constitution. A revolt ensued, and marines from a visiting gunship surrounded the royal palace. But without a single shot being fired, the monarchy was overthrown in 1893, and Sanford Dole (whose relative, James, later became pineapple king) took control of a provisional government.

Queen Liliuokalani's overthrow was illegal according to international law. President Cleveland attempted to correct this "illegal act against a foreign government," but Congress ignored him. In 1900, Hawaii became a U. S. territory, eliminating the royalty.

During the first half of the twentieth century, tourists began a new kind of take-over of the islands, until the bombing of Pearl Harbor shattered the serenity of this peaceful tropical getaway in 1941. Tourism would soon rebound, however, because the war introduced the islands to thousands of American military men who would later return as tourists.

World War II also brought more political and military attention to Hawaii. As senior U. S. military commanders and politicians began to visit Hawaii, they saw the islands as the new business gateway to Asia and the Pacific. Because Pearl Harbor was the single most important military base outside the United States, its bombing tied the islands to America forever. After the war, more than twenty legislative bills addressing the issue of U. S. statehood for Hawaii were considered by the American Congress. Despite the attention, it still took nearly fifteen years before the U. S. Congress offered Hawaii statehood. In 1959, in a deal that was linked with Alaska's statehood, Hawaii became the fiftieth state.

After World War II, government and agriculture were the most important economic factors in Hawaii's development. However, commercial jet service soon linked Hawaii with the U. S. mainland, Australia, and Asia—and tourism began to soar. Suddenly, people who wanted to see paradise for themselves could travel there in less time than it took to enjoy a meal and a movie. And travel they did.

Today, Hawaii is one of the world's most popular destinations. The islands are home to a diverse, yet harmonious society. Quality of life and average life expectancy is among the highest in the United States, while unemployment, violent crime, heart disease, and deaths from cancer are among the lowest. Hawaiians will tell you the reason has always been the *Ohana*, their spirit of *Aloha*.

△ *Lobster claw heliconia, native to tropical America, grows in clumps of paddle-shaped leaves and hides its flowers inside bright red sheaths.*
▷ *Mokolii Island, better known as Chinaman's Hat, is a tiny island set on the windward side of Oahu.*

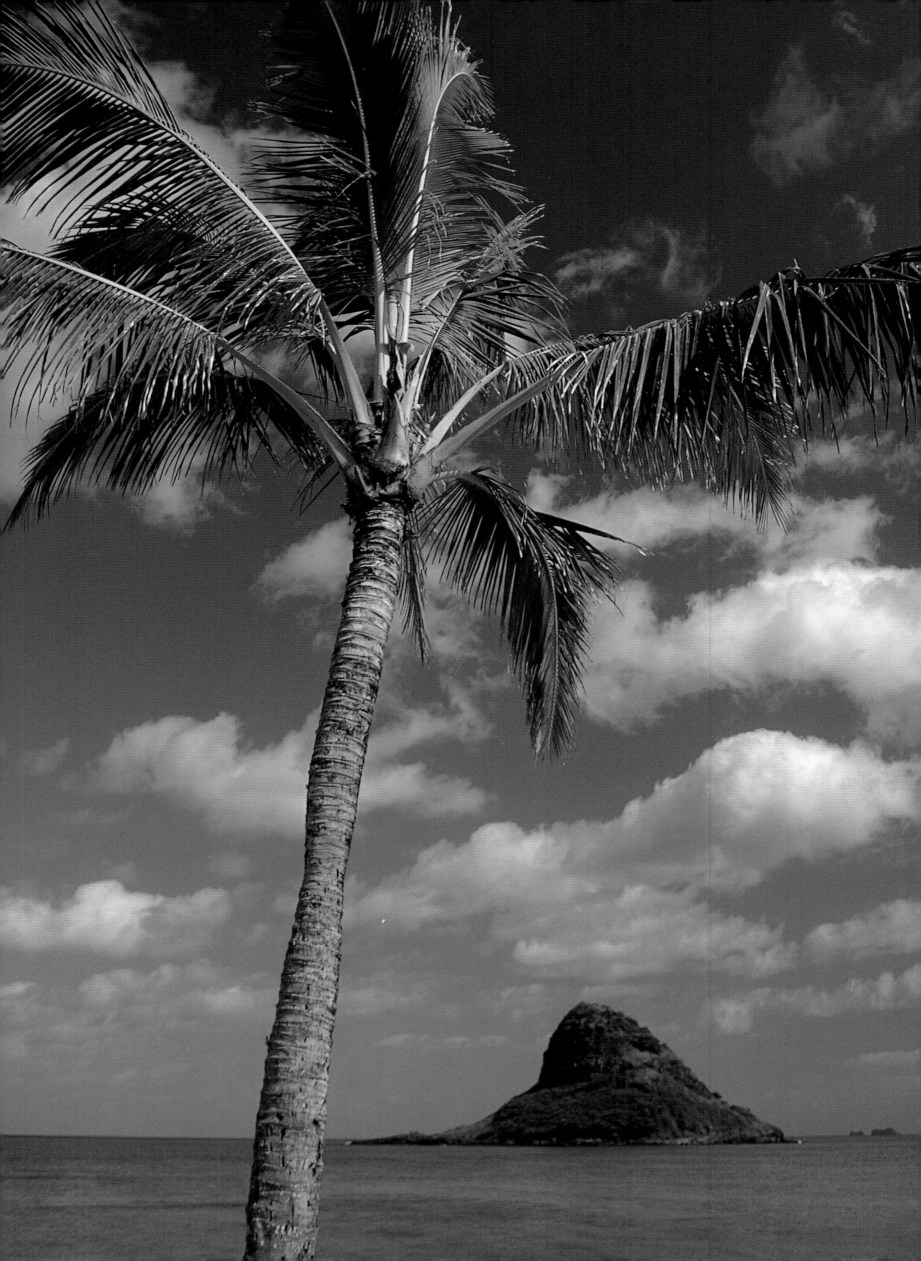

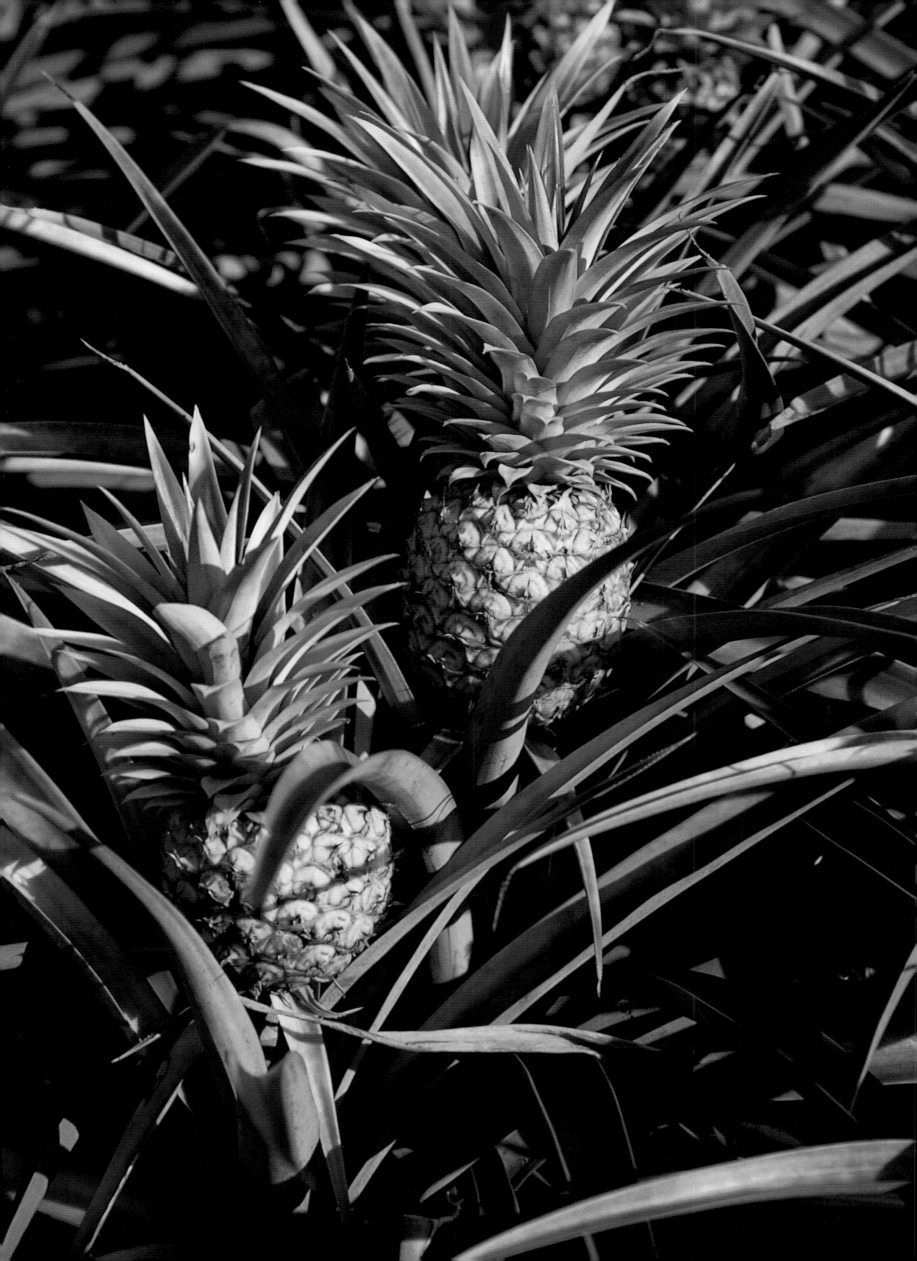

Oahu

As your aircraft descends alongside Diamond Head, on approach to Oahu, you sense something special in the air. A golden beach sparkles below as turquoise waters gently kiss its shores, visually turning the fantasy of paradise into a reality. At Honolulu International Airport, smiling faces and the pleasant fragrance of plumeria blossoms and coconut oil welcome you into the "Heart of Hawaii." Part paradise and part sophisticated business hub, the island of Oahu is one of the most unusual places in the world.

Oahu has been the primary center for business, society, and culture since the Hawaiian Islands were united into a kingdom two centuries ago. The modern monarchy chose Oahu's main city of Honolulu as the site for the royal palace. When Hawaii became a state, the people confirmed Honolulu as their capital. The first tourists, traveling by ship, docked here a hundred years ago. More than six million tourists and business people now pass through the airport each year. Oahu is home to more than 80 percent of Hawaii's population, but only occupies 10 percent of the state's total land mass.

Half a dozen locations around the island help Oahu easily live up to its well-deserved reputation as "The Gathering Place." Foremost is the perfect natural harbor the early Hawaiians named Honolulu, or "protected bay." As the only sheltered harbor within two thousand nautical miles, it is the business and shipping gateway to the South Pacific, Asia, and the Americas. Nearby Pearl Harbor, made navigable approximately a hundred years ago, greatly increased the island's importance. Today, Pearl Harbor houses one of the most strategic military bases outside the continental United States. It is also the site of the Arizona Memorial, a beautiful white structure anchored over the battleship USS *Arizona,* which was sunk during the Japanese bombing on December 7, 1941.

Stretched along the shoreline of these shimmering harbors is the cosmopolitan city of Honolulu. The governmental jurisdiction of the city extends some fourteen hundred miles up the Hawaiian Chain to the Kure Atoll near Midway Island. In Honolulu, the island's leaders gather at the open-air legislature and government buildings, which are located next to the only royal palace in the United States of America. Iolani Palace is a Florentine building with huge Corinthian columns and stone verandas that imitate some of the early European royal courts.

In stark architectural contrast, several original missionary homes across the street are now a museum complex. Nearby is the acclaimed Bishop Museum, built in memory of Princess Bernice Pauahi Bishop, the last direct descendant of Kamehameha the Great. It houses one of the Hawaiian Islands' and the Pacific's largest collections of anthropology and natural history.

Honolulu is the gathering place for one of the most diverse ethnic mixes of any municipality in the world. Immigrants from far and wide have contributed to the rainbow culture that is modern Hawaii. It is not uncommon in one day to hear words spoken in English, Hawaiian, Chinese, Japanese, Korean, Thai, Portuguese, Tagalog, and several Pacific island languages.

For visitors to Oahu, the most popular place has always been the golden sands of Waikiki Beach. With perfect waves, swaying coconut palms, clear blue-green waters, spectacular sunsets, and a throng of oiled sunbathers, Waikiki is the world's most famous beach. Surrounded by world-class resorts, restaurants, shopping, and nightlife, the Waikiki area has also become a glittery international playground. More than one hundred thousand people play and work here each week.

Equally famous Diamond Head Crater silently watches over the activity and excitement of Waikiki and Honolulu. Thrust from the sea about half a million years ago, Diamond Head earned its name when British seamen mistook its calcite crystals for diamonds. The Hawaiians called it *Lae Ahi,* meaning "Cape of Fire," for the signal fires lighted to guide early whaling and cargo ships. The Hawaiian

◁ *From the Waianae Mountains on one side to the Koolau on the other, central Oahu is a wide stretch of pineapple fields.*
△ *Dendrobium orchids are just one of some seven hundred species of orchid found throughout the Hawaiian Islands.*

name can also be loosely translated as "Tuna Face," after the Ahi tuna. The younger "beach boys" especially enjoy pointing this out to the daughters of visiting tourists.

Beyond the metropolitan area, the Polynesian Cultural Center is Oahu's most popular place for tourists and residents alike. The complex is a miniature South Pacific, a university, and a Mormon church all rolled into one. It is the only way to experience the Pacific's Polynesian life, including much of Hawaii's ethnic history, during a single afternoon and evening. The center has created authentic villages of Tahiti, Tonga, Hawaii, Fiji, and Samoa—all filled with arts, crafts, and Brigham Young University students from those same island homelands.

Another popular tourist gathering place on Oahu is Sea Life Park, with its exciting dolphin and tropical killer whale shows, a three-hundred-thousand-gallon reef tank, and colorful underwater exhibits. Visitors soon learn that these public attractions support some of the Pacific's most important oceanographic research projects, including a wildlife rehabilitation and recovery unit.

Hanauma Bay Beach Park is where people and fish gather for underwater encounters. A horseshoe-shaped crater with one end open to the Pacific, the bay is a state marine conservation area. Snorkeling here is exciting because the small fish are fearless and enjoy snuggling against unsuspecting swimmers. Surrounded by tall coconut palms, the beach attracts an audience of sunbathers and beach-chair adventurers. Hanauma Bay's mix of sandy bottom and coral reef, set against clear waters, blue sky, and white clouds, presents a panorama of breathtaking views. It is a favorite place for photographers, both above and below the water.

Sooner or later, visitors and locals alike head for the beaches and small towns along the island's North Shore. During the winter months, the most exciting way to experience the Banzai Pipeline's rolling surf is to "hang ten," riding the front of a surfboard along beaches like Sunset—that is, if your idea of excitement is to look danger in the eye. The Pacific's winter storms create a huge surf that often swells to heights three to four times higher than the surfers who brave the hazardous waves. In stark contrast, during the summer months, this two-mile-long, two-hundred-foot-wide stretch of golden sand is kissed by gentle waters and soft breezes. In any season, Sunset Beach is one of the world's most attractive and enjoyable places.

The small town of Haleiwa is the North Shore's focal point and most popular destination. For years, it has been the home of surfers, artists, fishermen, and aging hippies. Tourists enjoy the quiet town's character and charm, which is further enhanced by the residents' eclectic mix of funky boutiques, galleries, and restaurants. The lure of "shave ice" keeps people coming to the little stores that line Front Street. Shave ice is a Hawaiian gourmet snow cone, with the ice shaved from a block—not crushed—and topped with fruit syrup. On a hot afternoon, the cooling effects are like heaven in your mouth.

Oahu is ringed with golden sand beaches that are smaller than those on the North Shore and lesser known than Waikiki—but just as nice. Warm blue waters and soft trade winds make beaches such as Makapuu, Kailua's Lanikai, Sandy, and Waimanalo favorites for body surfing, swimming, fishing, and/or catching a snooze during one of those famous long Hawaiian lunch hours.

Central Oahu is a huge valley covered with green pineapple and sugarcane fields. Seen from the air, these fields add an artist's touch to the vibrant blue waters and sandy beaches. The Koolau Mountain Range crosses the east side of the island, and the Waianae Mountains to the west offer cloud-covered green peaks, deep valleys, and cascading waterfalls. It is only fitting that these mountains on Hawaii's most populated island should hide myriad nooks of privacy and escape. In these quiet places, ancient Hawaiian gods whisper in the winds, calling people to experience some of the internal beauty that is also the island of Oahu.

△ *Blossoms of the plumeria, blooming year-round, come in a variety of colors—white, pink, crimson, and yellow..*
▷ *Lights glow at night along Waikiki Beach, the world's most famous beach.*

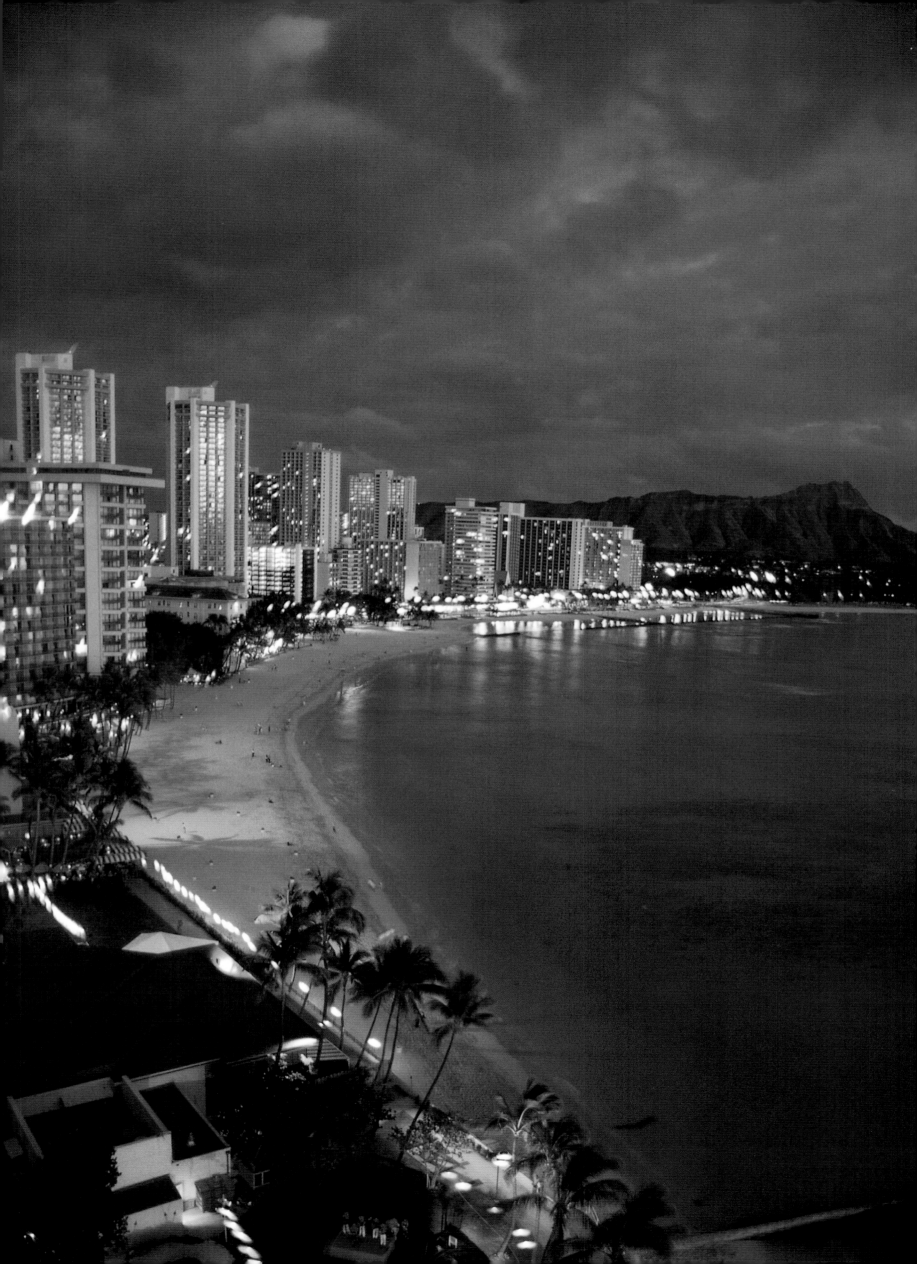

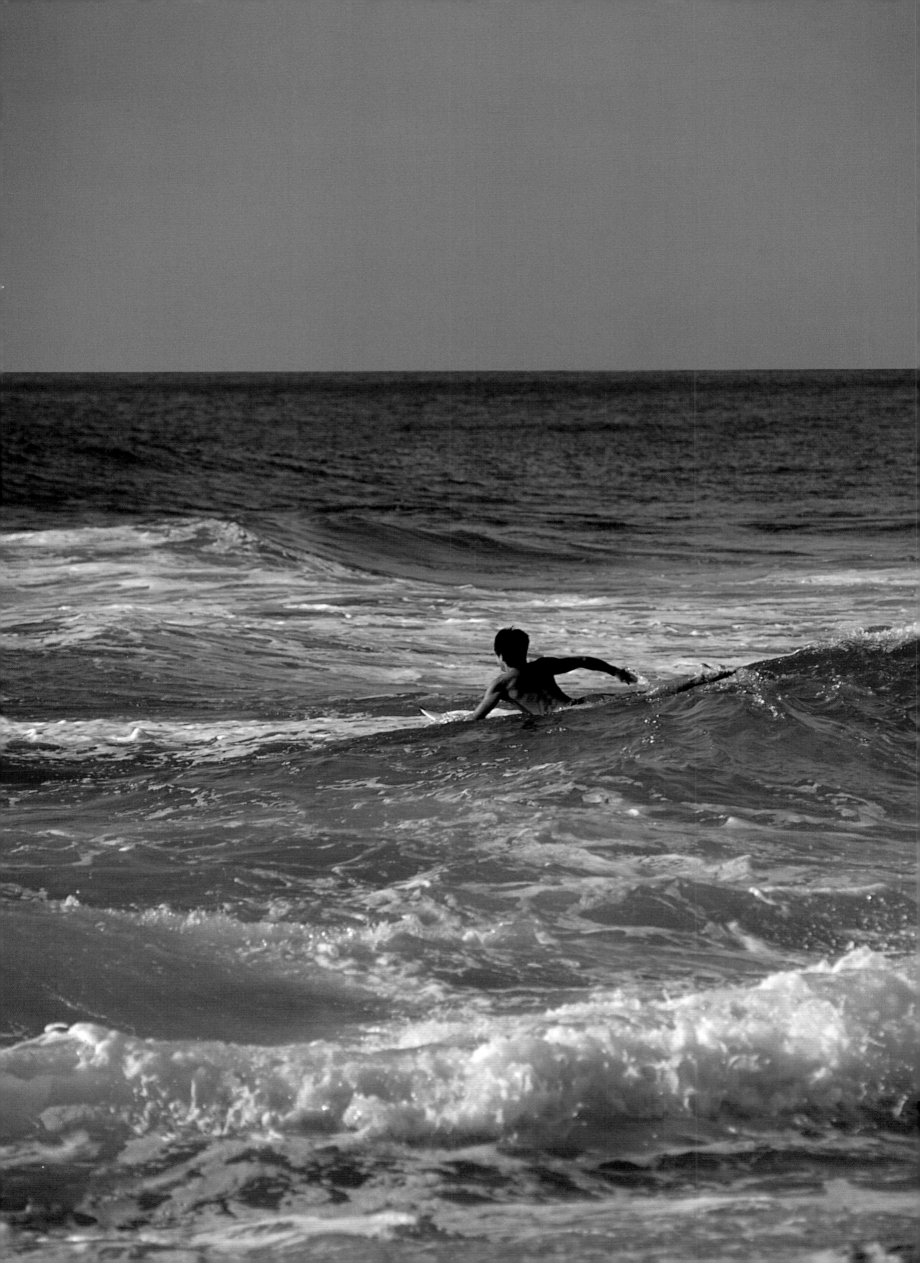

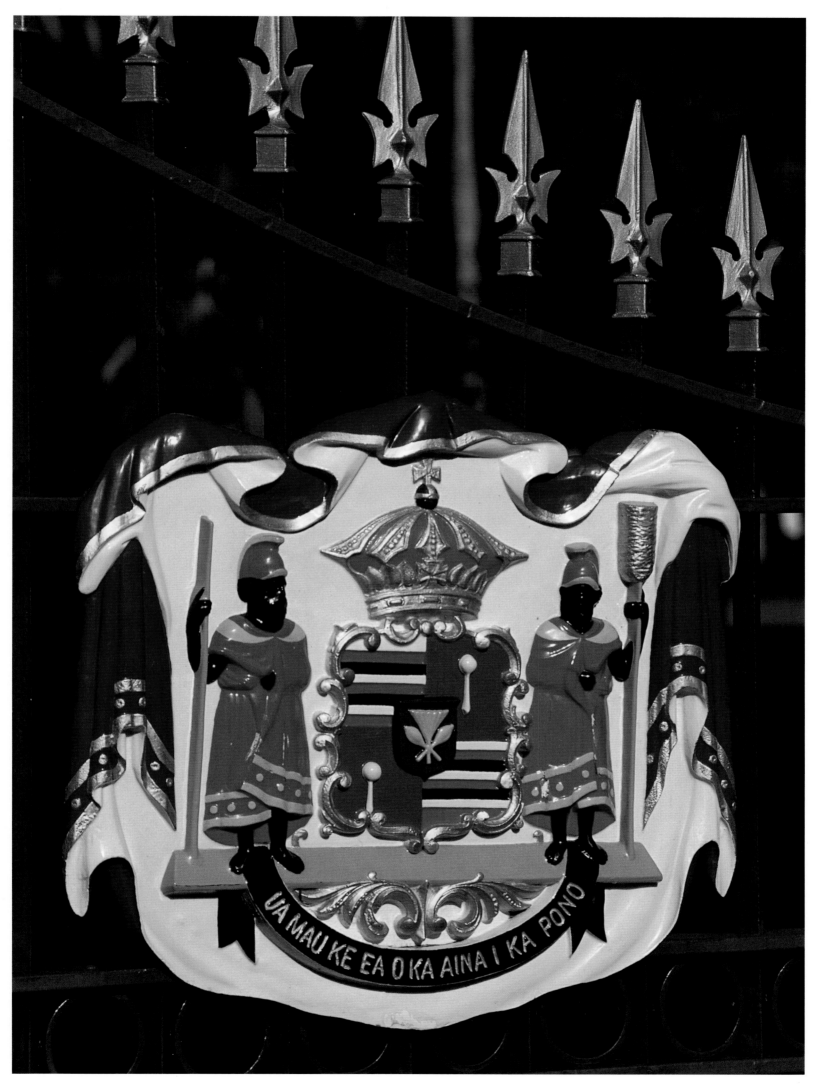

◁ Golden sand and the island's best body surfing make Sandy Beach Oahu's most popular destination for young people.
△ The Hawaiian motto on the gate to Iolani Palace means, "The life of the land is perpetuated in righteousness."

△ A snorkeler floats above the coral reef at Hanauma Bay, Oahu's underwater park.
▷ Surfers carry their boards in for the day, as Waikiki Beach welcomes sunset.

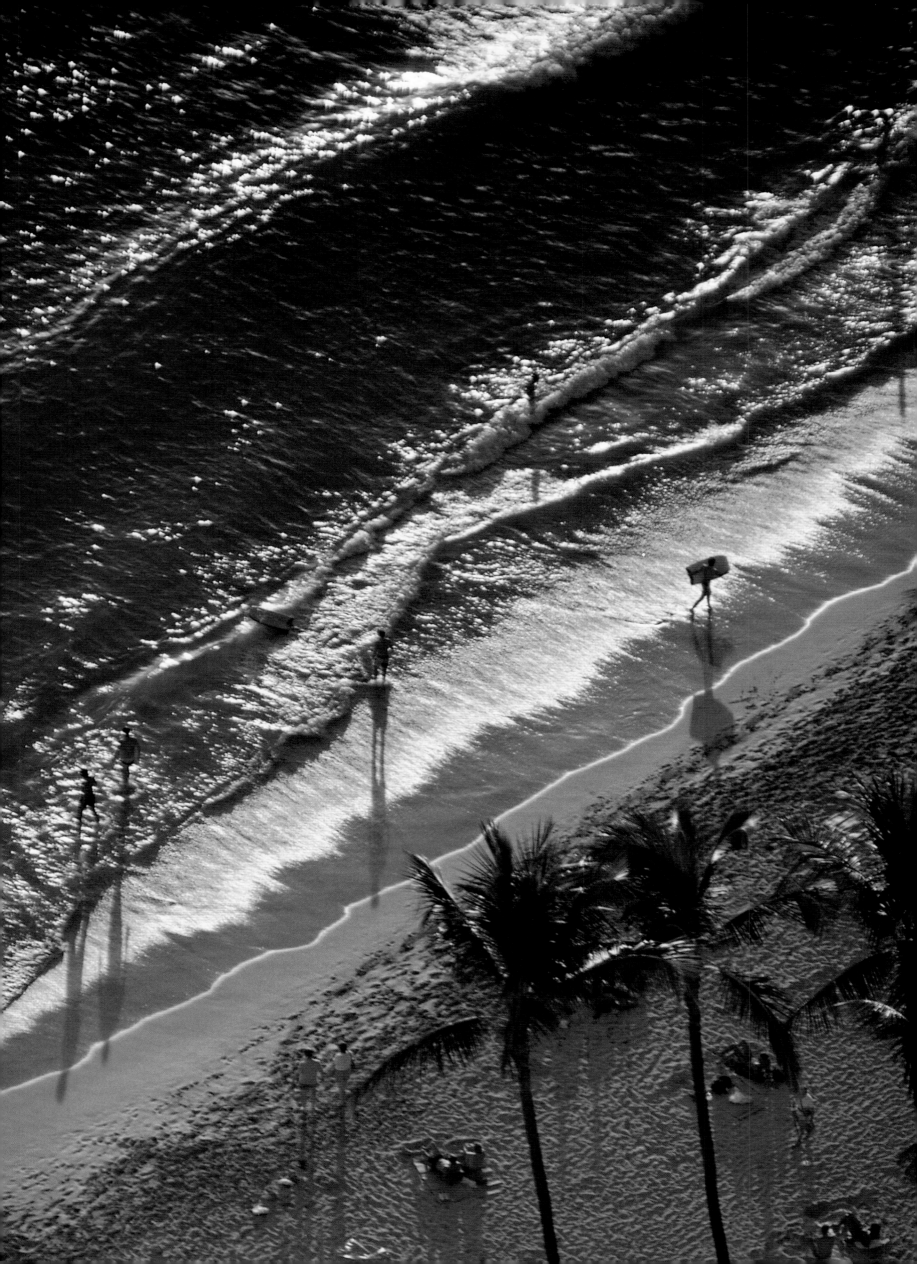

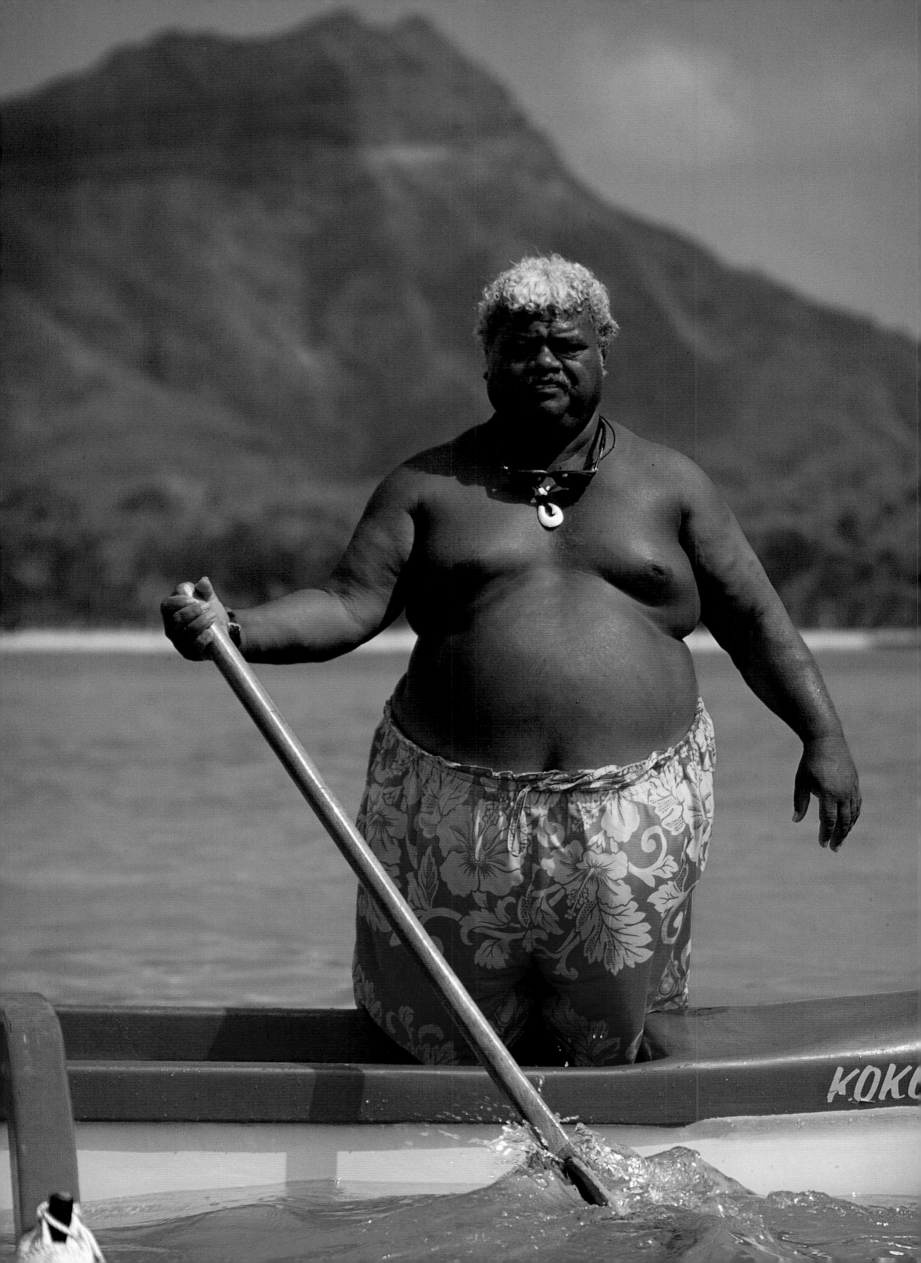

◁ Koko, a Hawaiian "beach boy," stands in his outrigger canoe in the waters of Waikiki.

▽ With Diamond Head behind, a colorful outrigger canoe cuts through the waves off Waikiki Beach. These canoes resemble those used by early Polynesians to fish and travel close to their islands.

▷ ▷ The Valley of the Temples boasts the beautiful and serene replica of the famous Byoto-In Temple in Kyoto, Japan.

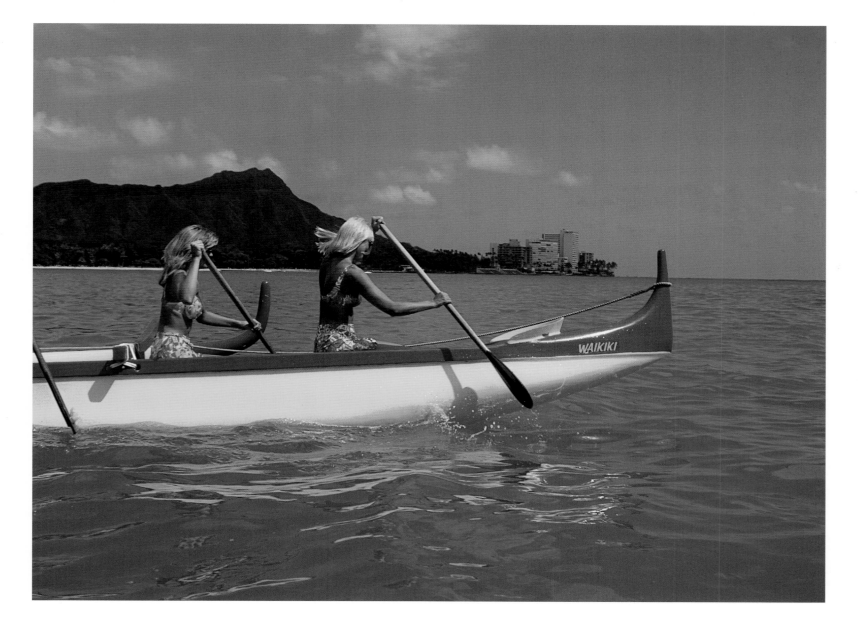

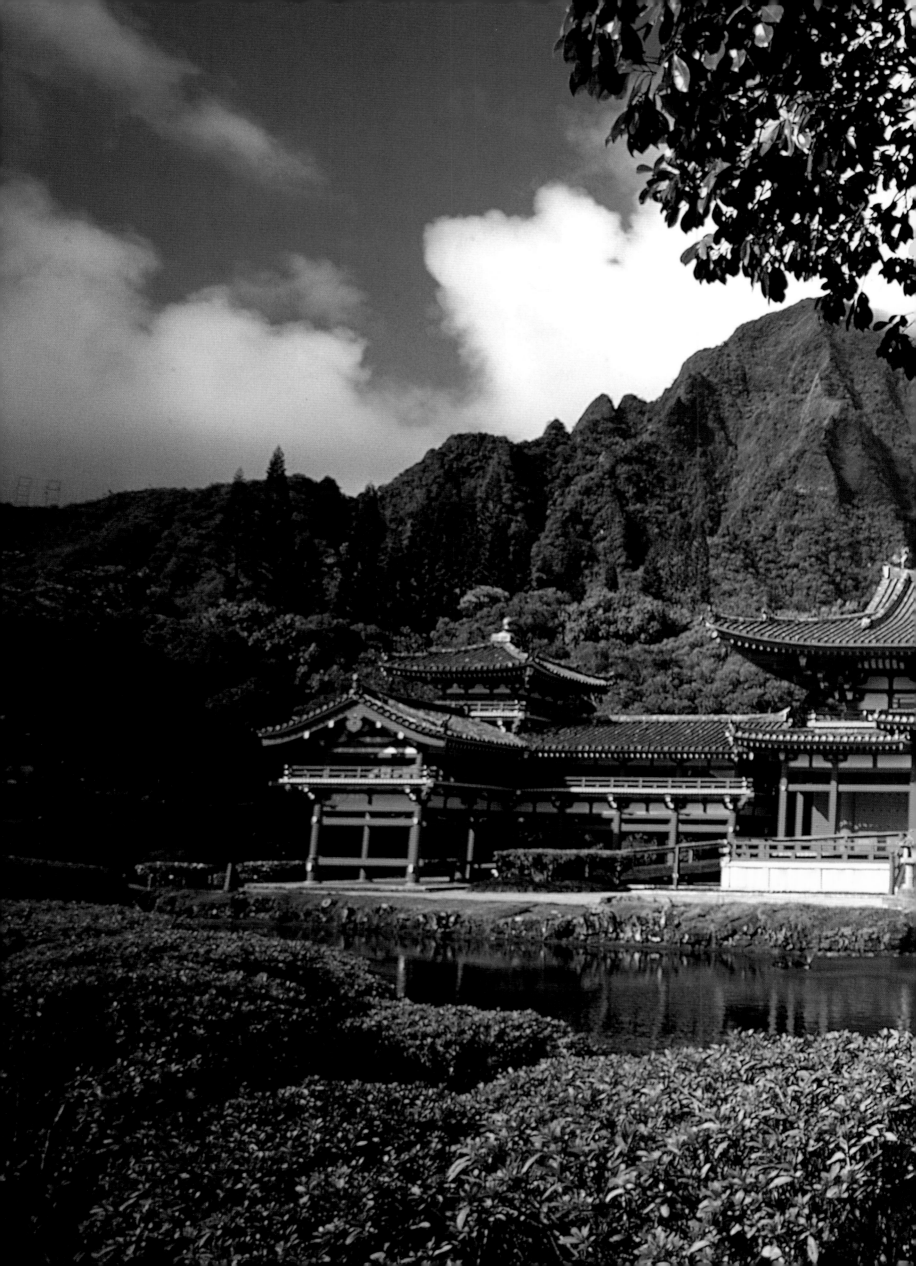

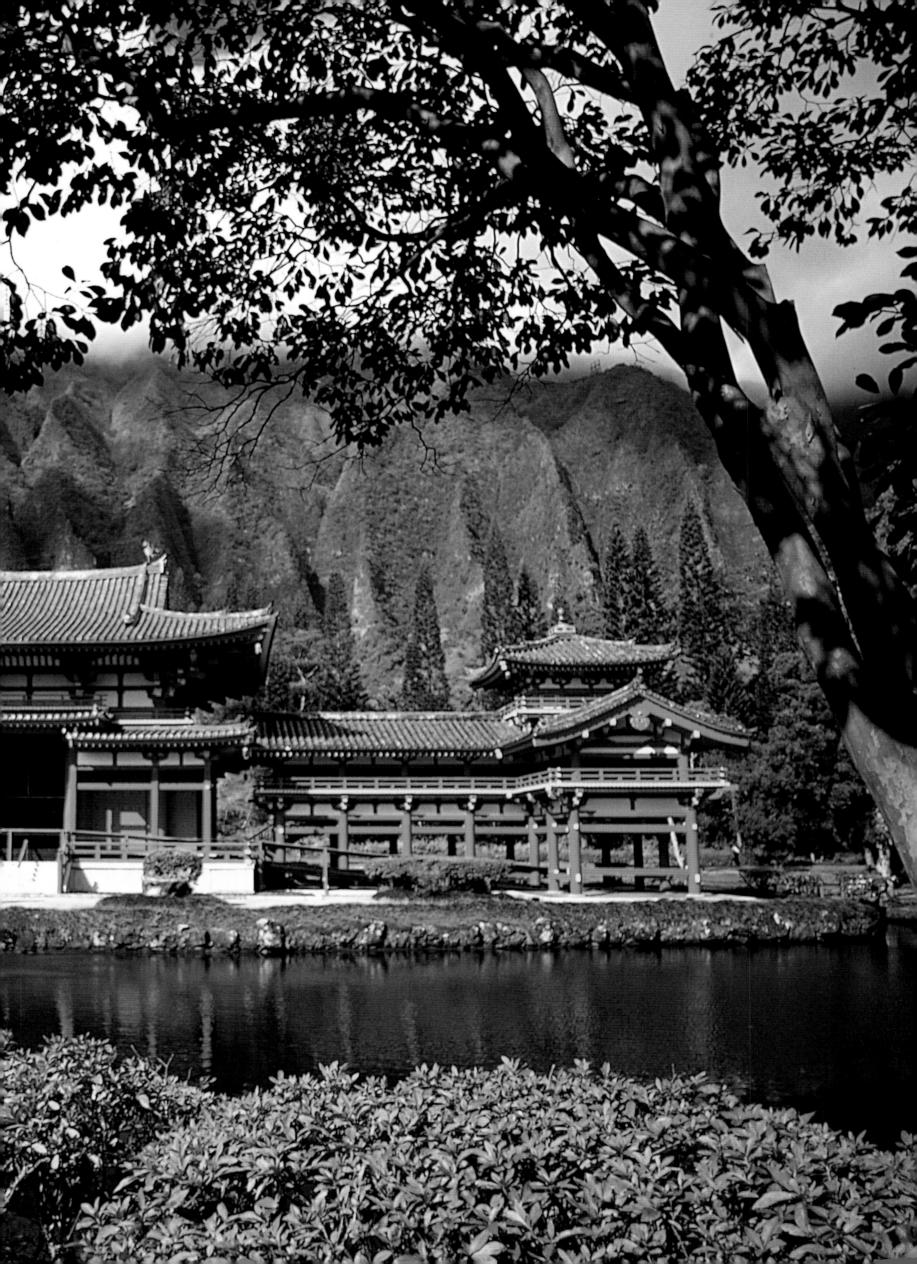

▽ Red and yellow outrigger
canoes sit ready for paddlers,
while umbrellas and
stately palms cast cooling
shadows on the golden
sands of Waikiki Beach.

▷ A body surfer approaches a
towering wave at Sandy Beach
and graphically illustrates why
only the experienced should
challenge Hawaii's ocean
strength. By using only their
outstretched arms, or placing
their arms to their sides, the
swimmers become one with the
waves and glide toward shore.

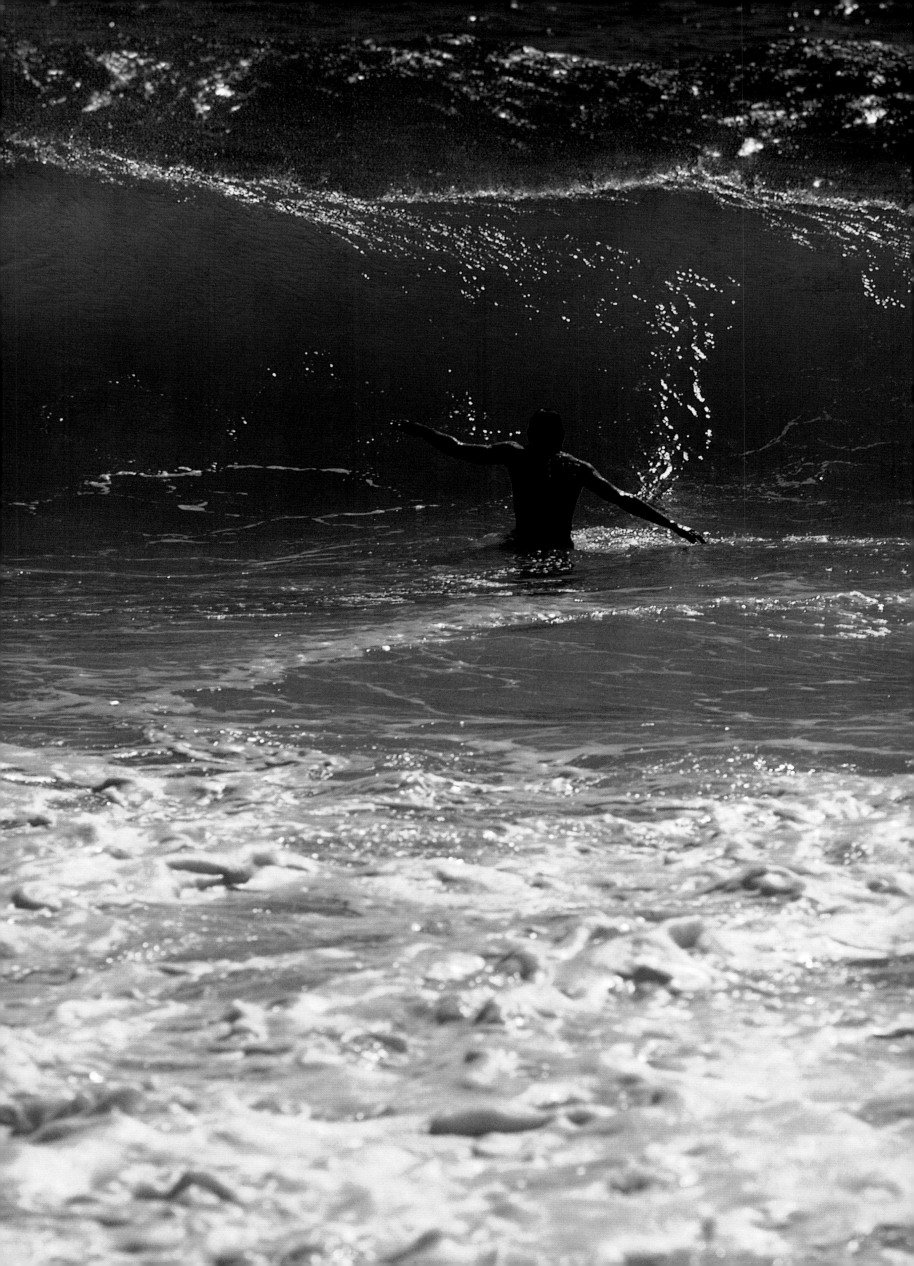

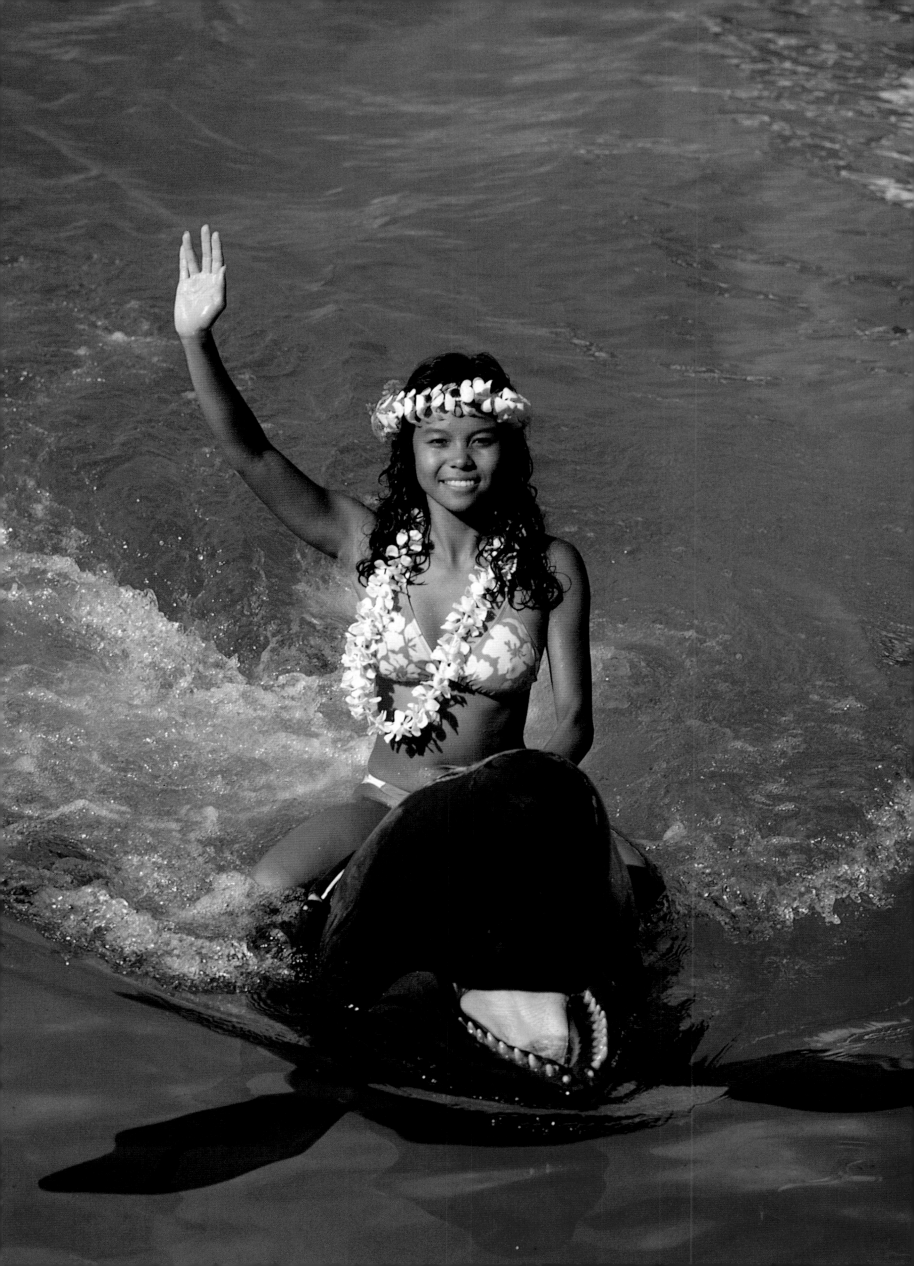

◁ Sea Life Park provides entertainment by whales, porpoises, and seals, but it is also a serious marine-life research center, with a wildlife rehabilitation and recovery unit.

▽ A Polynesian couple from Tonga grow fruit at their home and sell it at this stand along the North Shore road. Locals from a multitude of ethnic backgrounds sell food or their homemade crafts at stands throughout the islands.

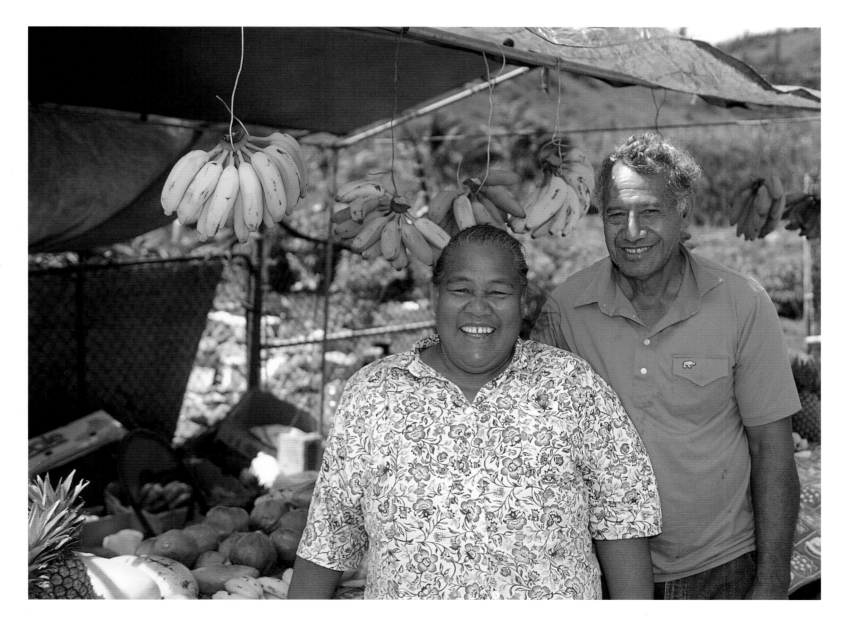

▽ Hawaiian chants tell of
surfing exploits as early as
the fifteenth century. Ancient
Hawaiians called it *heenalu*,
which roughly translated
means, "wave sliding."

▷ Spectacular Waikiki Beach,
with Diamond Head rising
majestically behind, was a
playground for the Hawaiian
monarchy long before the
building boom of the 1950s
turned the area into one of the
most visited spots on earth.

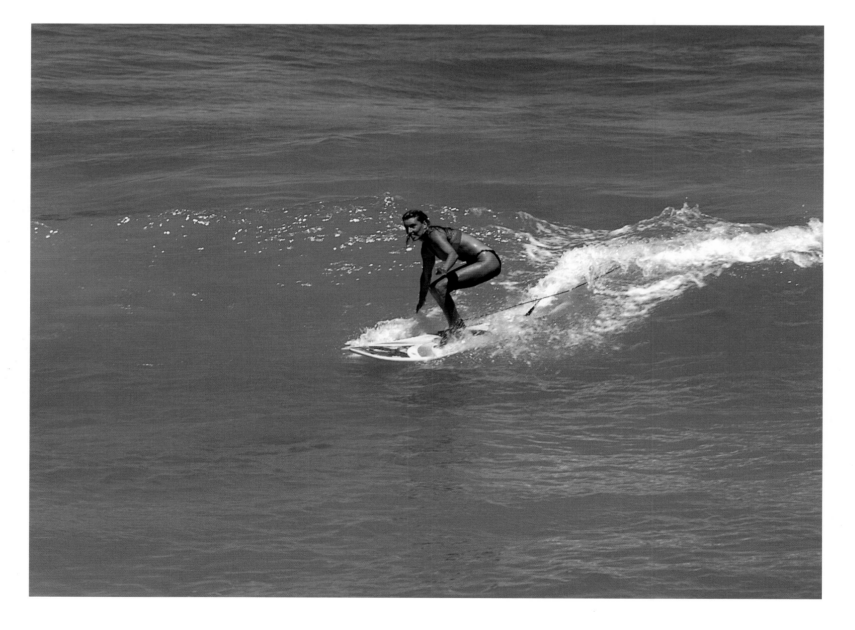

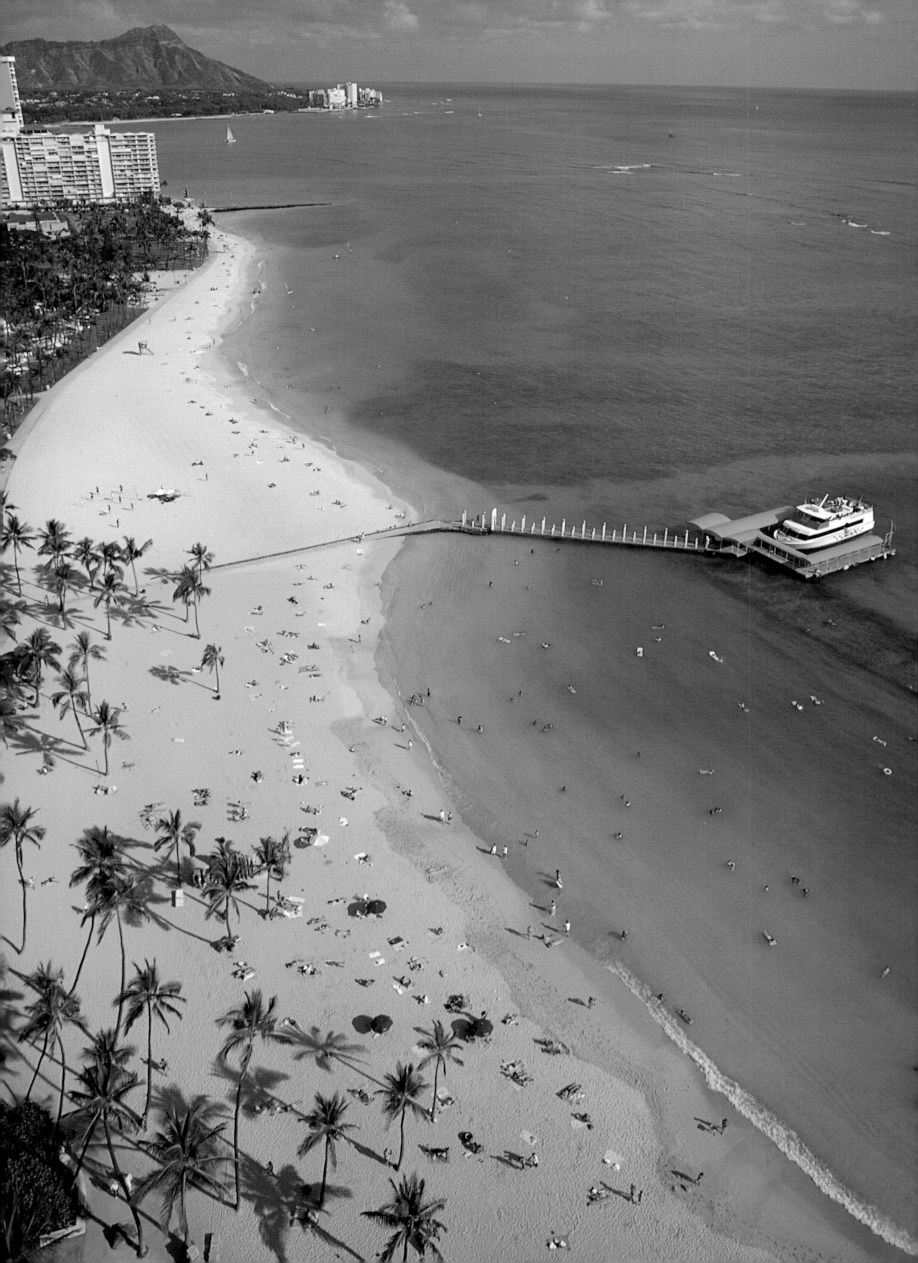

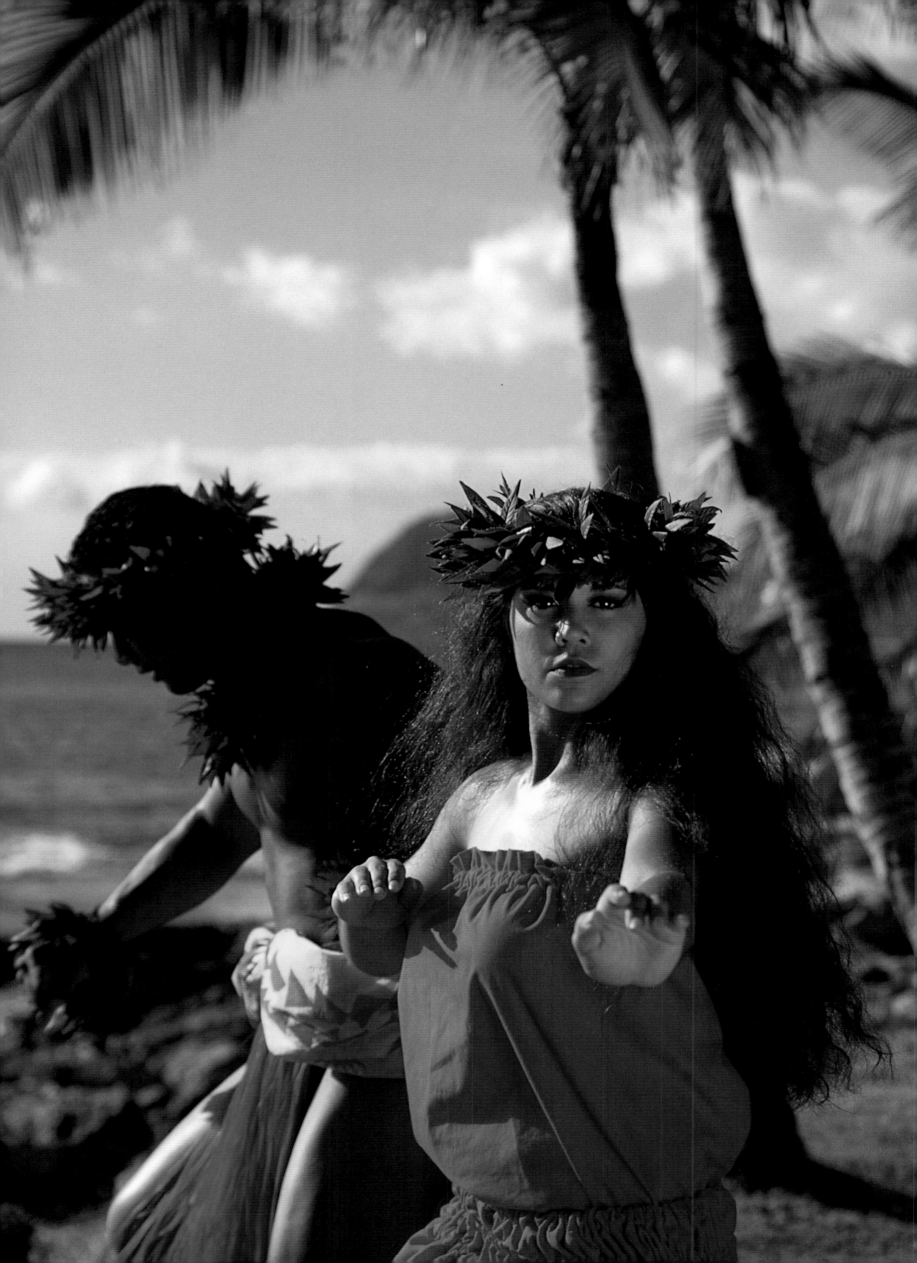

◁ Modern and traditional hula,
Tahitian dance, fire dancers,
and a variety of entertainers mix
with craft demonstrations,
Hawaiian games, a simulated
village of thatched homes,
and a variety of local food
to make Paradise Cove
an interesting experience.

▽ The seaside rim of Diamond
Head Crater stretches 761 feet
above the sea below, offering
a spectacular view of Waikiki
and Oahu's south coast.

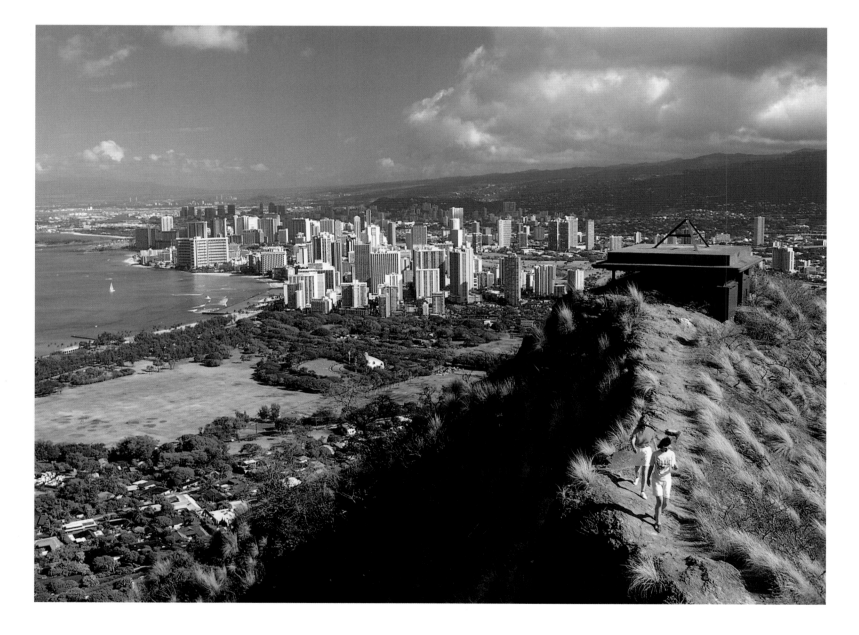

▽ In winter, Sunset Beach's gentle waves become towering mountains of crushing power, which attract the world's most daring surfers.

▷ A golden sand beach and stunning turquoise waters make Kailua's Lanikai Beach one of Hawaii's most beautiful locations. It is the site each year of an international world cup windsurfing competition.

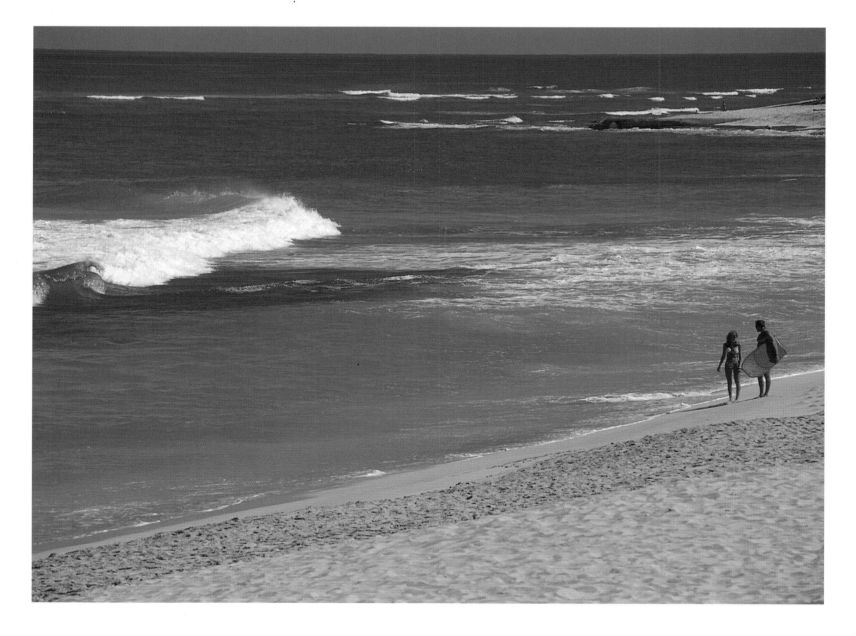

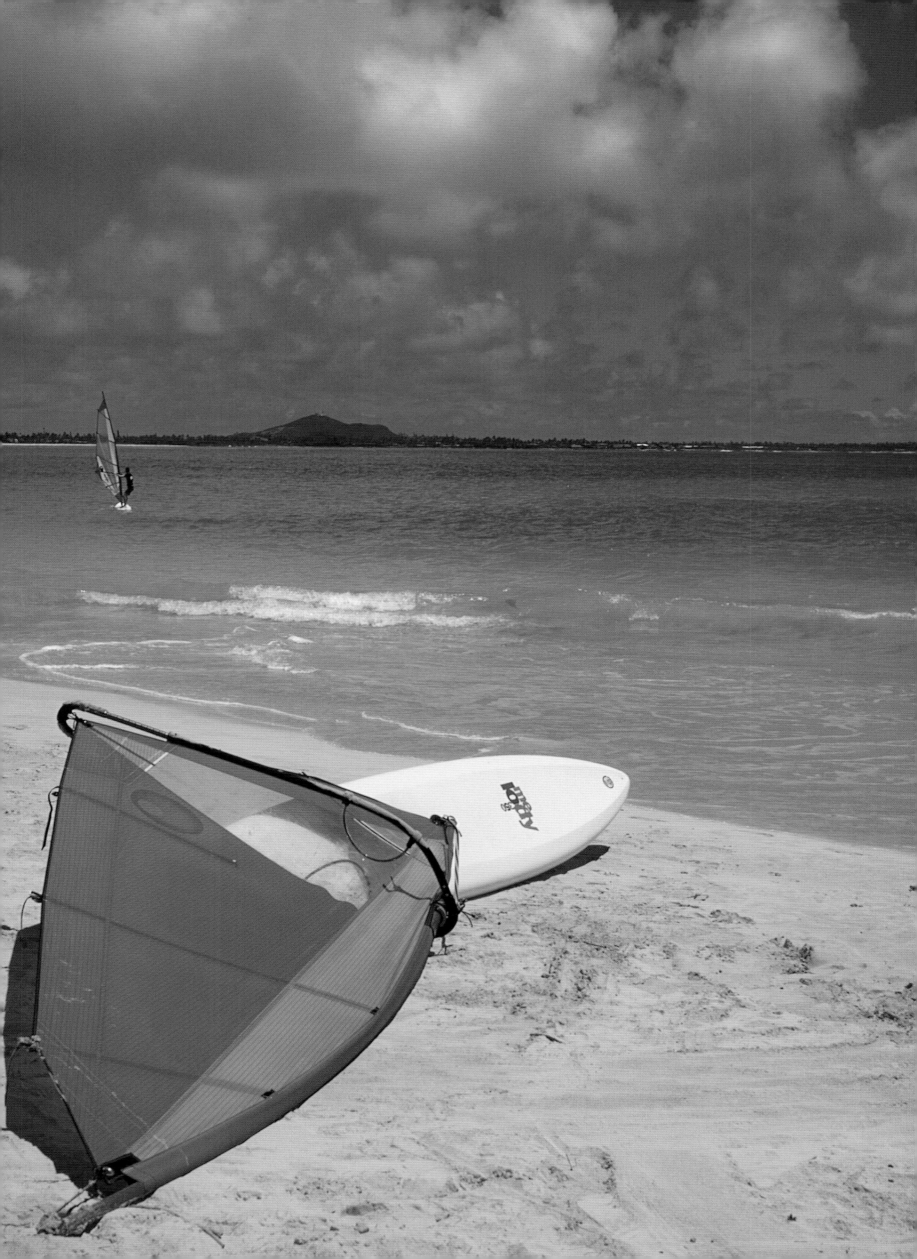

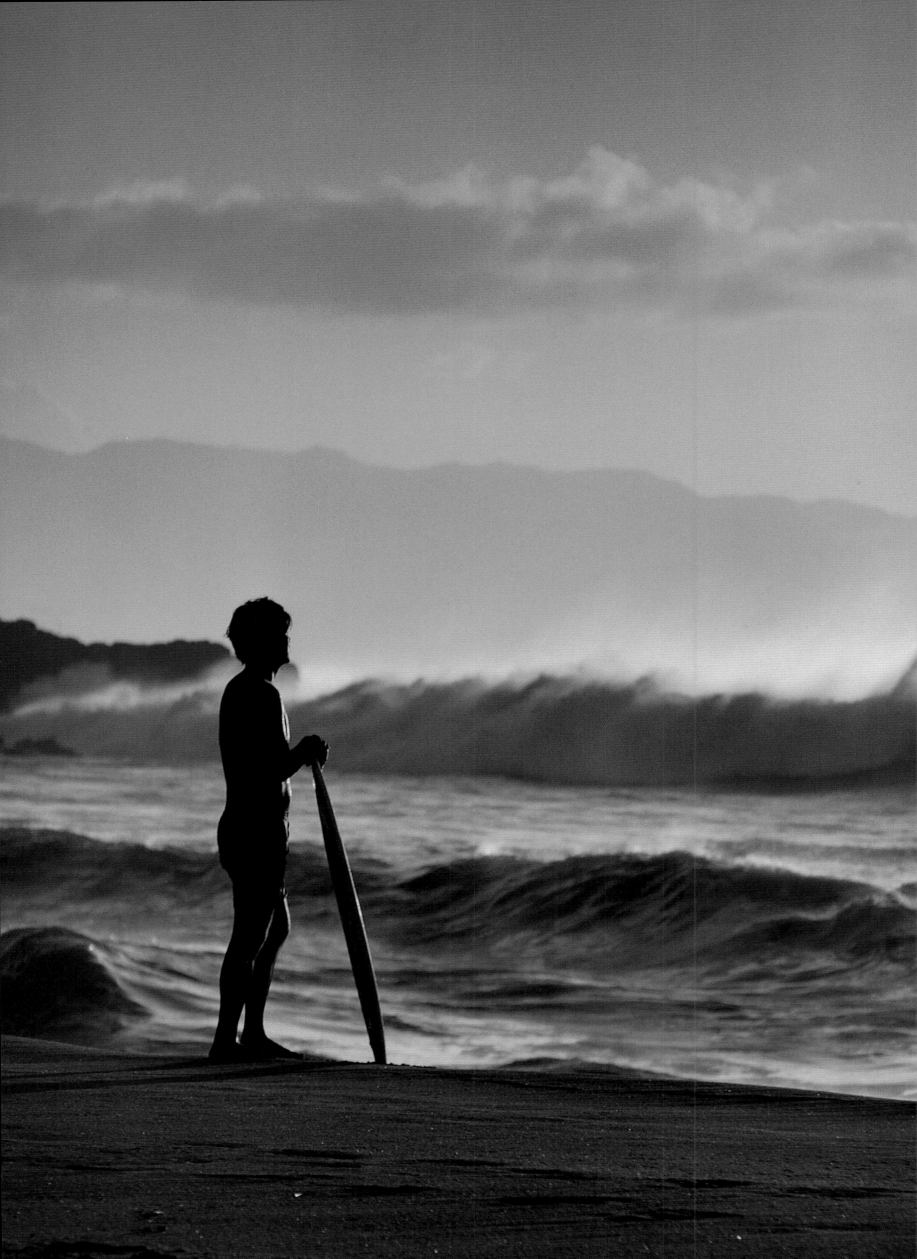

◁ Waimea Bay is home to what many call the world's best surfing waves. Winter storms in the Arctic send wave pulses that swell to some twenty to thirty feet, pounding the beach with their power.

▽ The USS *Arizona* rests with the remains of her valiant crew of 1,102 men at the bottom of Pearl Harbor. The simple, stark white Arizona Memorial pays moving homage to the events of December 7, 1941, when Japanese dive bombers sank the U. S. Pacific Fleet at anchor.

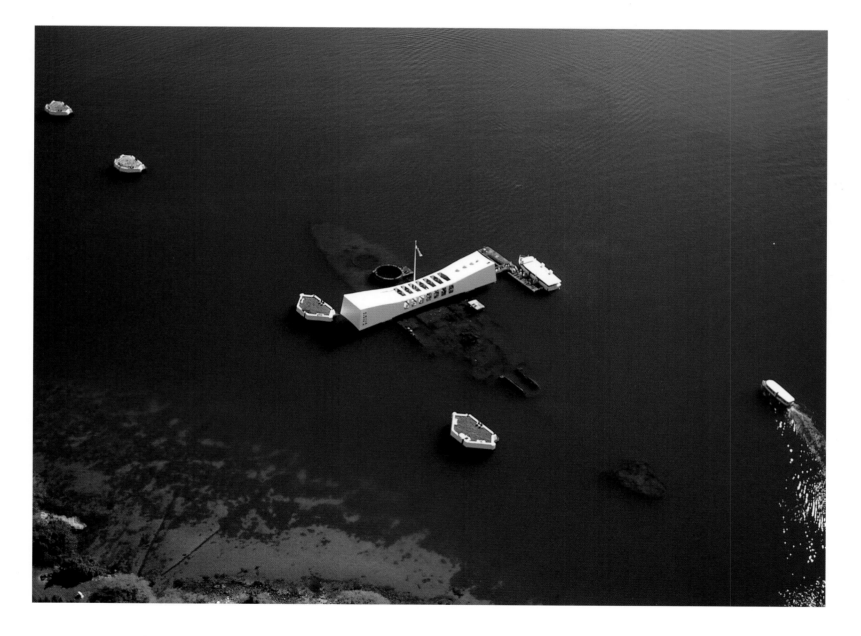

▽ Manana, commonly called Rabbit Island, is situated across from Oahu's Makapuu Beach. Manana is a sixty-seven-acre, state-protected sanctuary for seabirds.

▷ Paddlers move in the canal past the Ala Wai Yacht Harbor, with Waikiki and Diamond Head in the background.

▷ ▷ Coral formations filled with Hawaiian fish are visible beneath the brilliant emerald blue waters of Hanauma Bay, making it Oahu's most popular snorkeling and diving location.

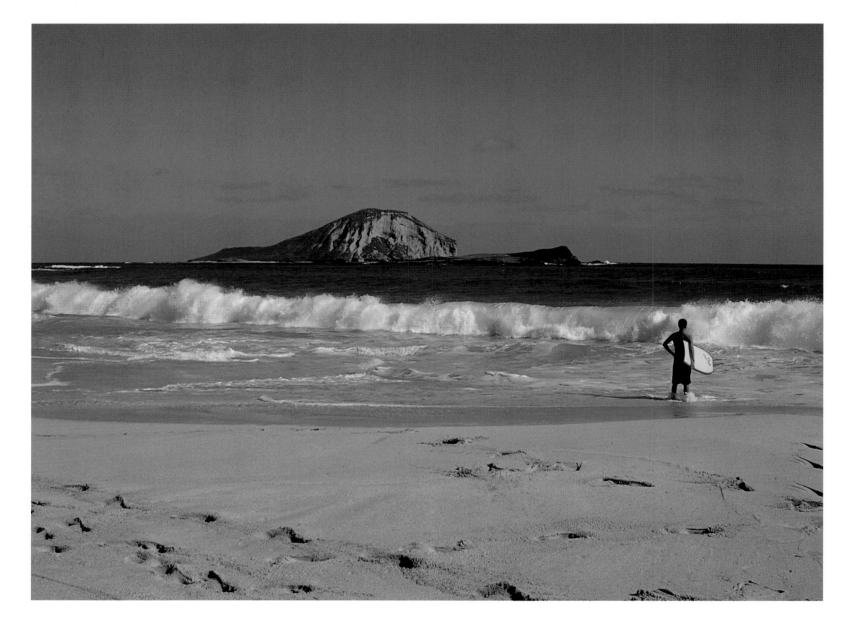

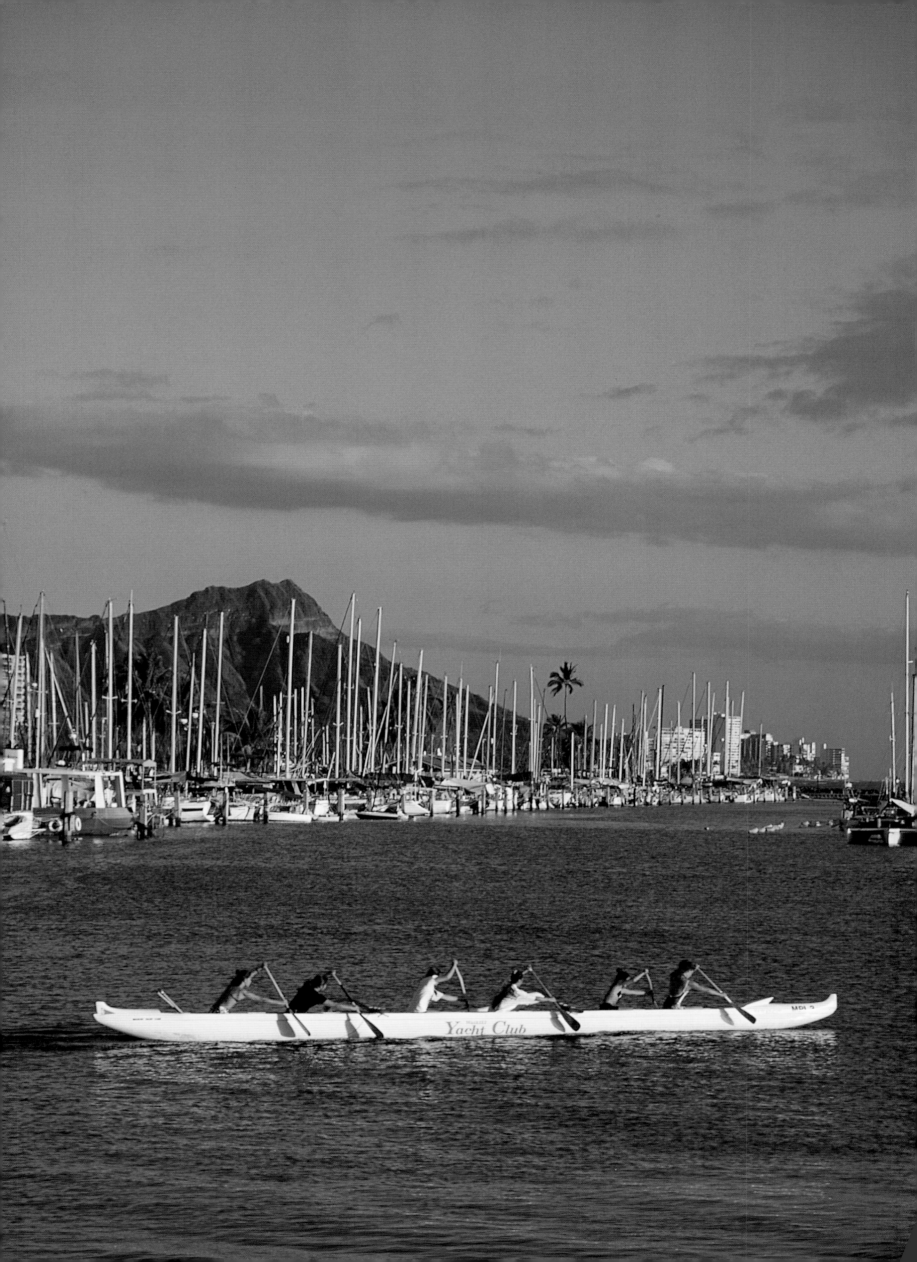

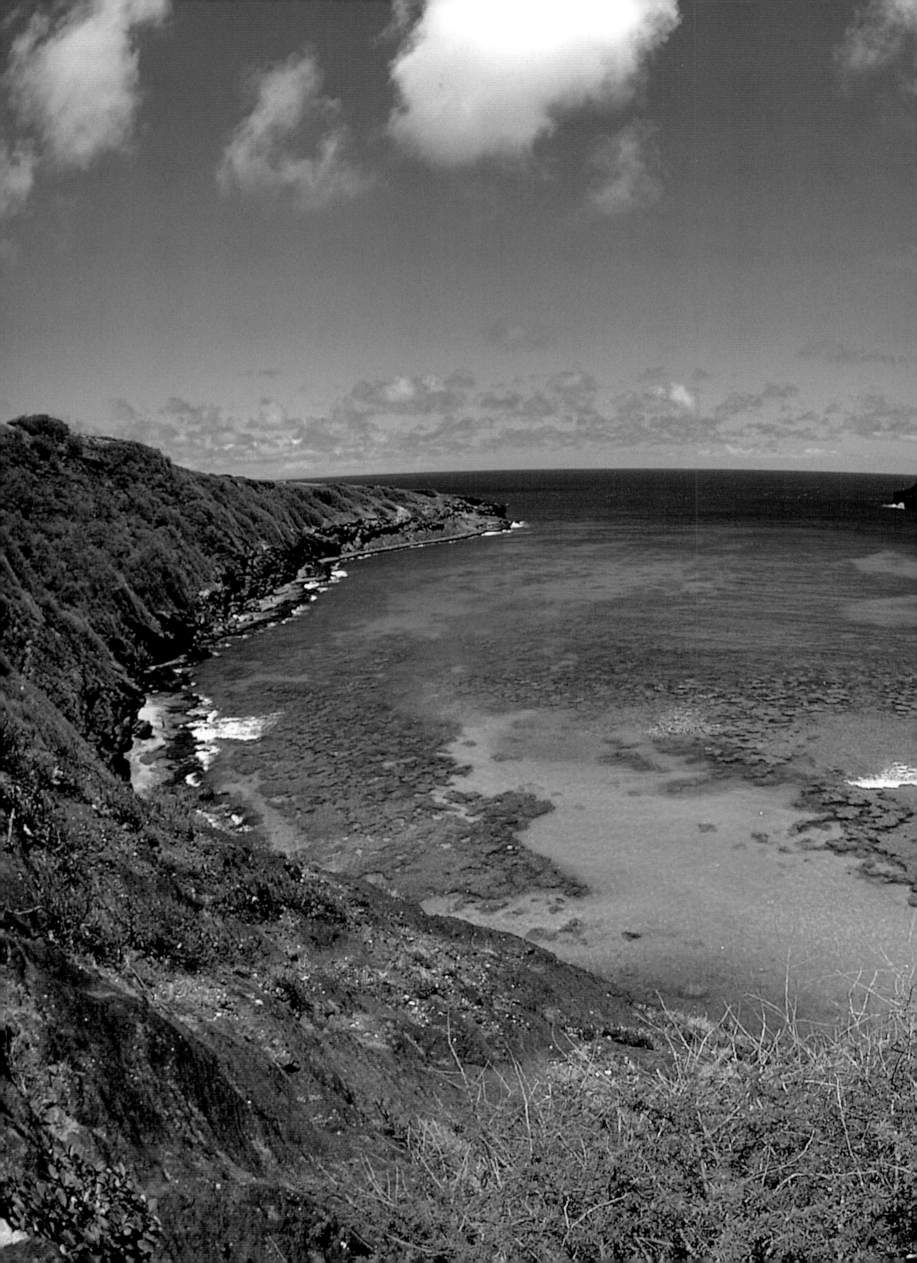

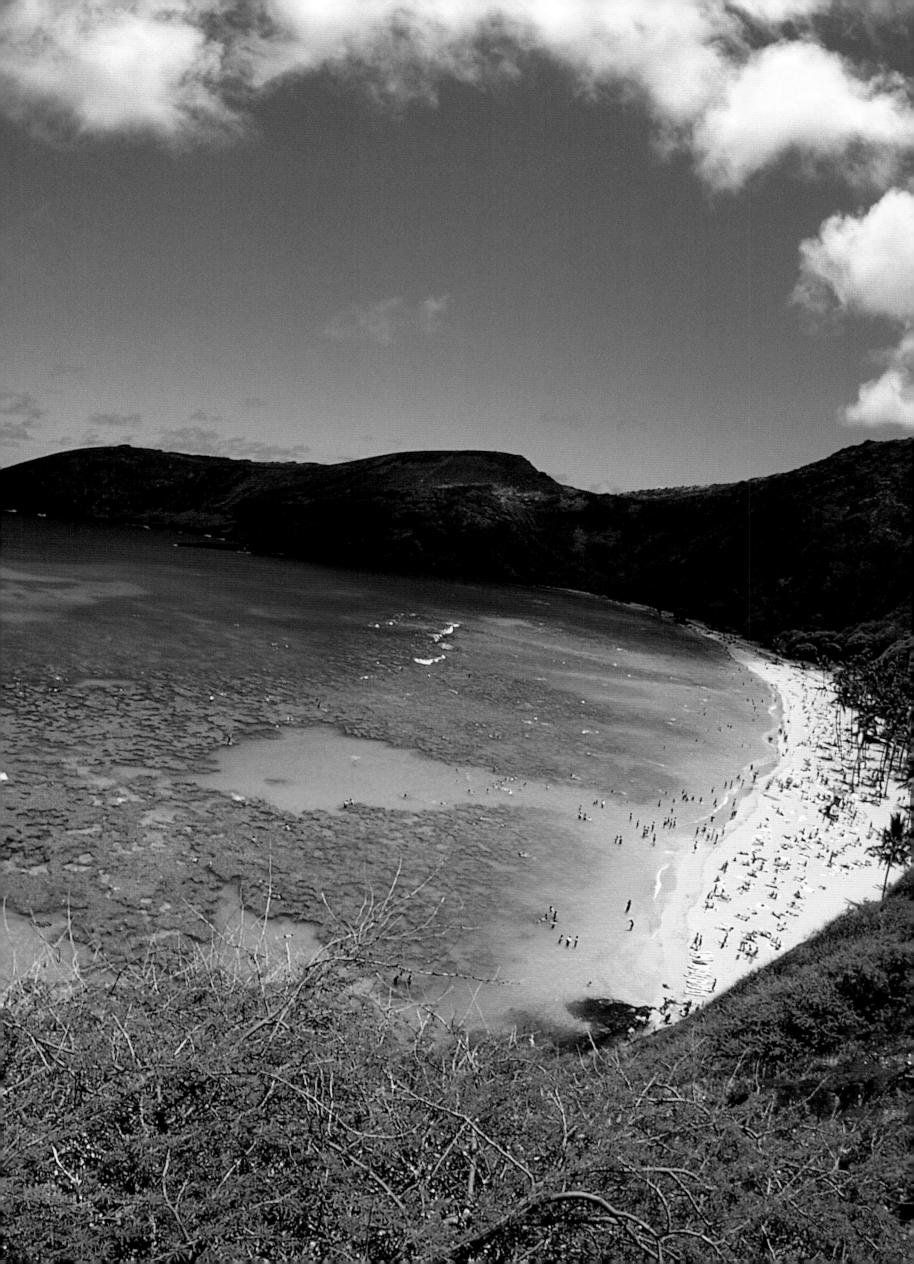

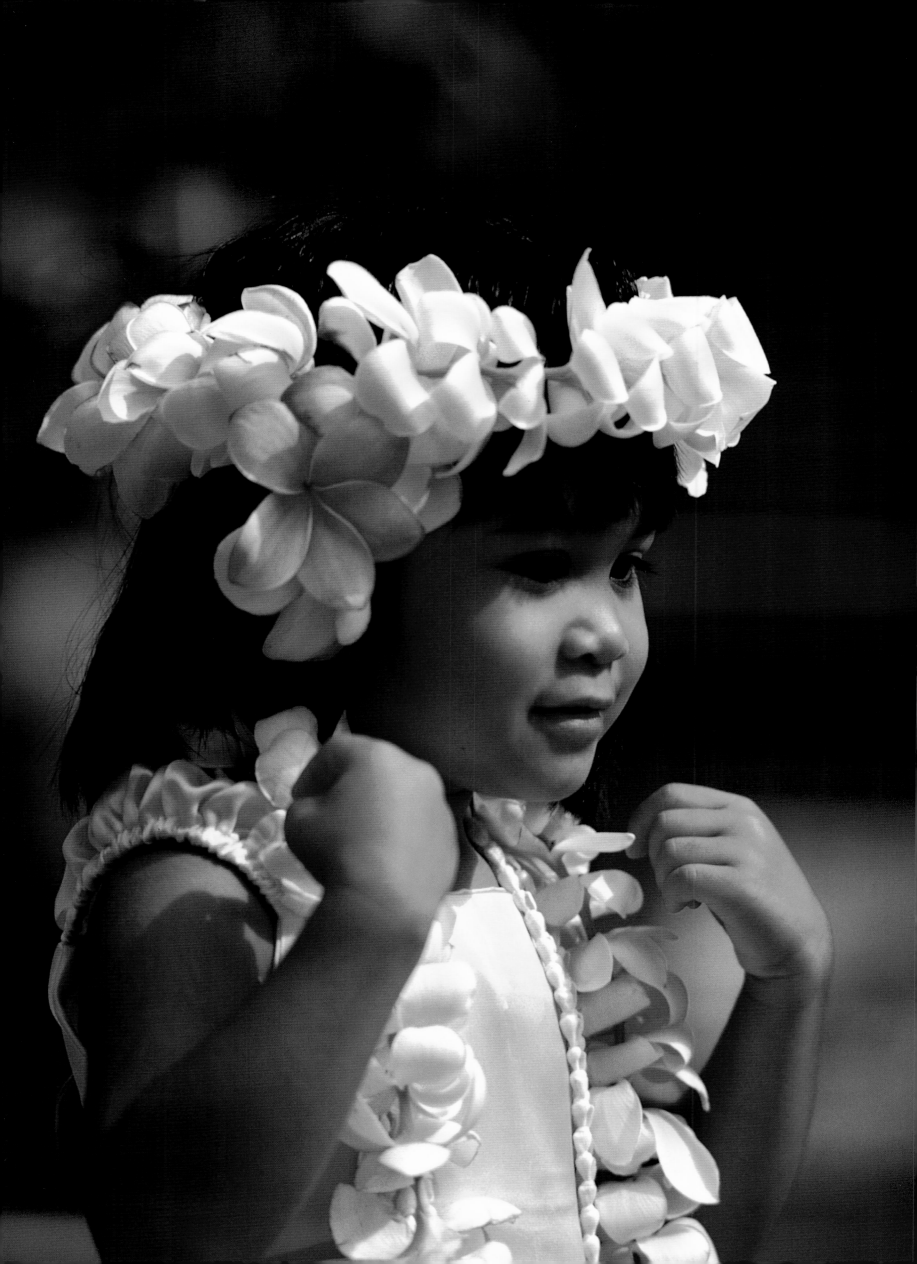

◁ Keikei Hula, or children's hula, flourishes throughout the islands. The Hawaiian culture, including the hula, was nearly extinguished by Protestant missionaries in the nineteenth century. Both are now thriving as children are taught the language and customs of their forefathers.

▽ A busy stretch of Waikiki Beach sits beyond the towering Sheraton Waikiki and the stately "Pink Lady," as the Royal Hawaiian Hotel is called. Built in 1927, its distinctive architecture and flamingo color still attract attention.

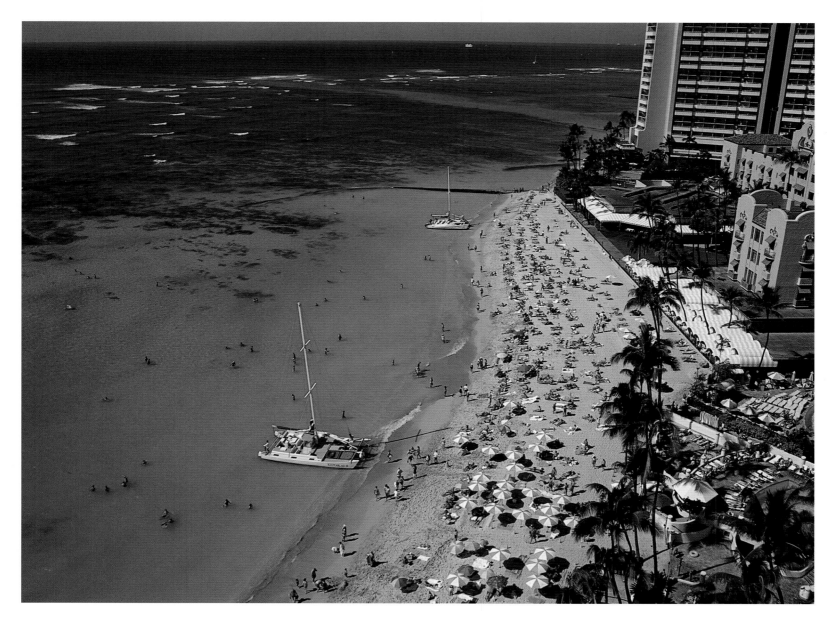

▽ The Halau Hula Olana Hula Dance Group performs during King Kamehameha Day festivities in Honolulu. King Kamehameha the Great, who ruled from 1795 to 1819, united the Hawaiian Islands.

▷ White anthurium, red ginger, and orange bird of paradise flowers frame a lovely lady aboard a parade float. The parade is held each June 11, in honor of Kamehameha the Great. King Kamehameha Day was designated as a public holiday by Royal Proclamation on December 22, 1871.

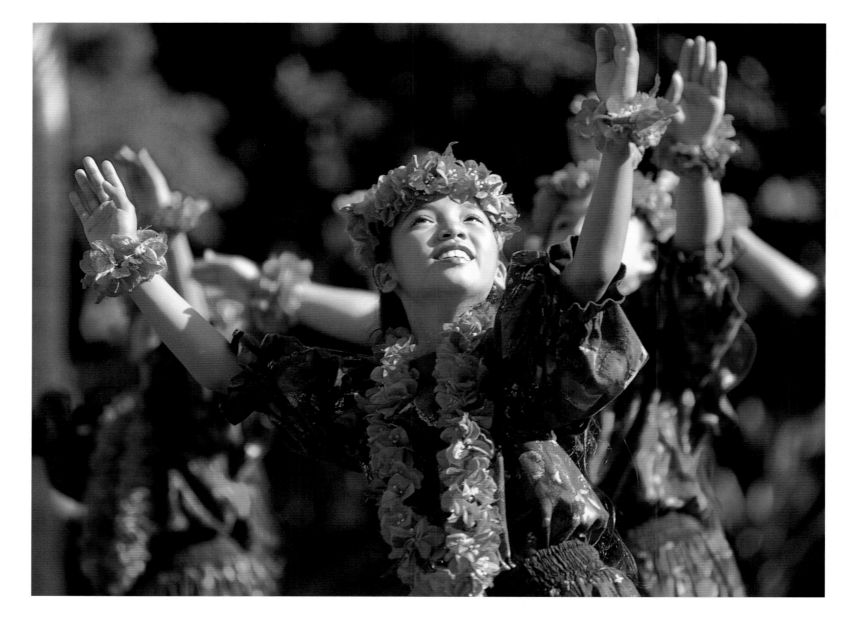

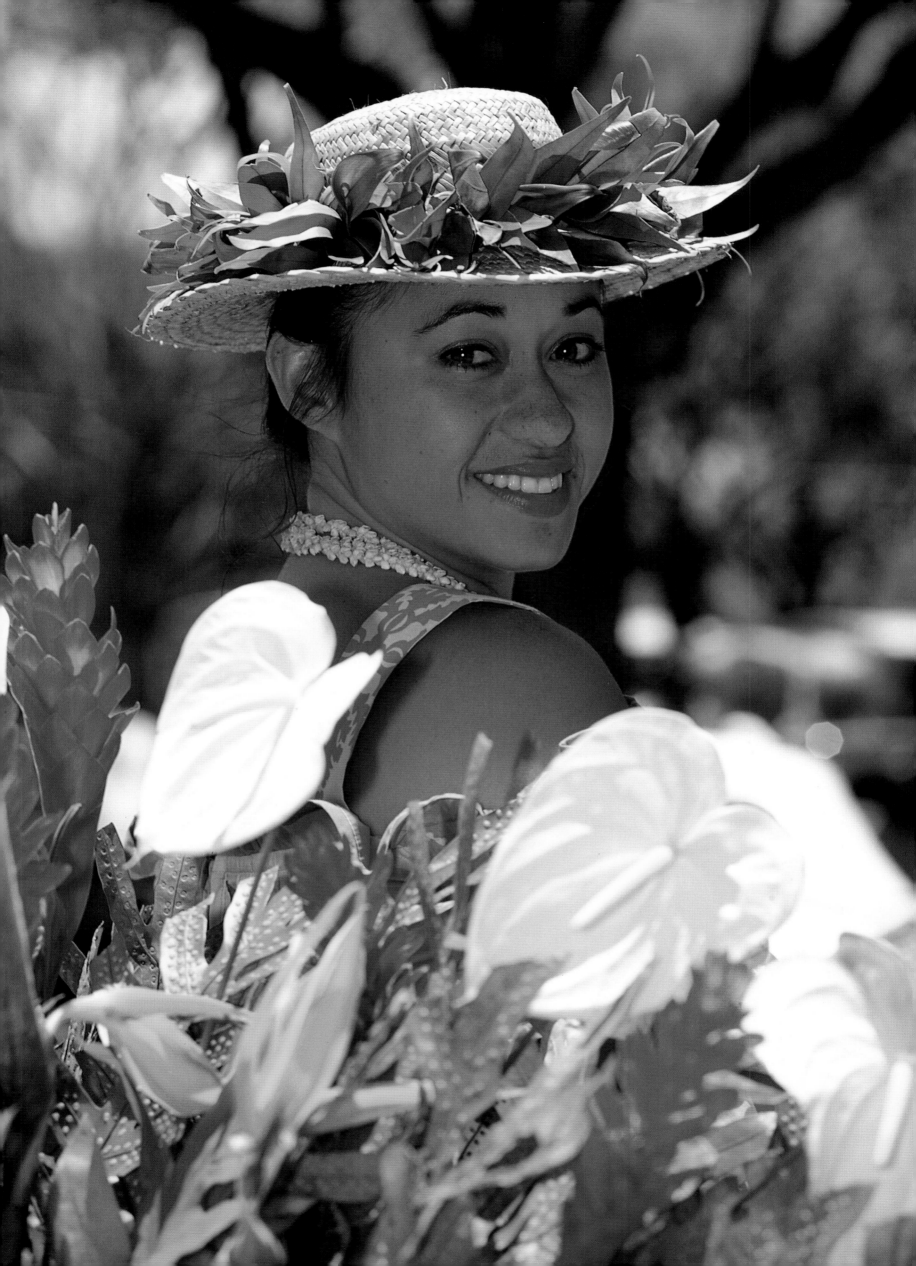

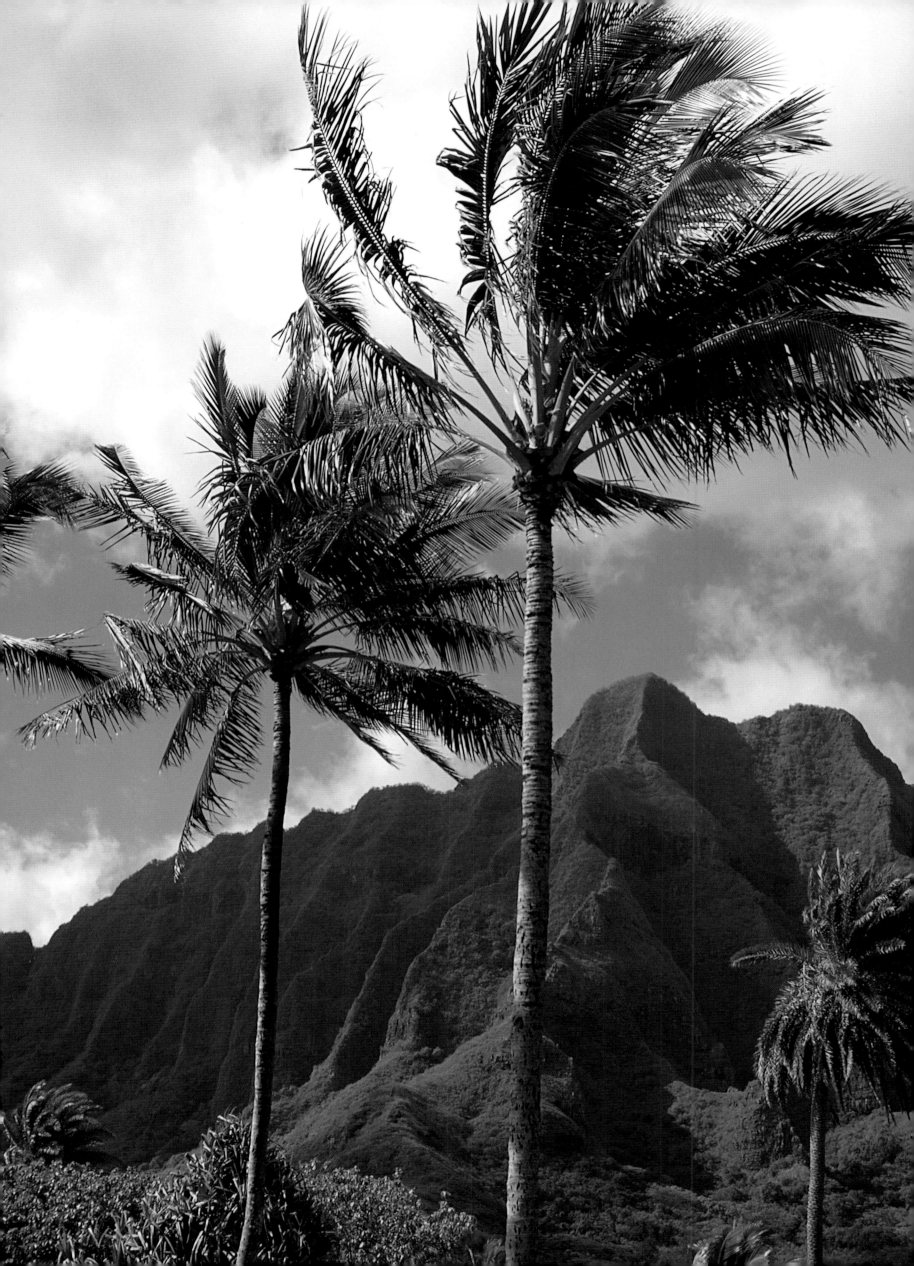

◁ From Makapuu to the North Shore of Oahu, the towering Koolau mountain range is home to crystal waterfalls, green valleys, and rugged cliffsides.

▽ A beautiful Hawaiian girl wears a *haku* head lei made from *maile* leaves. The majority of people who call themselves Hawaiians are of mixed blood, called *hapa,* or part Hawaiian. Only approximately one percent of the population is full-blooded Hawaiian, and most of these people reside on the island of Niihau.

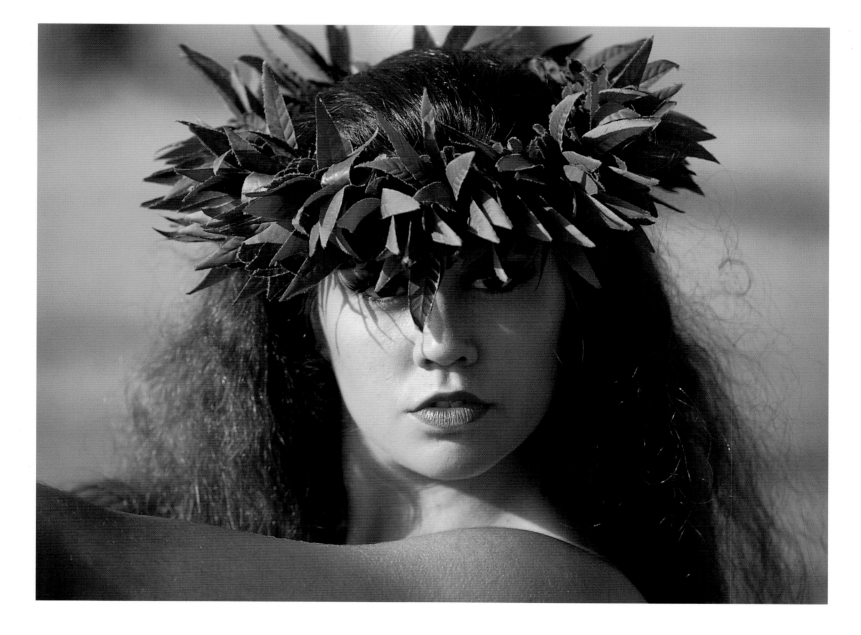

▽ A young Hawaiian blows a conch shell at the setting sun to announce the start of the Paradise Cove Luau show. The luau has a Polynesian review, featuring both ancient and modern hula, models wearing replica ancient Hawaiian royalty costumes, a torch lighting ceremony, and beachfront *hukulau,* or "net fishing."

▷ Waimanalo Beach not only supplies good fishing, but is Oahu's longest continuous beach, stretching more than three miles. Rabbit Island rises from the ocean just beyond.

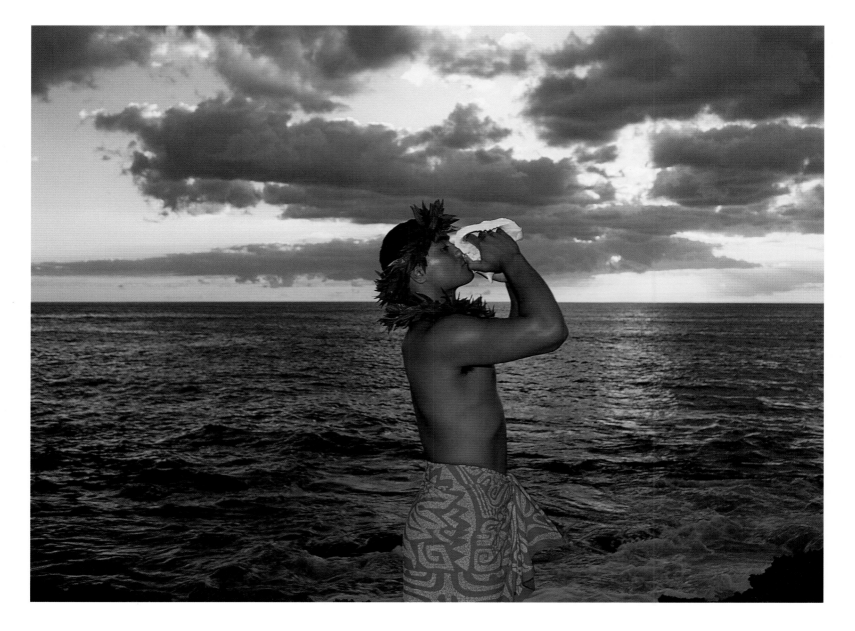

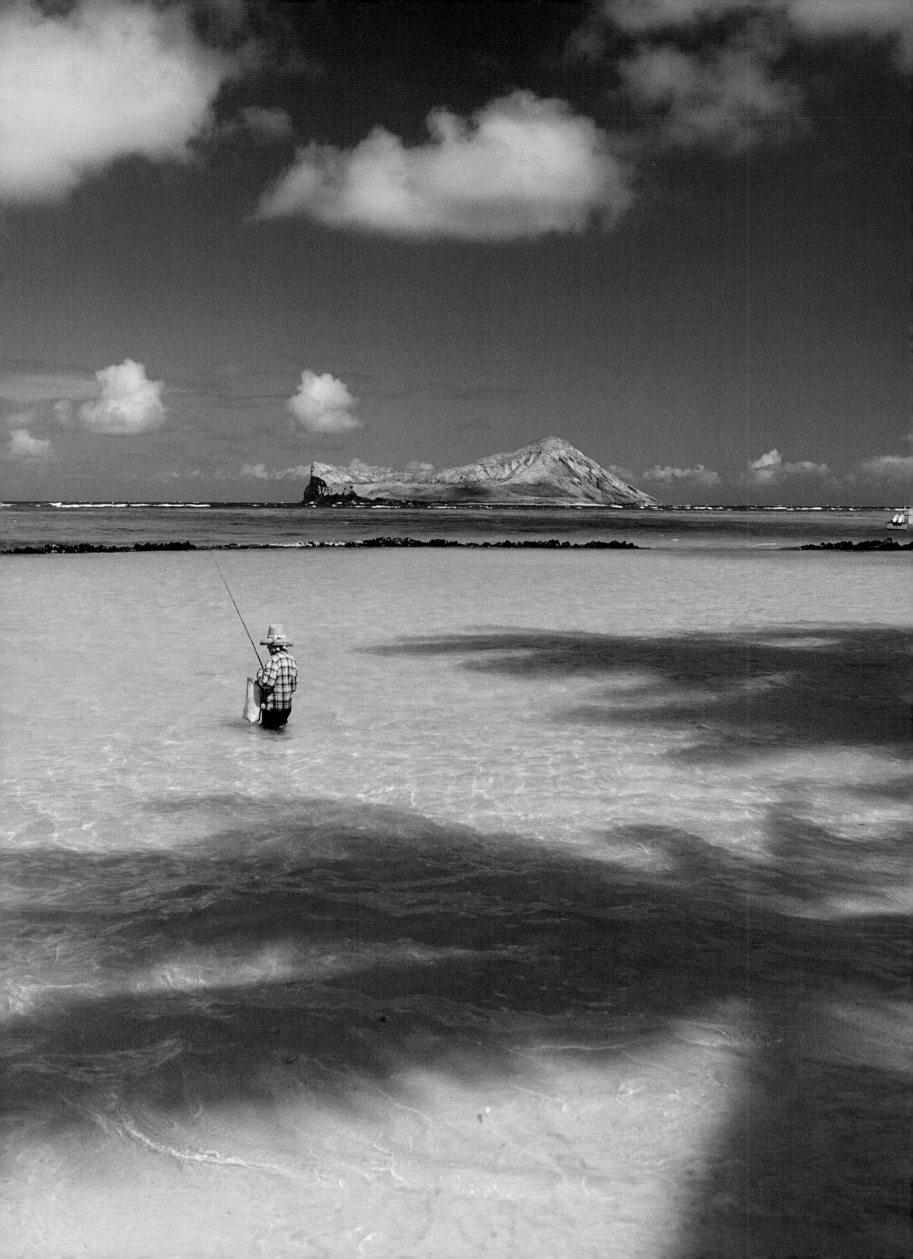

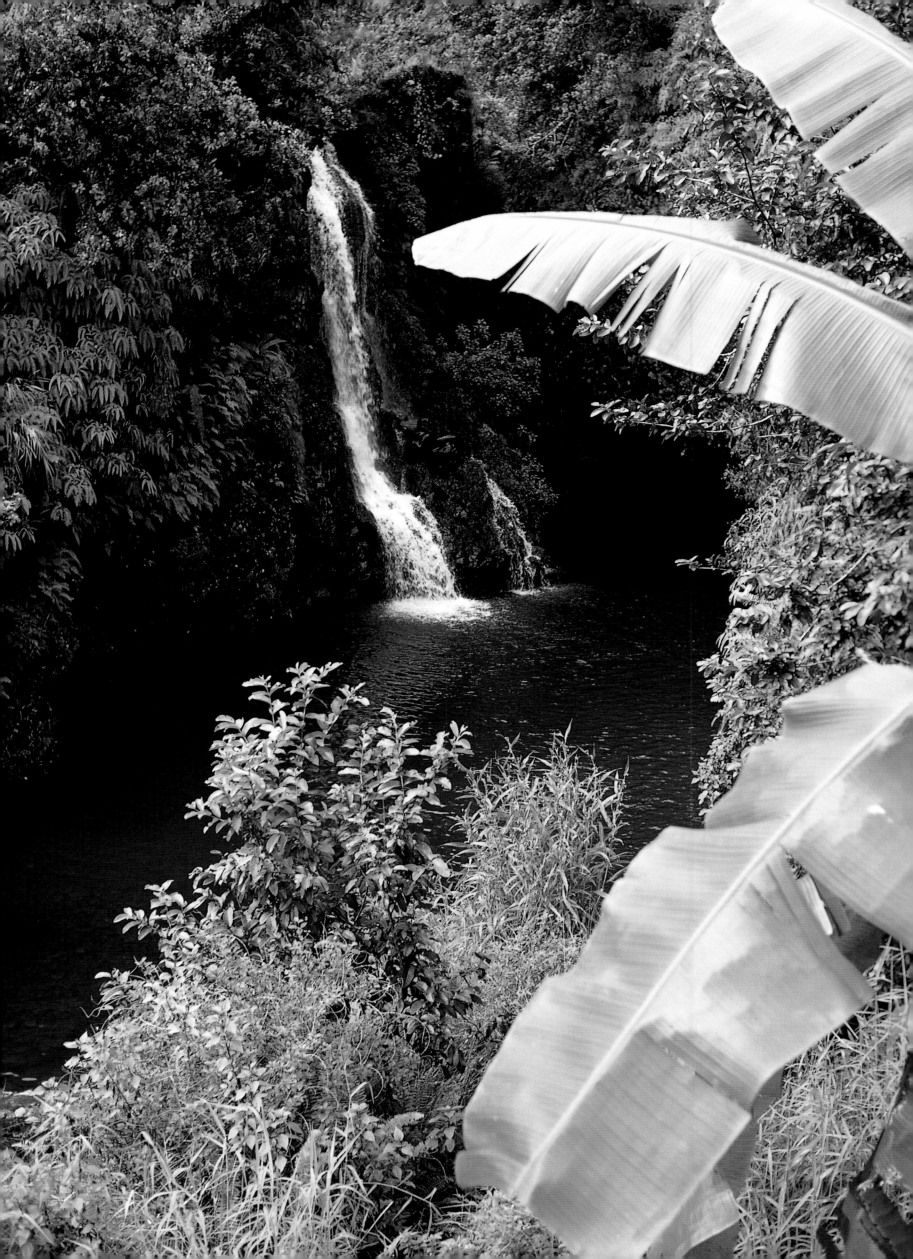

Maui

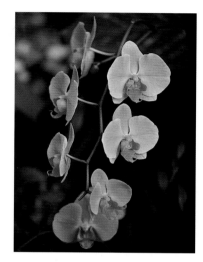

Thousands of centuries ago, a volcano erupted deep within the Pacific Ocean. The flowing lava grew and grew until it breached the surface, then continued high into the clear blue sky, creating Mauna Kahalawai. Soon another eruption began not far away, and it grew even faster and higher until it had reached ten thousand feet above the water, forming Haleakala. As molten lava continued to flow, it gradually rose above the steaming ocean and connected the two giants to each other, giving birth to a fertile isthmus and hundreds of lush valleys. Now, centuries later, tourists call the island of Maui the "Valley Isle."

Ancient Hawaiian legend says the half-god, half-man Maui used a magic fish hook to pull all of the Hawaiian islands up from the sea. He then chose the slopes of *Haleakala*— which means "House of the Sun" in Hawaiian—to be his home. His choice turned out to be an unlucky one, because the days there were very short. The sun was lazy, often sleeping late before racing across the sky. Maui solved his problem by snaring the sun one morning as it rose over the crater's rim. He held the sun hostage until it promised to go slower when passing over his island. These days, the sun rises very early and drifts casually over Haleakala and the island of Maui. And ever since those bygone days, Hawaiians have called Maui the "Magic Isle."

Anyone who has ever been on Maui knows the special character of the island. Locals simply say *Maui no ka oi*, which means "Maui is the best." Visitors will agree after they have experienced the island's wealth of natural and man-made wonders.

Haleakala is the island's centerpiece. High above the rest of Maui, it seems to float in the air, sitting on a blanket of white clouds. Below, green fields of pineapple, sugarcane, and green pastures carpet the lower slopes. These slopes are home to several botanical gardens displaying a rainbow of exotic flowers, charming country towns, and dozens of small farms that grow sweet Kula onions and Irish potatoes. Visitors often are amazed to learn that the not-so-exotic carnation is Maui's leading flower, most of which end up strung in leis around the necks of tourists. The mountain is part of Haleakala National Park, whose primary purpose is to preserve native animals and plants, such as the rare silversword. Found only along the ridges of Hawaiian volcanoes, silversword takes some twenty years to mature, only to bloom once and then die.

Starting before sunrise and lasting into the dusk after sunset, the Haleakala Crater is a spectacular setting. The brilliant blue sky contrasts with red cinder cones and ridges of burnt sienna to make a dazzling palette for artists, photographers, and tourists alike. The crater is larger than New York's Manhattan Island. The volcano last erupted about two hundred years ago, which classifies it as dormant, but not yet extinct.

Across the island, the Mauna Kahalawai volcano created the West Maui Mountains. Among the many hidden treasures inside this range is the beautiful Iao Valley, which is the home of a tiny, magical mountain called the Iao Needle. The needle (actually an erosion remnant) rises twelve hundred feet above the valley floor and is completely covered with lush, emerald green vegetation. Hawaiians named the place, "Asking for Clouds," because of the constantly changing skies and weather around the needle. Four hundred inches of yearly rain make it one of the wetter spots in the islands. A great battle for Hawaiian unification took place here in the late 1700s, but today it is a peaceful place to hike, relax, or take photos—as long as the sun is shining.

If there is a single place that epitomizes Maui's glory days, it is the old whaling town of Lahaina. After unifying the Hawaiian Islands, King Kamehameha the Great established a residence in the small village. Many of his children were born here, including son Liholiho, who made Lahaina the capital of the kingdom for a short time following his father's death in 1819. That same year, Lahaina became a supply port for whaling ships from New England. The *Carthaginian* is a restored nineteenth-century square

◁ *Numerous waterfalls line the Hana highway, which winds for fifty miles from Paia to Hana on the windward side of Haleakala.*
△ *Phalaenopsis orchids are found throughout the islands. There are more than 25,000 species, and at least 100,000 hybrids, of orchid.*

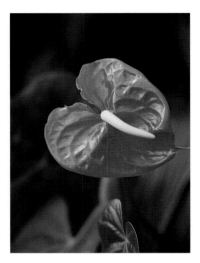

rigger that is tied up at the local marina as a floating museum. The *Carthaginian* is reminiscent of the more than four hundred ships that anchored in the harbor during the height of whaling. Authors Mark Twain and Herman Melville frequented the many bars along Front Street, along with venturesome sailors from those ships.

Today, Lahaina is a national historic landmark and retains much of its Victorian charm in its quaint wooden buildings. Front Street is lined with chic galleries, gourmet restaurants, and trendy shops frequented by tourists. The island also continues to be Hawaii's modern whale capital. Humpback whales arrive each fall and stay until spring, enjoying the sheltered Auau Channel between Maui and nearby Molokai and Lanai Islands. As they frolic, sing, and give birth to their calves, the majestic animals are watched and photographed from small boats.

At nearby Kaanapali Beach, the world's first planned tourist destination, several deluxe resorts now support Maui's endless popularity with tourists. With its legendary sunsets and two miles of golden sand, modern Hawaiians could not have picked a better place. Kaanapali has its own magical location called Black Rock, an outcropping of lava that divides the long beach and makes it an excellent snorkeling spot. Ancient Hawaiian royalty considered the rock a powerful spiritual place from which souls of the deceased departed for their ancestral spirit world.

Maui has many resort areas that have sprung up along the island's beautiful western-facing golden beaches in recent years. At one time or another, places like Makena, Wailea, and Kapalua have been named among the world's best beaches. It is easy to see why when you consider the gentle waters, the view of Lanai Island, and the spectacular sunsets that color this part of the island.

In contrast to its soft-sand sunbathing beaches, Maui is also where the sport of windsurfing was born. Not-so-gentle breezes and lofty waves create some of the world's best windsurfing in places like Hookipa and the sensational Slaughterhouse Beach at Honolua Bay. *Hookipa* means "hospitality" in Hawaiian, but the challenging conditions there are not meant for casual swimming or surfing.

Across the island, hiding along its eastern coast, is the tranquil and remote town of Hana. Located below the windward side of Haleakala, Hana gets about seventy-five inches of annual rainfall, which creates lush green vegetation and numerous waterfalls. Getting there can be exciting.

The Hana highway is a narrow road with more than six hundred tight curves in about thirty miles. If you can avoid banging into local drivers and don't stop along the way, it takes two hours—and a lifetime of concentration—to reach Hana. If you don't stop to enjoy the scenery, though, the road is not much fun to drive. Take your time. There is a beautiful waterfall for every one of the fifty-six cramped bridges that must be crossed.

Visitors who drive to the end of the road find a lush rain forest and the tiny Palapala Hoomanu Church. Charles Lindbergh, the famous aviator, lies at rest in a courtyard that overlooks the beautiful sea. Nearby are the Seven Sacred Pools, which actually number anywhere from three or four to more than a dozen, depending on rainfall and where you start to count.

Famous entertainers and political personalities often can be seen walking along Hana's few streets or shopping at Hasagawa's General Store. Residents are a mix of outsiders trying to escape the outside world, and about fifteen hundred real Hawaiians. Tourists meet a lot of friendly people who will take a moment to say hello and pass the time talking about everything you *can't* find in Hana.

The town is pretty much the same slow, isolated place it has been for the past century. Hana's charm is its tranquility and its natural beauty. Those who survive the Hana highway usually agree that the scenic drive and sleepy destination are like no place on earth. Just like the rest of Maui. This "discovery" comes as no surprise to the locals, who have already declared, *"Maui no ka oi."*

△ *Anthurium, with its wax-like blossoms, is Hawaii's most popular exotic plant. It lasts as long as three weeks after cutting.*
▷ *A torch lighter stands on black lava rocks at Wailea Beach. Set on Maui's southwest side, the area enjoys spectacular sunsets.*

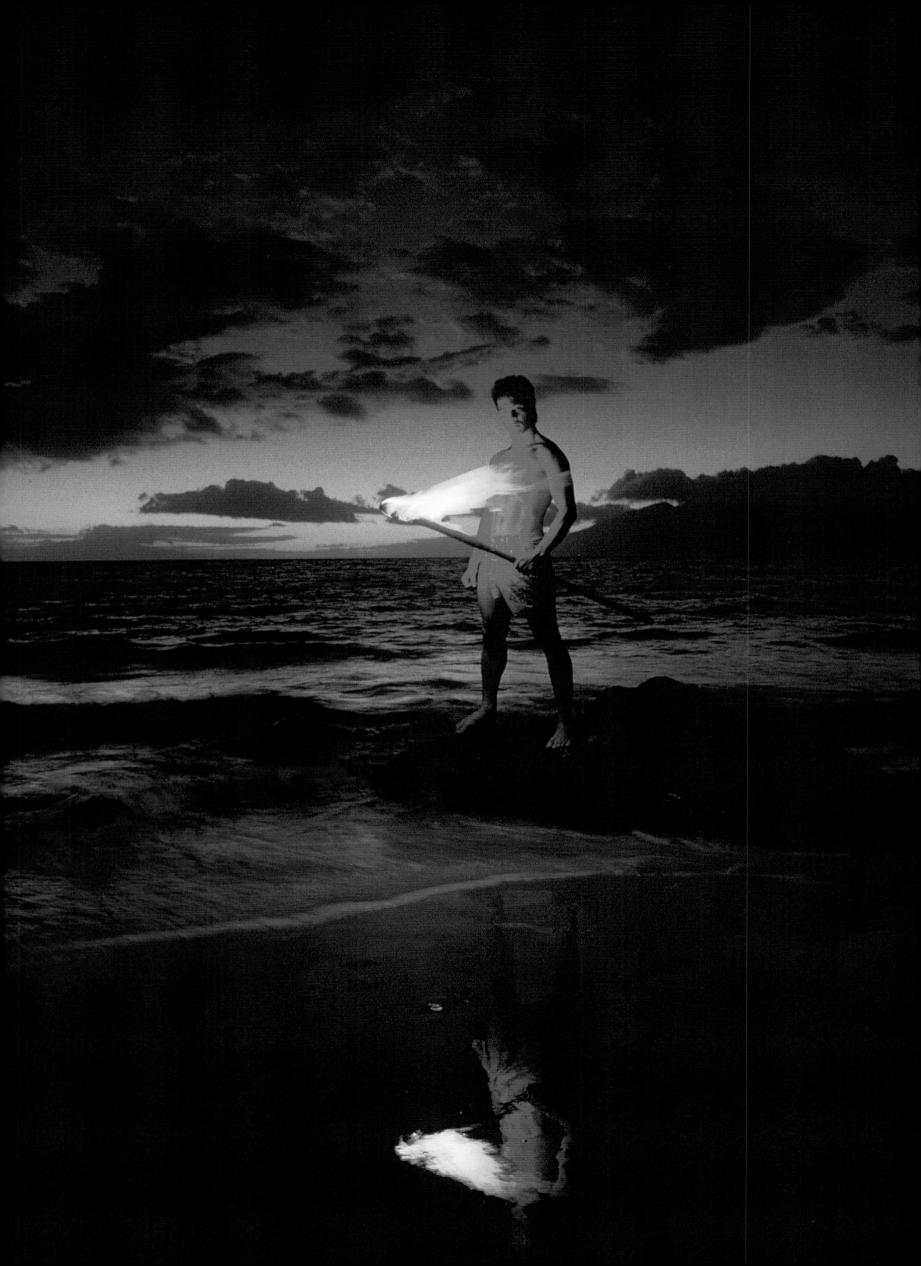

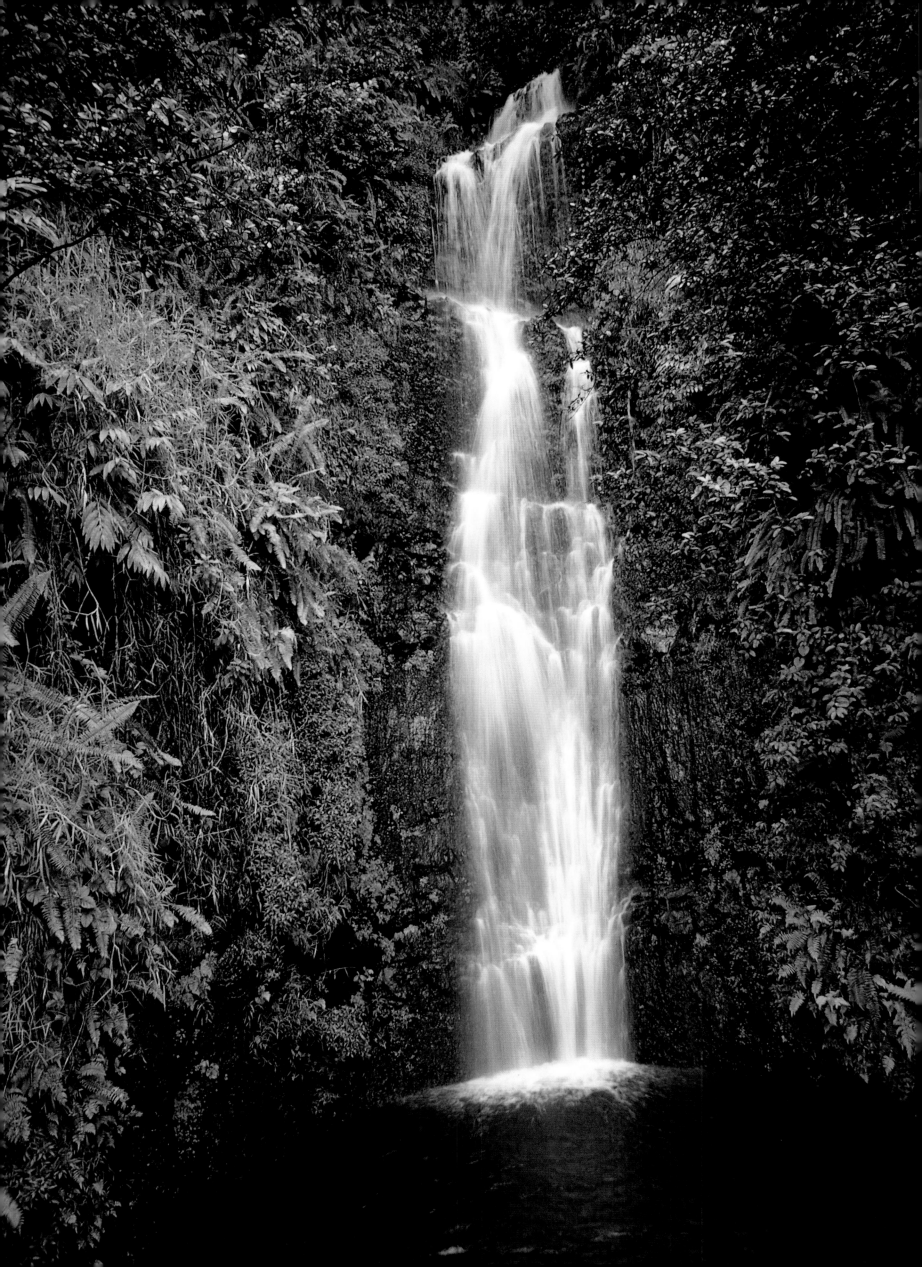

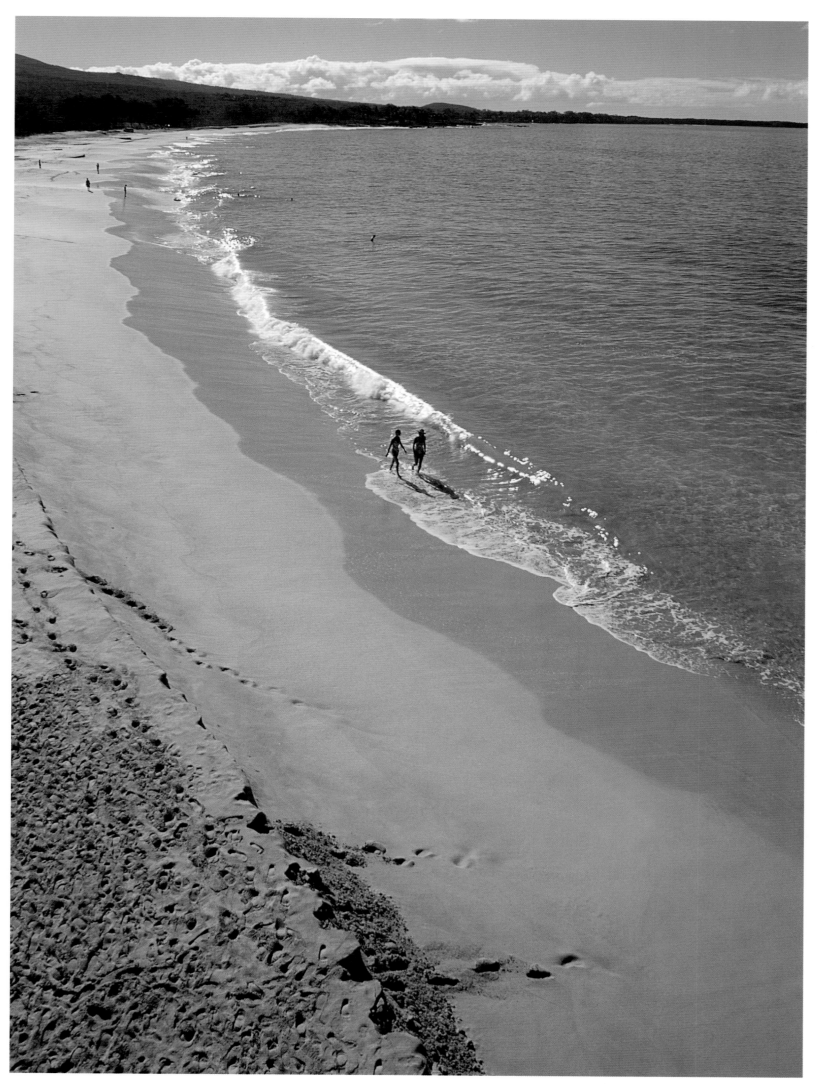

◁ The Hana highway, lined with countless waterfalls, contains 617 curves and 56 one-lane bridges.

△ Maui's Big Makena Beach is also known by Hawaiians as *Oneloa Beach,* meaning "long sands." It is three thousand feet long.

▷ ▷ A powerful winter wave crests behind lava rocks along Maui's Maliko Bay.

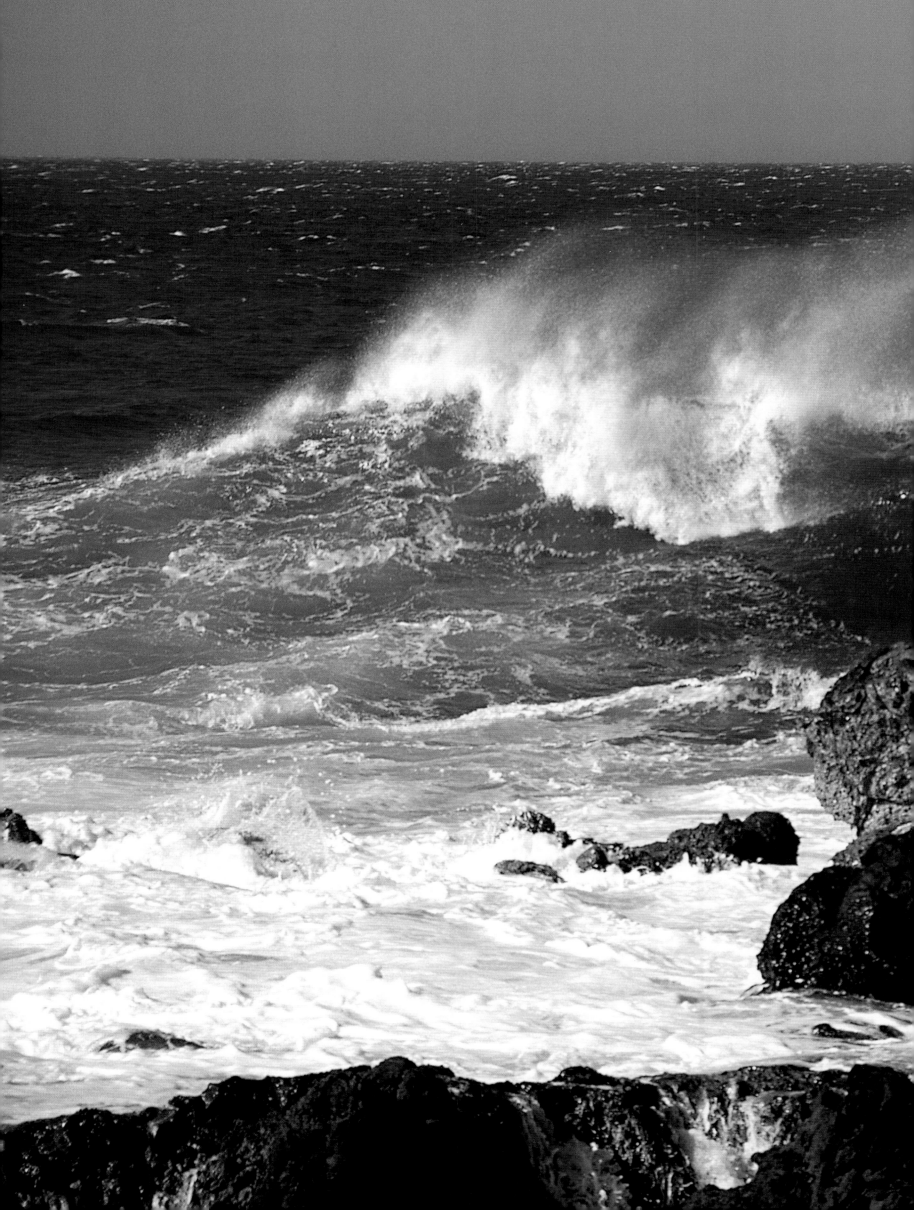

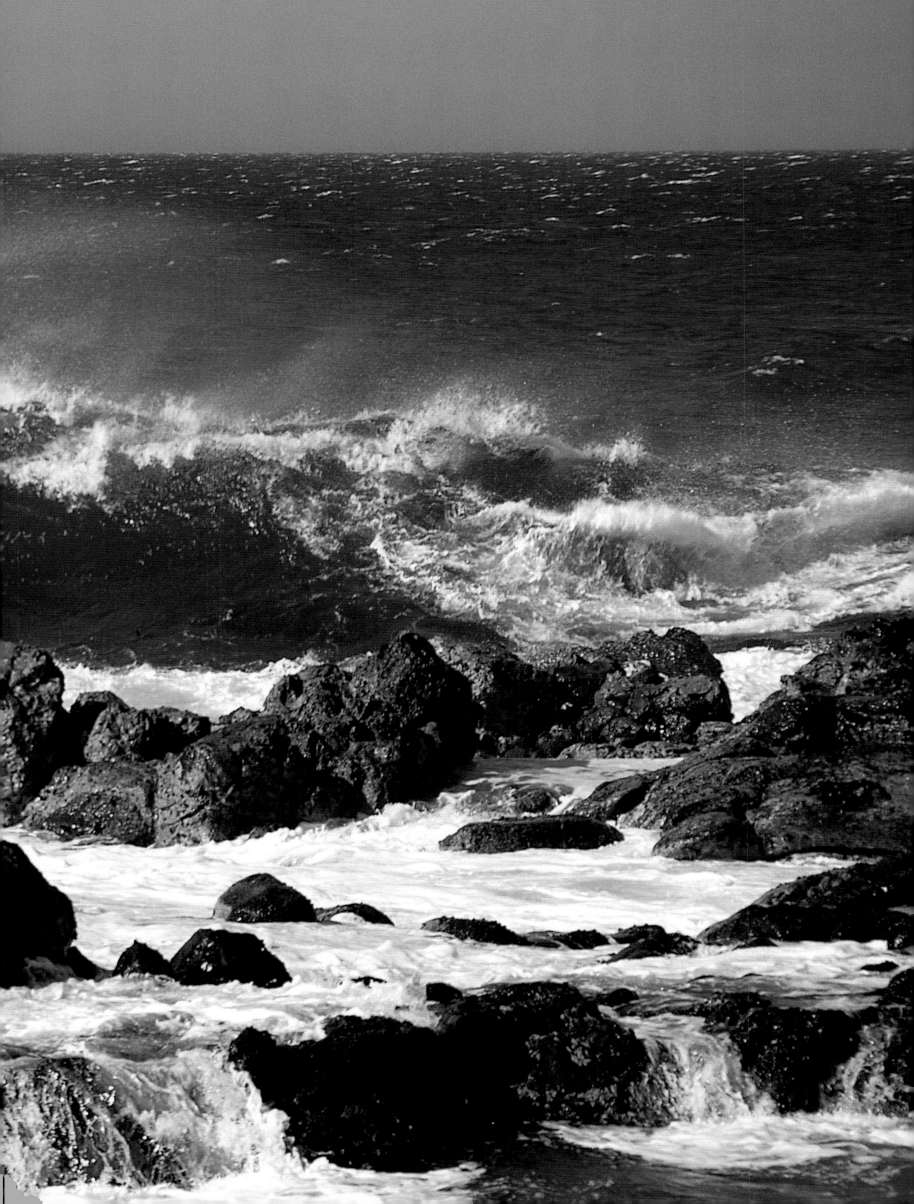

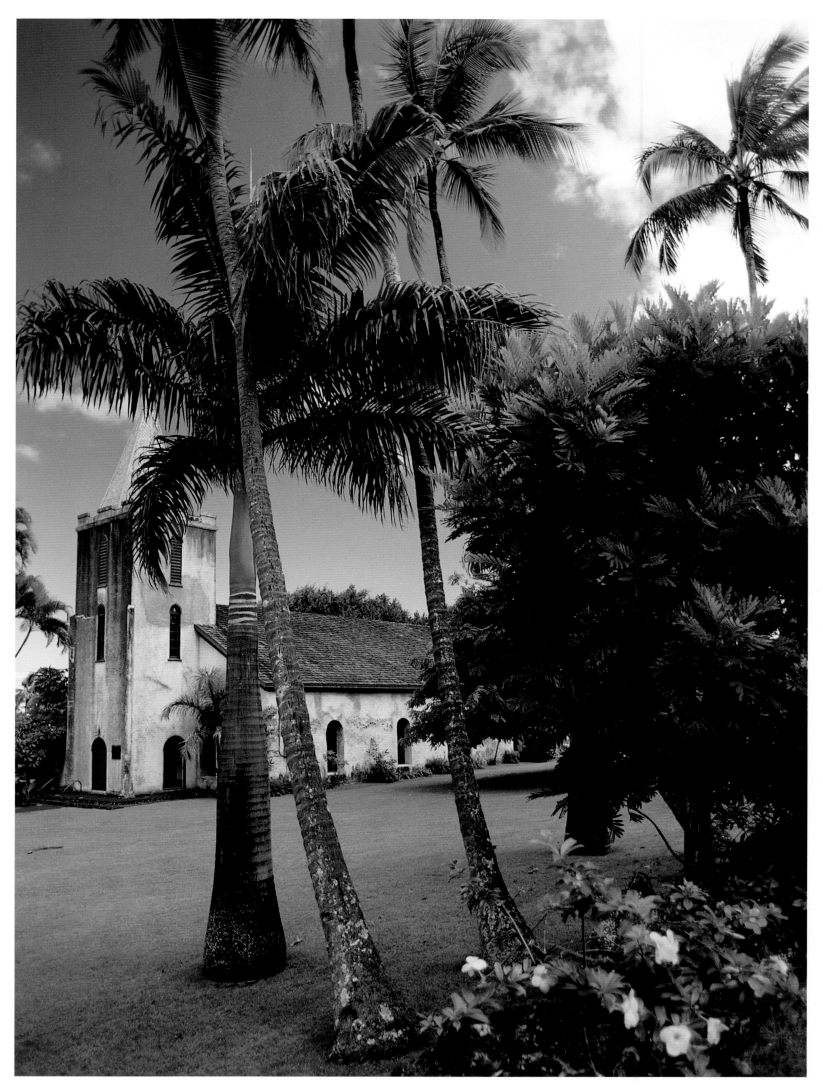

△ The Wananalua Church, completed in 1857, sits quietly beside the road as you enter the village of Hana.
▷ A rocky outcrop divides Makena Beach from Little Makena.

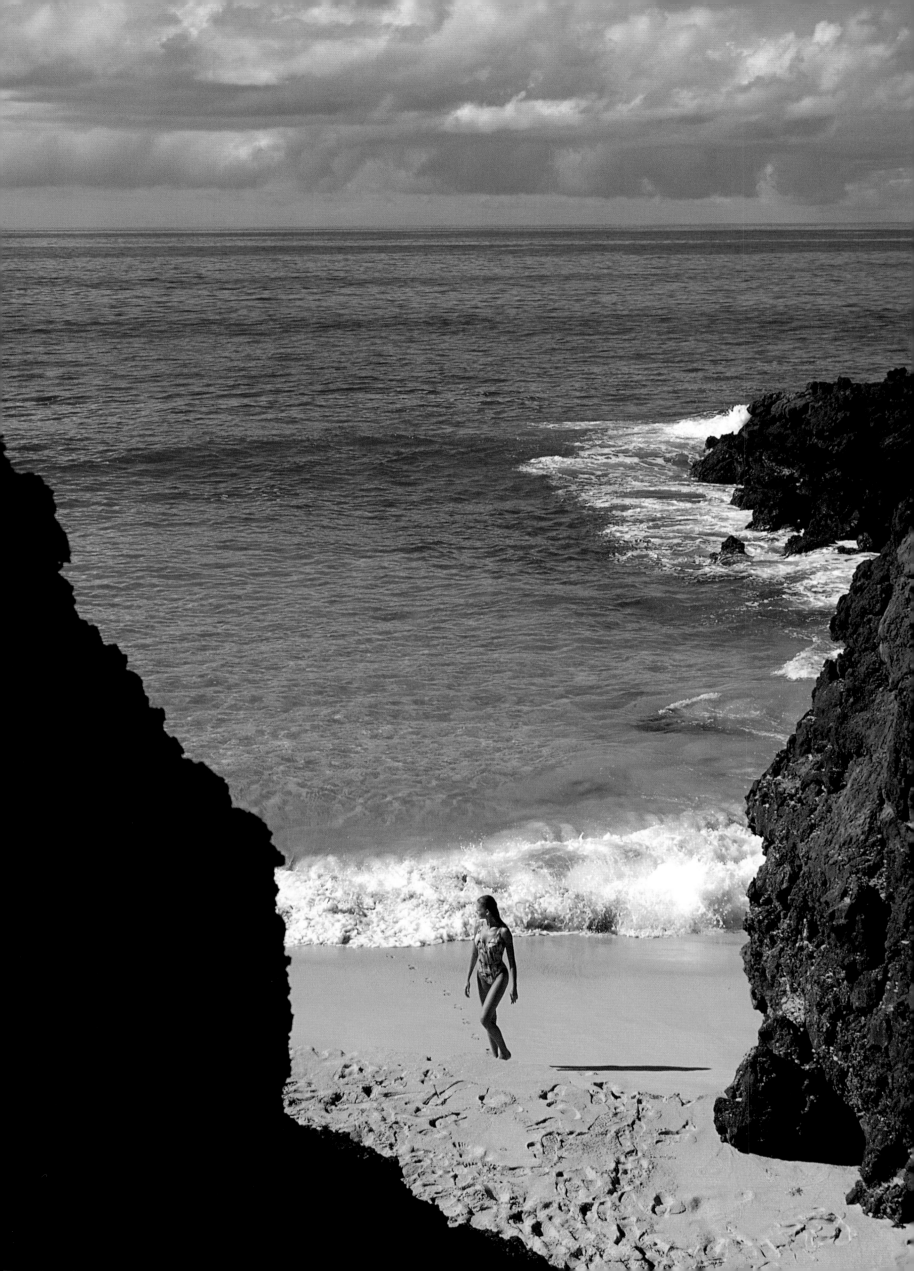

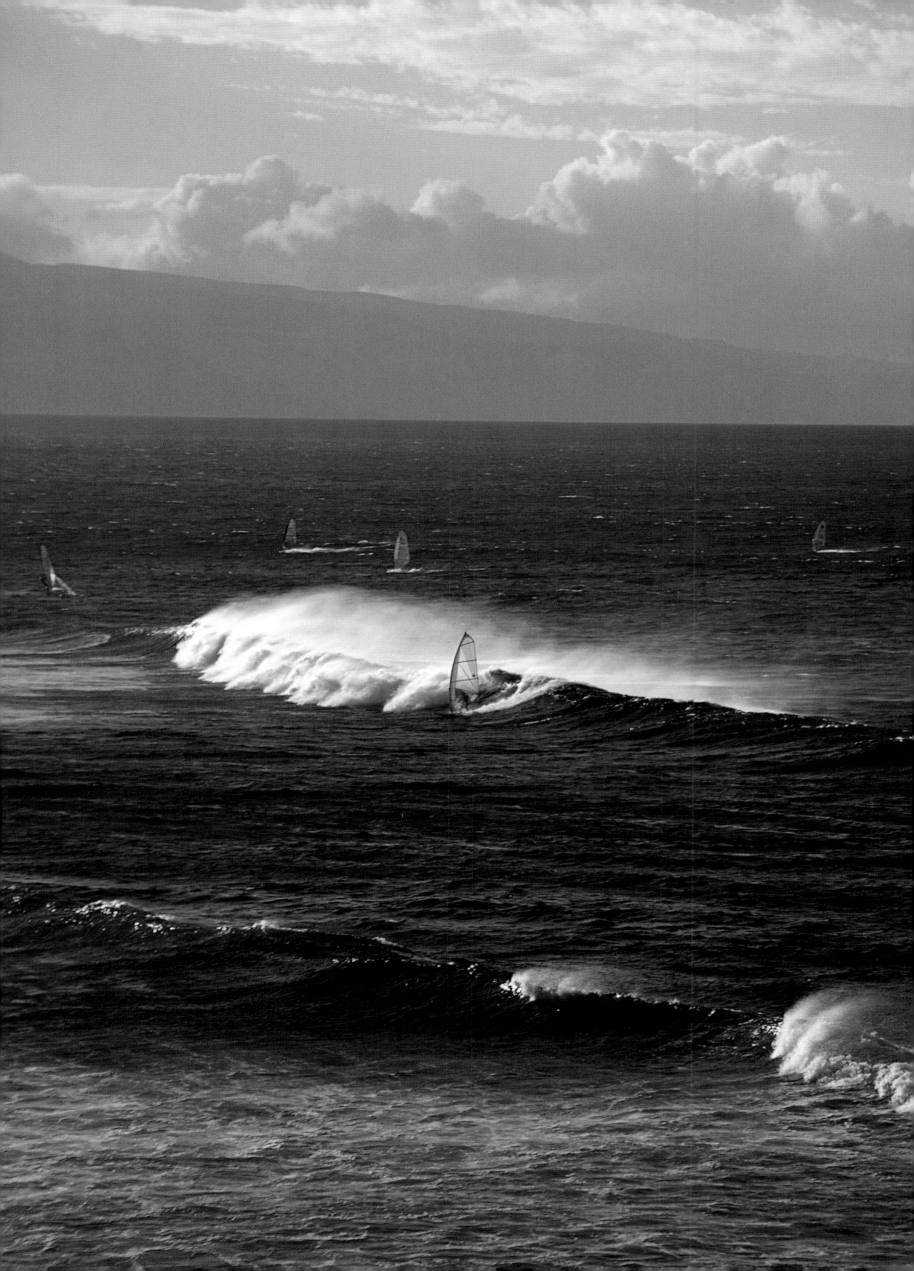

◁ Clouds of floating sea mist, known as *ehukai,* are created by brisk winds and large winter waves. Windsurfers from around the world flock to Maui during the winter, headquartering in the nearby town of Paia.

▽ Looking across from Kaanapali Beach to the island of Molokai, a lone catamaran tests its daring against the white-capped waters of the Pailolo Channel that runs between Maui and Molokai.

▽ Carp, edible freshwater fish
originally from Europe and
Asia, swim in a Maui pond.
Popular throughout the islands,
these colorful fish are treasured
for their sense of tranquility.

▷ A cruise ship sails at sunset
between the Hawaiian islands.
The sloop *Maile,* which departs
from the Big Island, and
the vintage steamship
SS *Independence,* which sails
from Honolulu's Aloha Tower,
both offer cruises through
the Hawaiian archipelago.

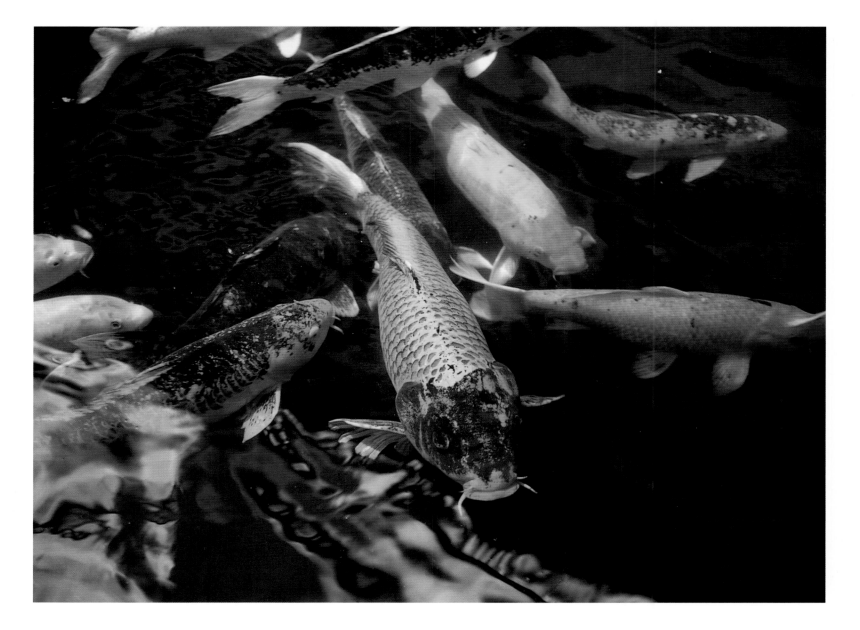

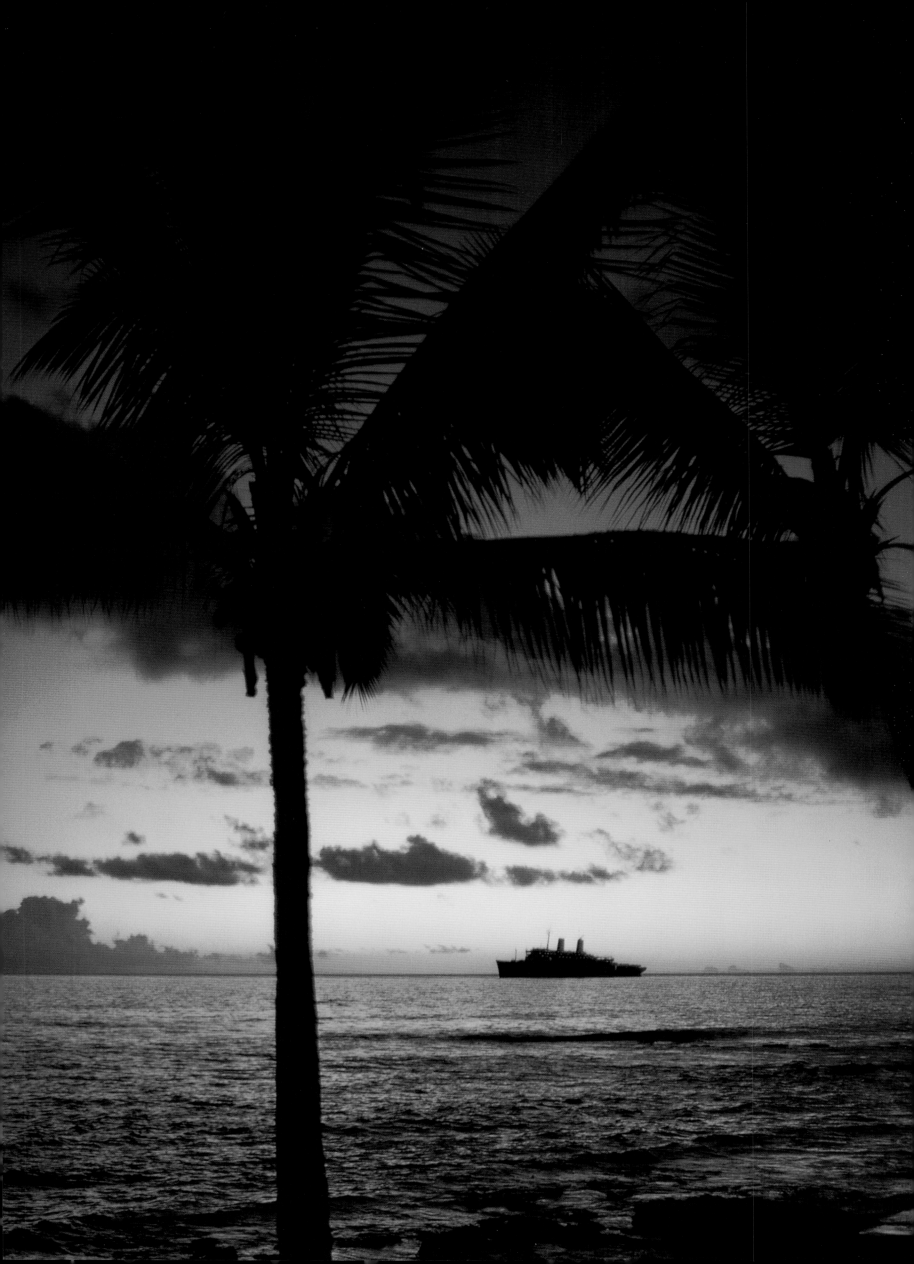

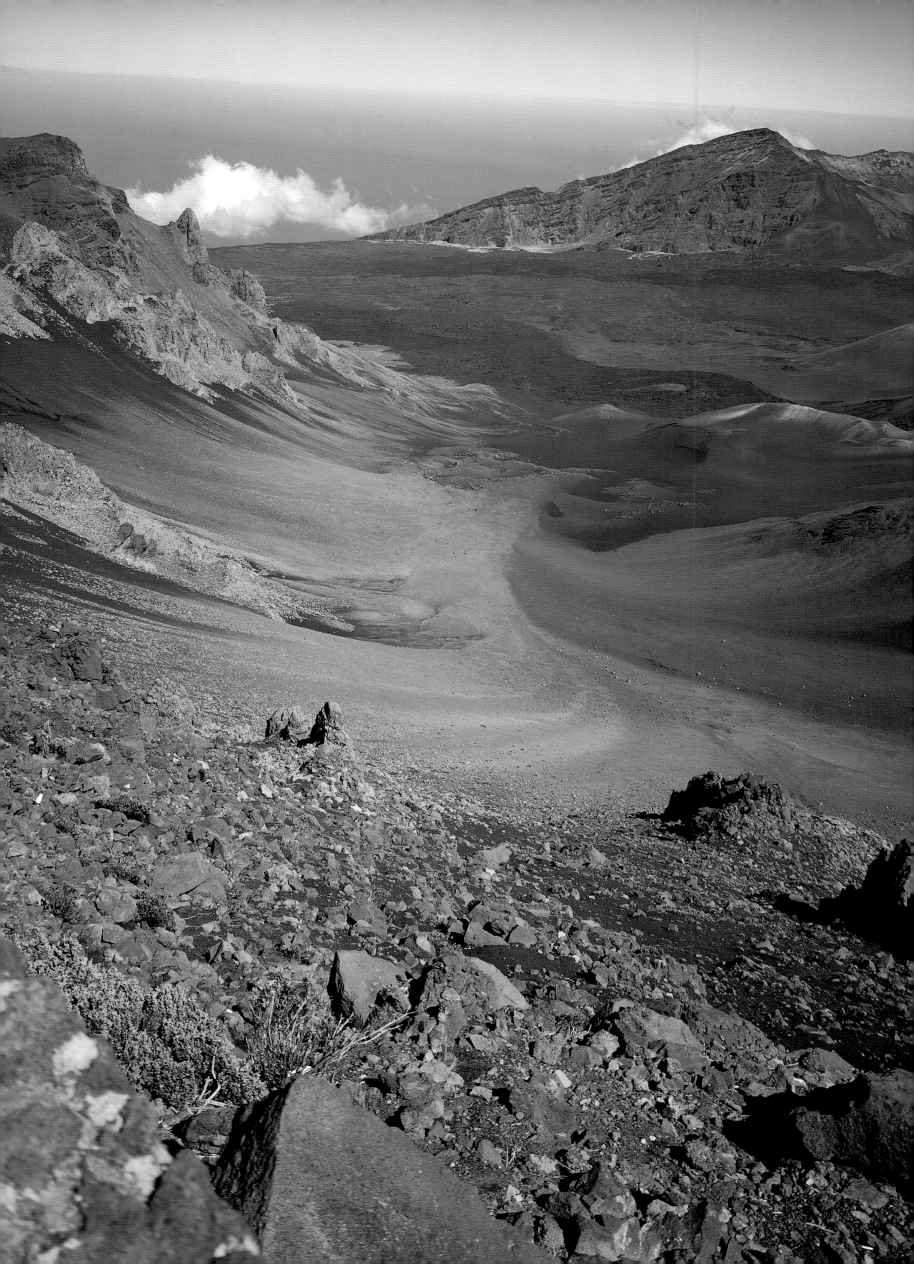

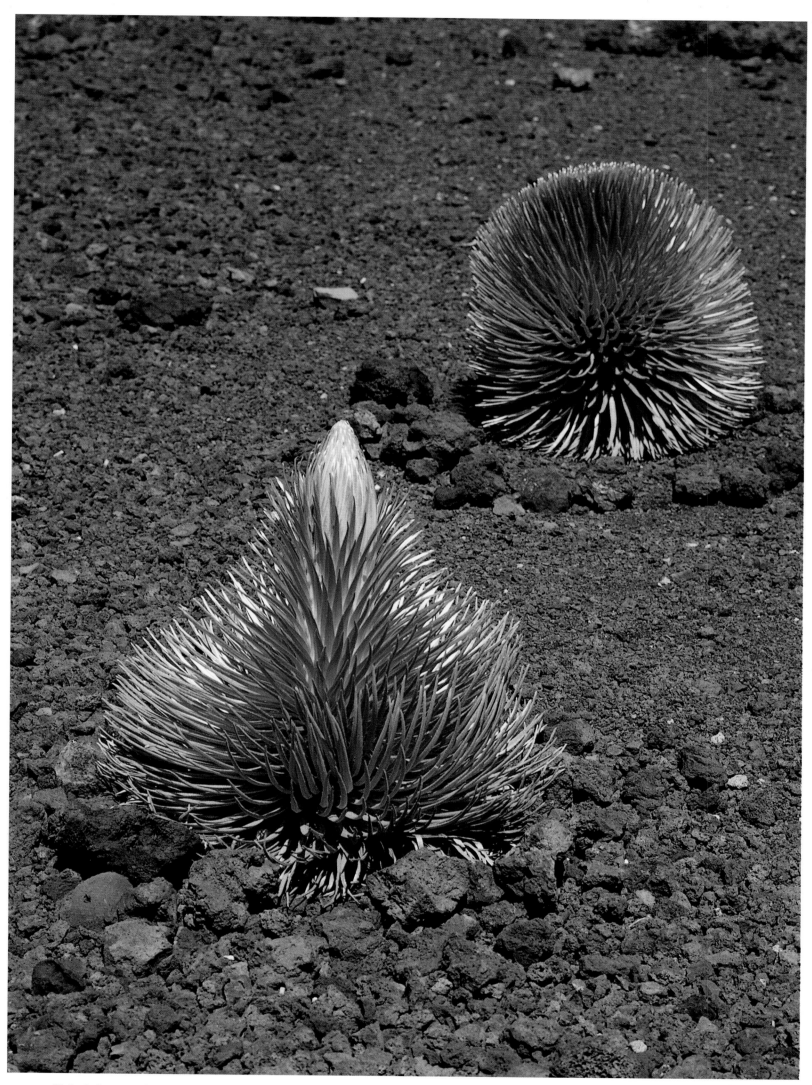

◁ *Haleakala,* meaning "House of the Sun," is classified as a dormant volcano. Its last eruption is thought to have been in 1790.
△ The endangered silversword plant grows only in Hawaii. It blooms once and then dies.

△ Moss-covered rocks nestle in seashell-filled sand in the shallow waters at Maui's Kuau Cove.
▷ Just off the Hana highway at Kuau Cove, the Mama's Fish House outrigger canoe sits under towering palms.

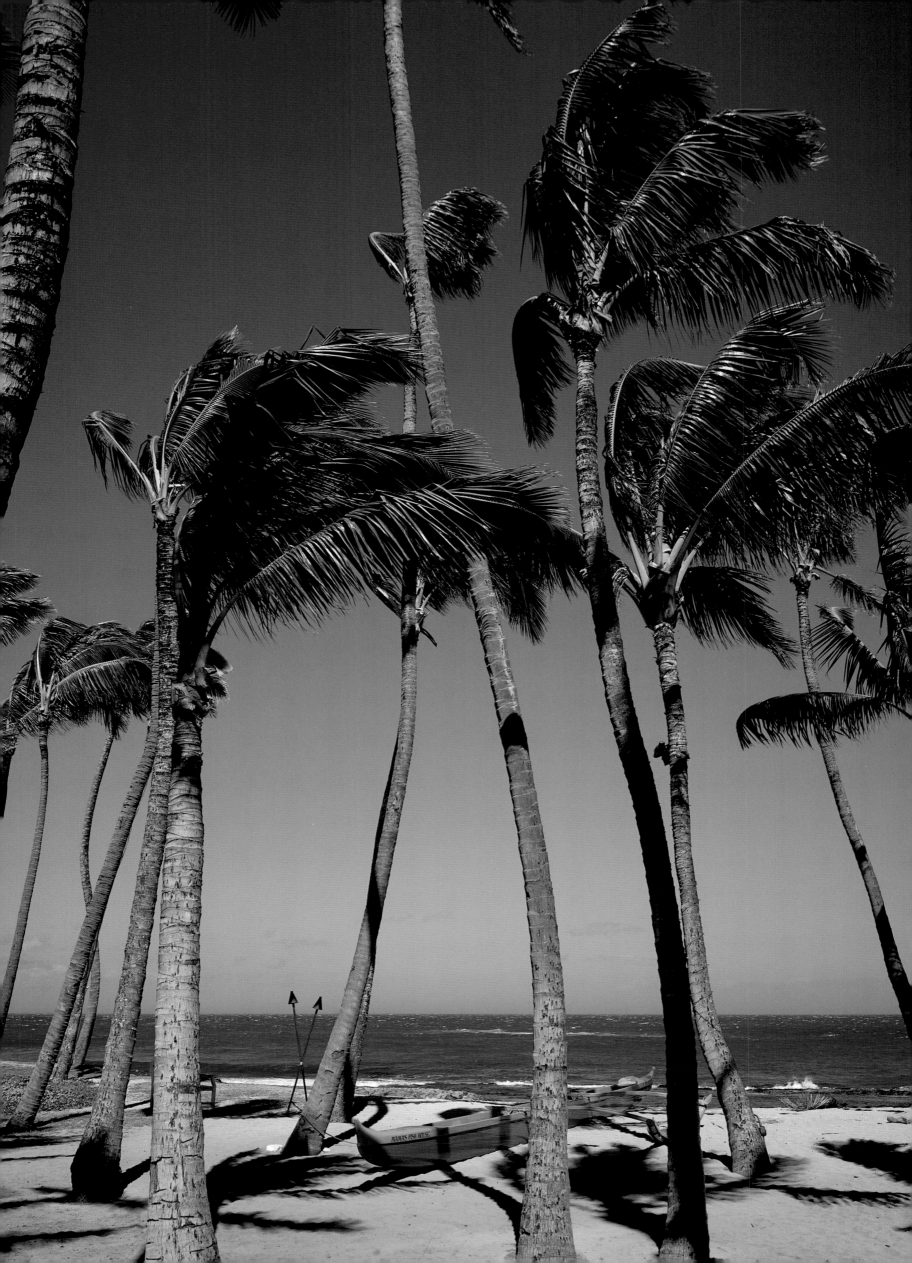

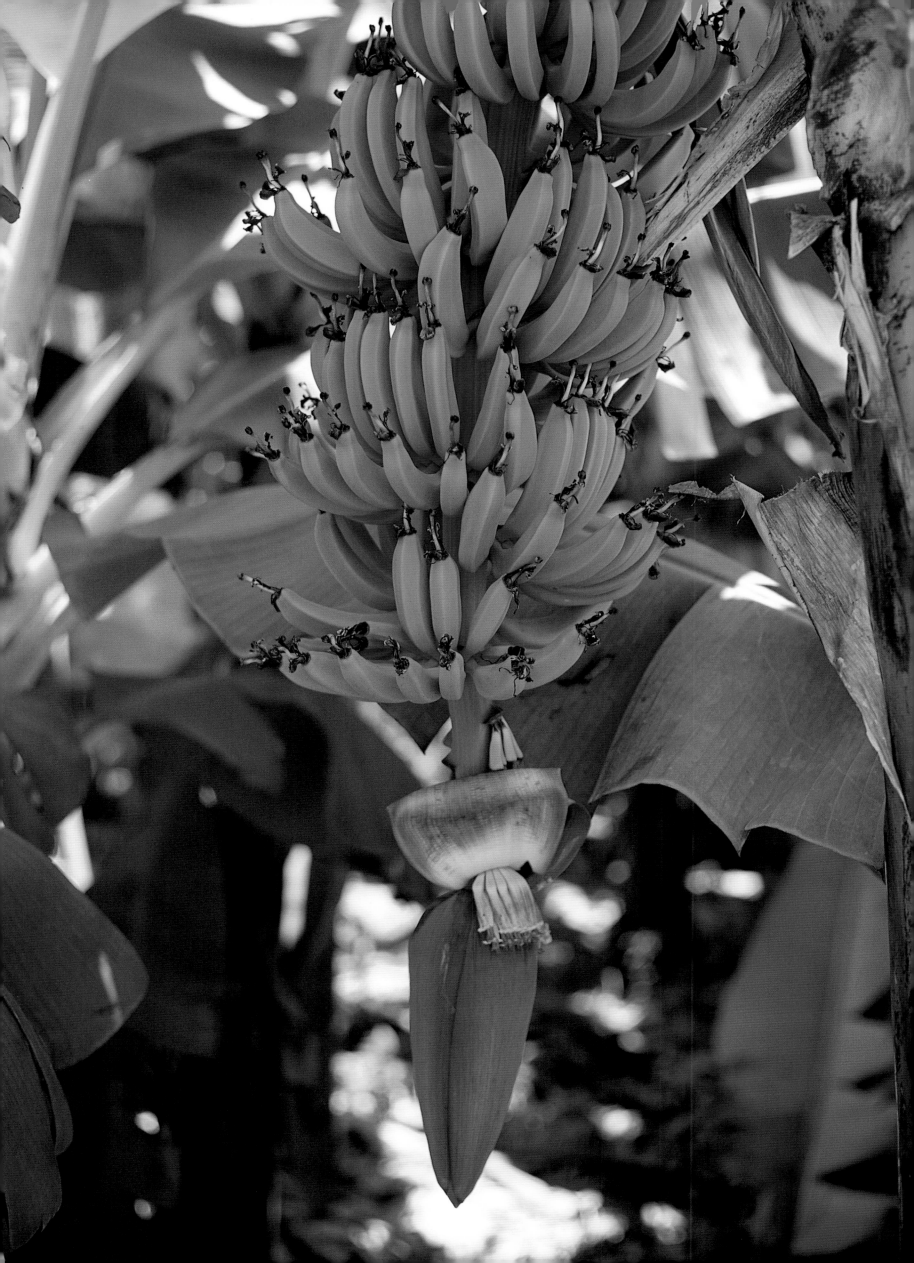

◁ The flowering banana is a tree-like tropical plant that bears one bunch, then dies. It is then replaced by another plant that grows from new shoots around the base.

▽ A colorful outrigger canoe sits on the sand at Maipoeina Oe Iau Beach Park, looking across Maalaea Bay at the hillside of West Maui. On the arid leeward side of East Maui, this park is part of the community of Kihei.

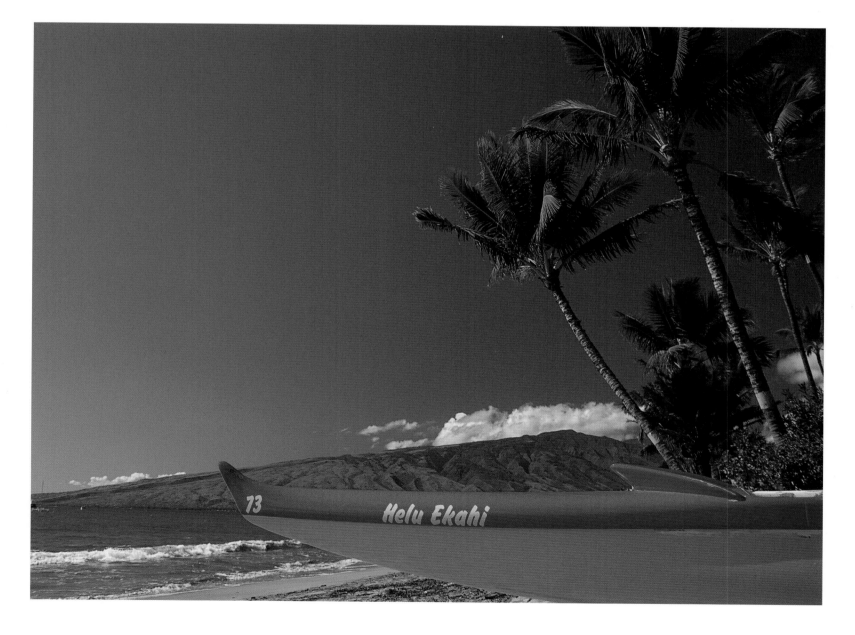

▽ The tombstone of legendary aviator Charles A. Lindbergh is engraved with the words, "If I take the wings of the morning . . . and dwell in the uttermost parts of the sea." These words capture the spirit of the first man to fly alone across the Atlantic Ocean, and the essence of Hana, the serene and spiritual community where he settled.

▷ With excellent waves and strong winds, Maui has what many consider to be Hawaii's best windsurfing.

▷ ▷ Makena Beach is a great place to swim, surf, sunbathe, and enjoy the view of Lanai.

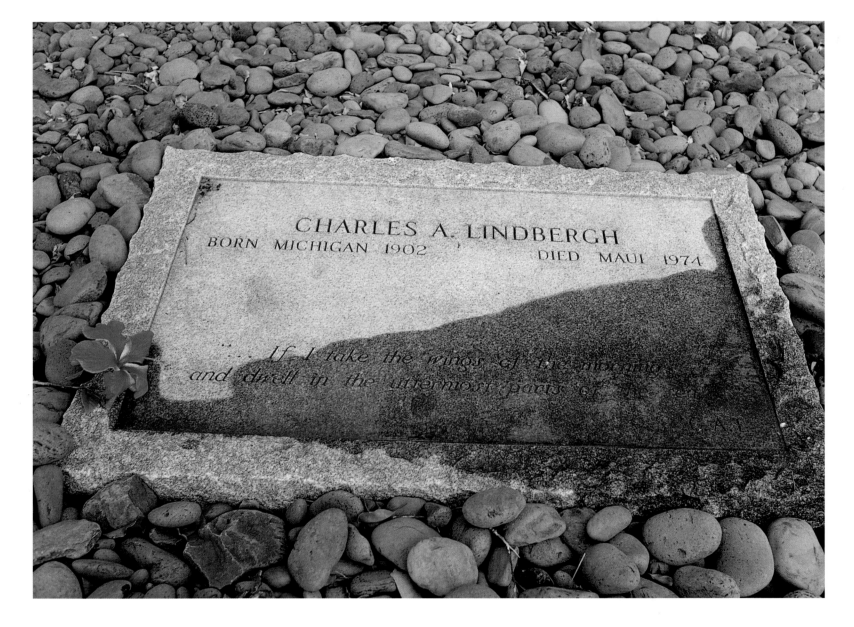

CHARLES A. LINDBERGH
BORN MICHIGAN 1902 DIED MAUI 1974

. . . If I take the wings of the morning . . . and dwell in the uttermost parts of the sea . . .

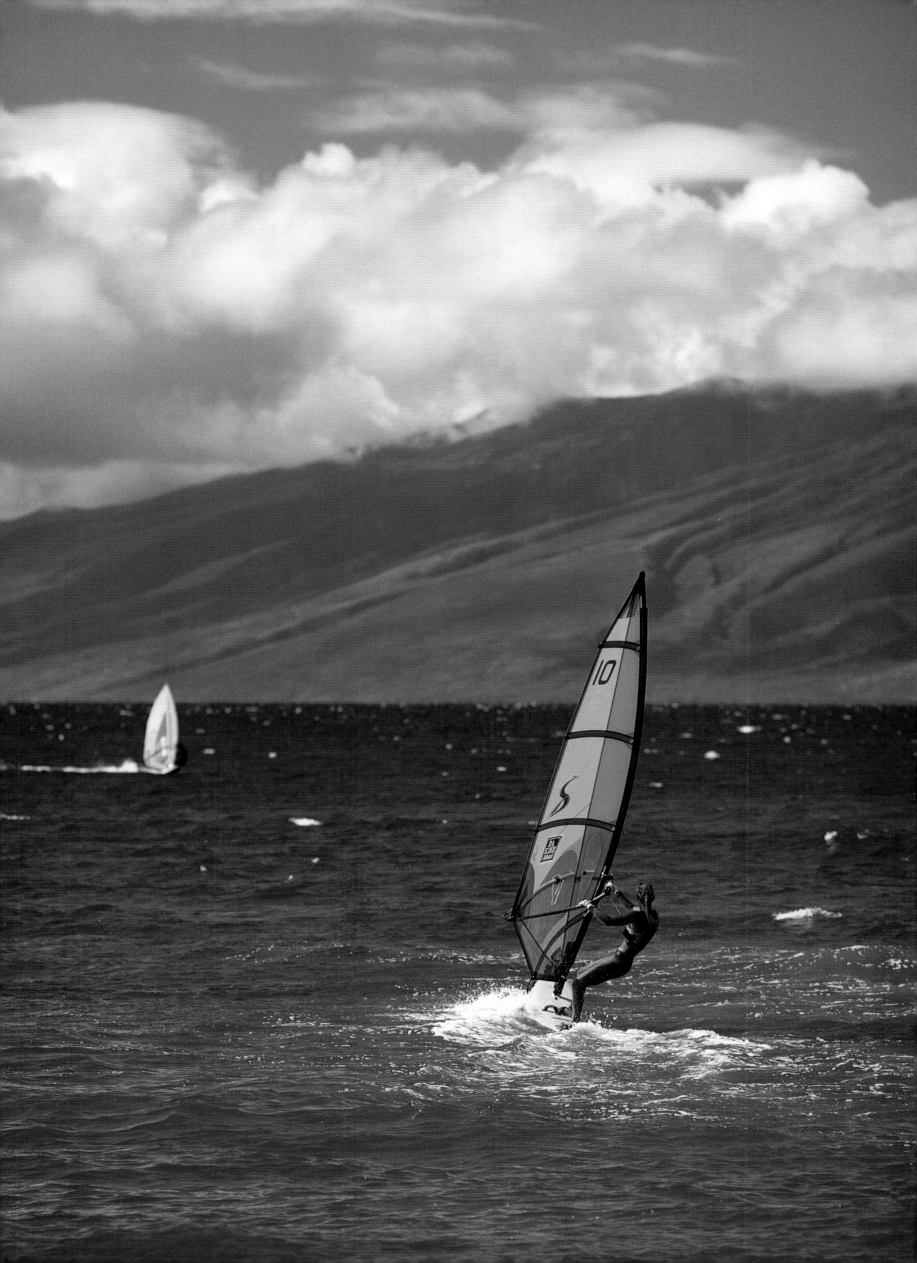

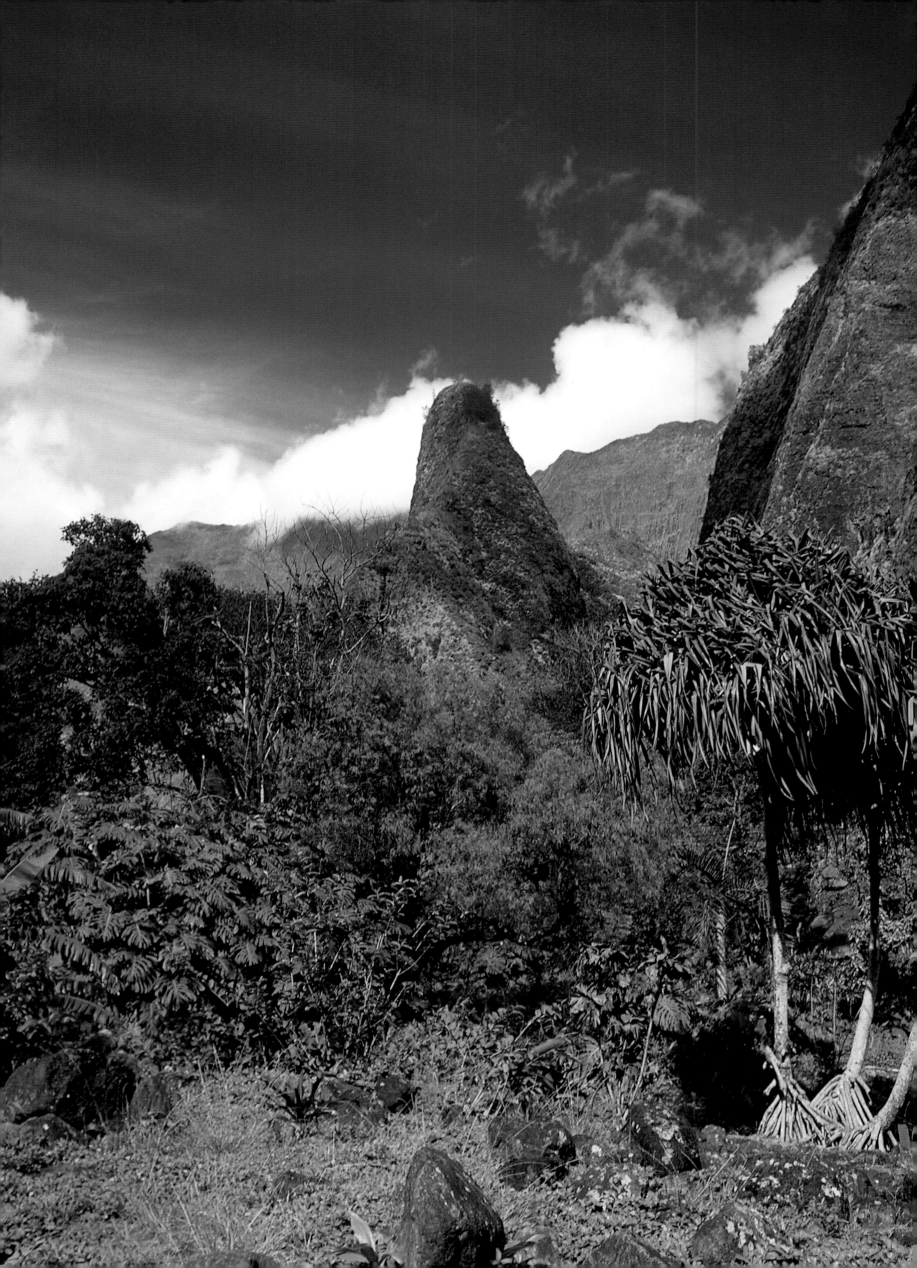

◁ Iao Needle rises twelve hundred feet from the valley floor. Situated in Iao Valley State Park in West Maui, the Iao Needle is the centerpiece of the crater left by the volcano that created this part of the island.

▽ While missionaries tried to stop all traditional Hawaiian customs, outrigger canoe racing and surfing survived and thrived. The Molokai to Oahu Canoe Race, an international paddling competition, is held each year in October.

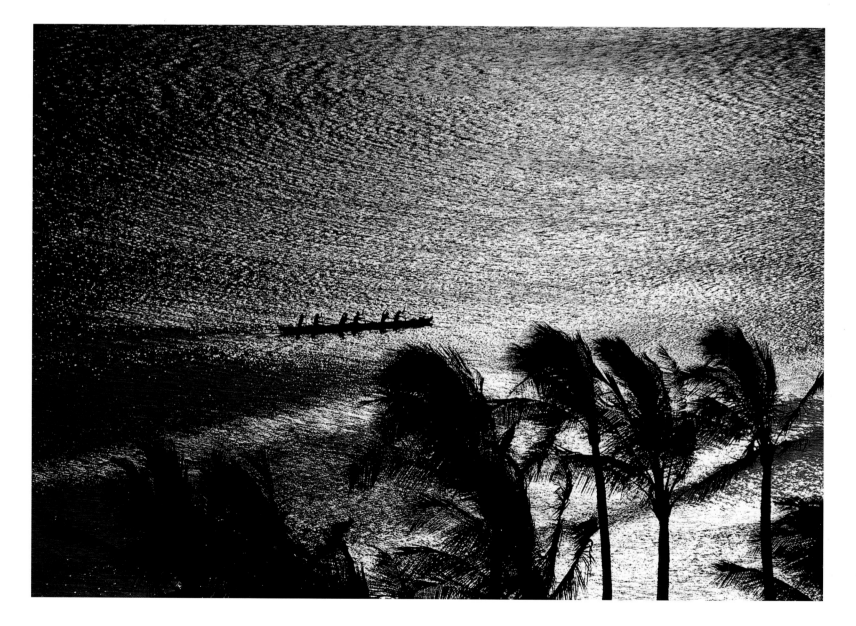

▽ A humpback whale's tail, or fluke, rises from the water off the coast of Maui. An estimated two hundred to six hundred humpback whales visit the islands between November and the end of May each year.

▷ The use of conch shells as trumpets was referred to in Greek mythology. Polynesians brought the tradition with them and used a *Charonia tritonis*, or "Triton's trumpet," for signaling.

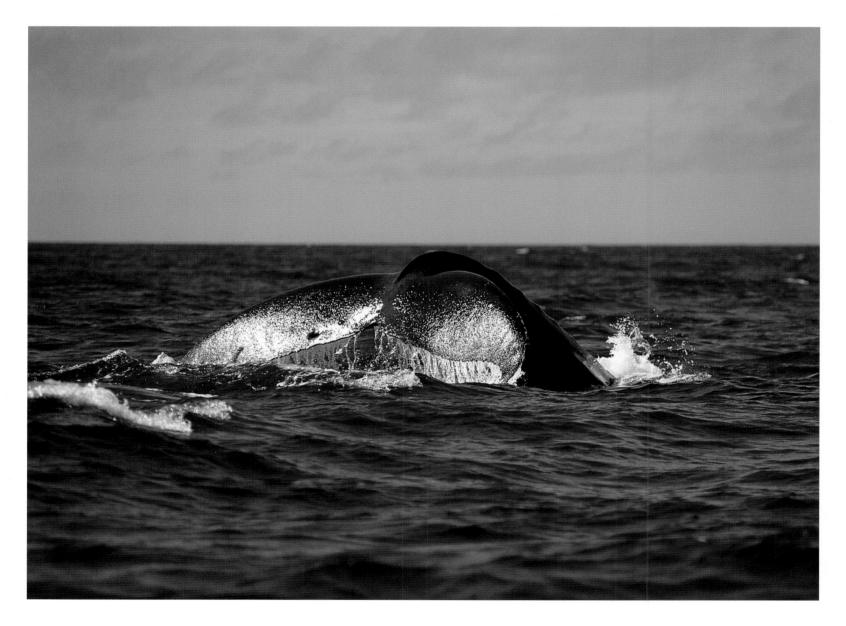

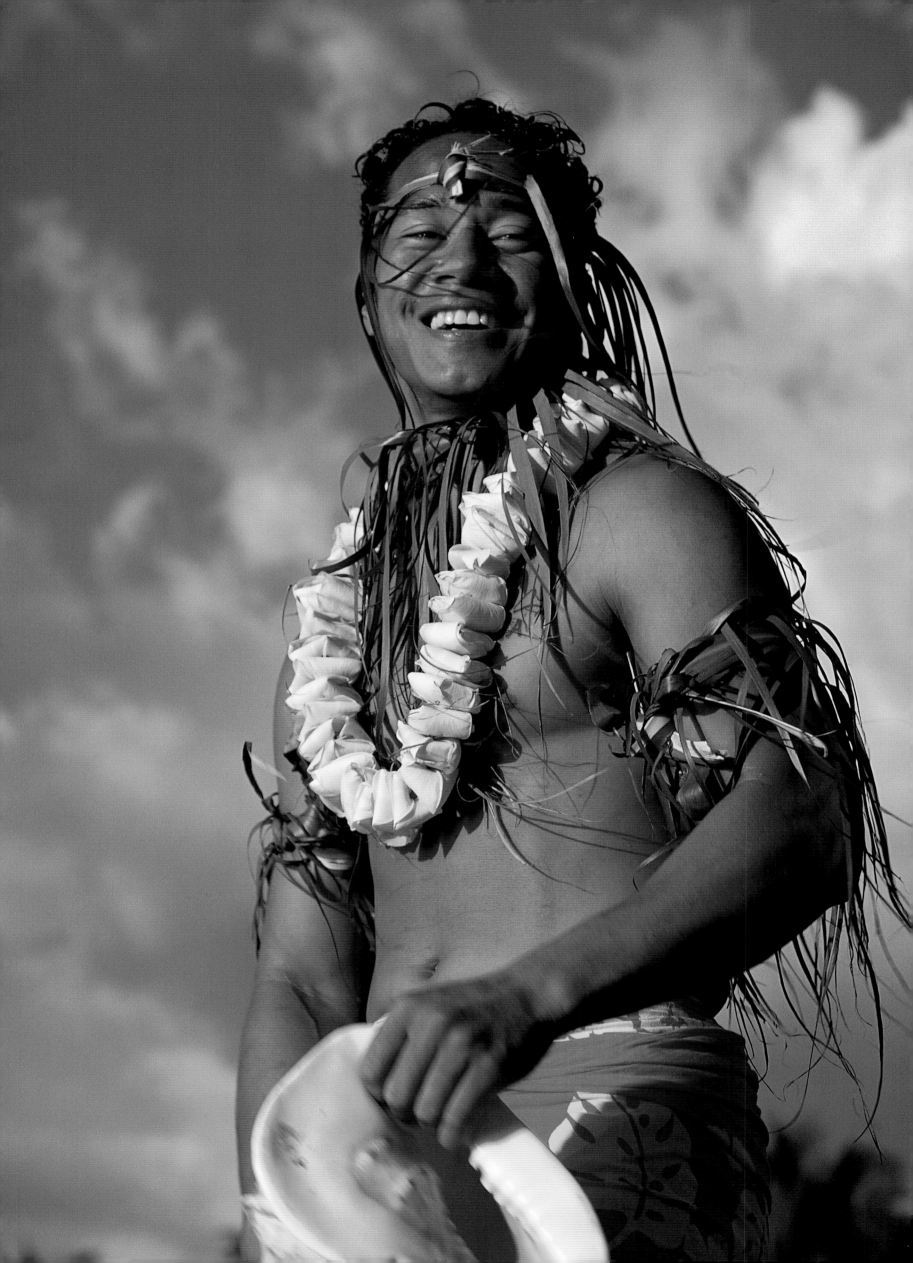

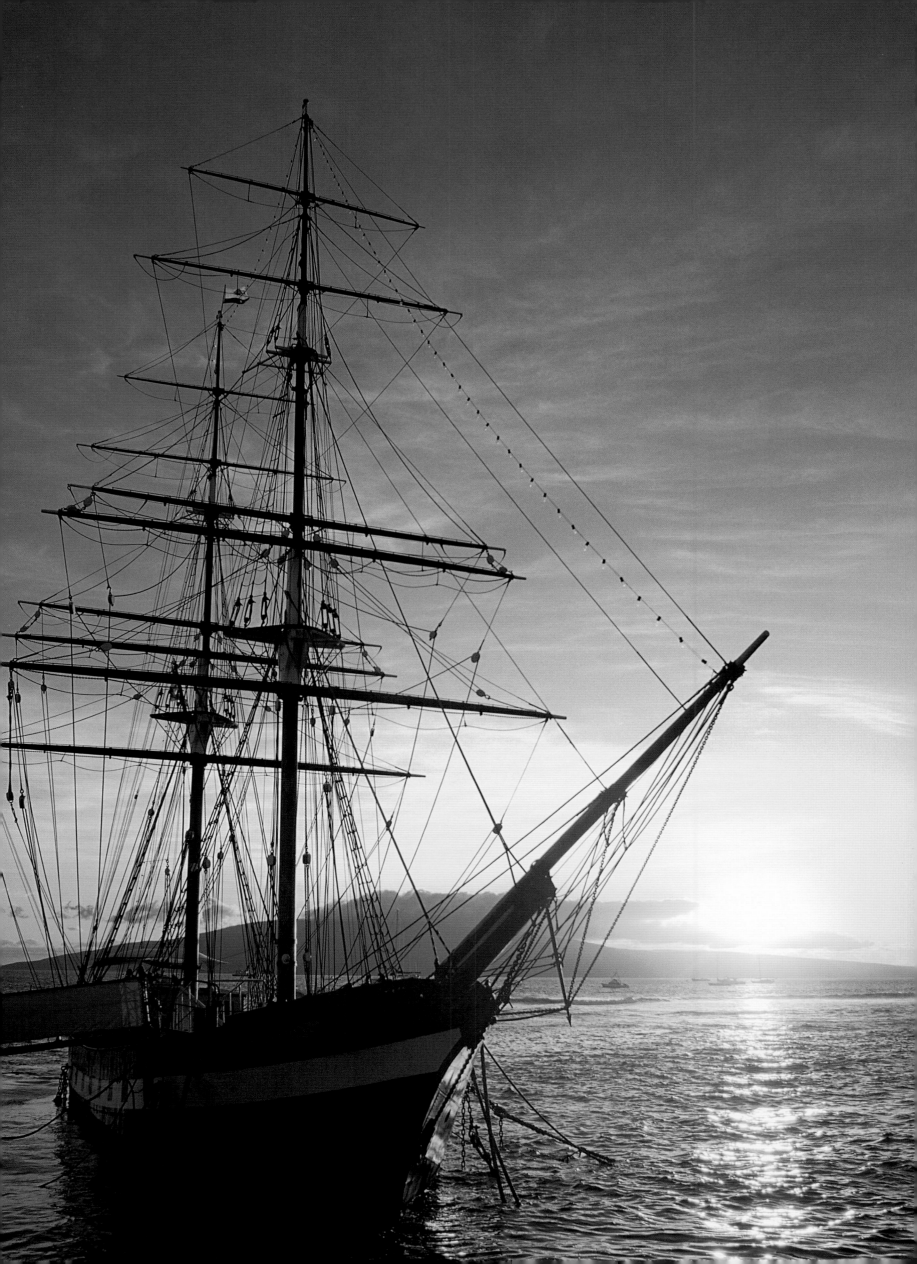

◁ A reminder of Lahaina's colorful heyday as the center of America's Pacific whaling fleet, the *Carthaginian* is the world's only true rigged brig. Bought in 1972 by the Lahaina Restoration Foundation, the two-masted schooner, built in Germany in 1920, was turned into a replica of a nineteenth-century square rigger and became a floating museum.

▽ A catamaran lies off the shoreline of Makena as the isle of Lanai looms behind.

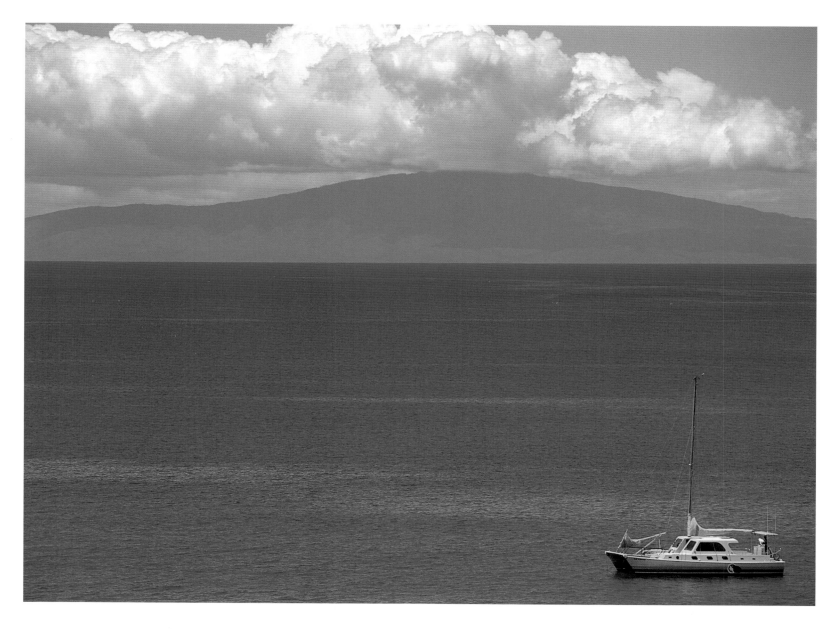

▽ Designated a National
Historic Landmark since 1962,
buildings such as these,
perched along the water's edge,
are part of the attraction of
West Maui's Lahaina.

▷ A sugarcane worker stands in
a field in central Maui.
Once a major crop for Hawaii,
sugar has been in decline for
many years. Land that once
was used for sugarcane now
produces other crops, such
as the sweet Maui onions.
Up country, Maui also grows
tropical flowers, including
bird of paradise, anthurium,
heliconias, and protea.

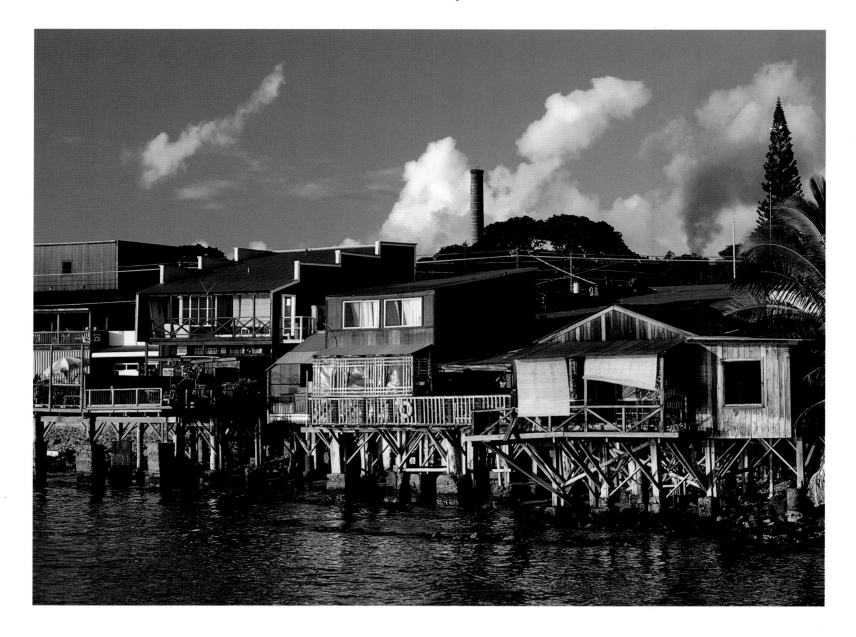

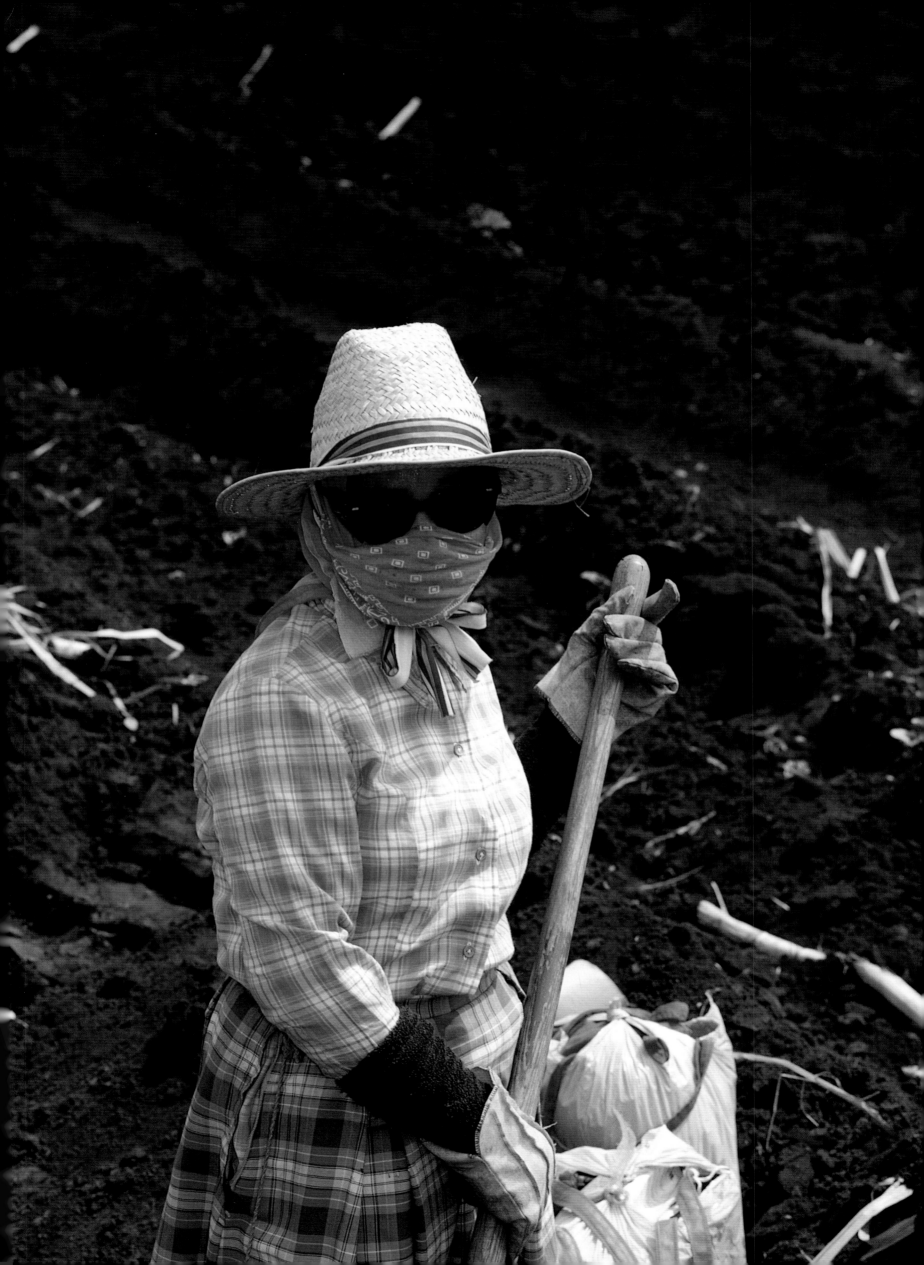

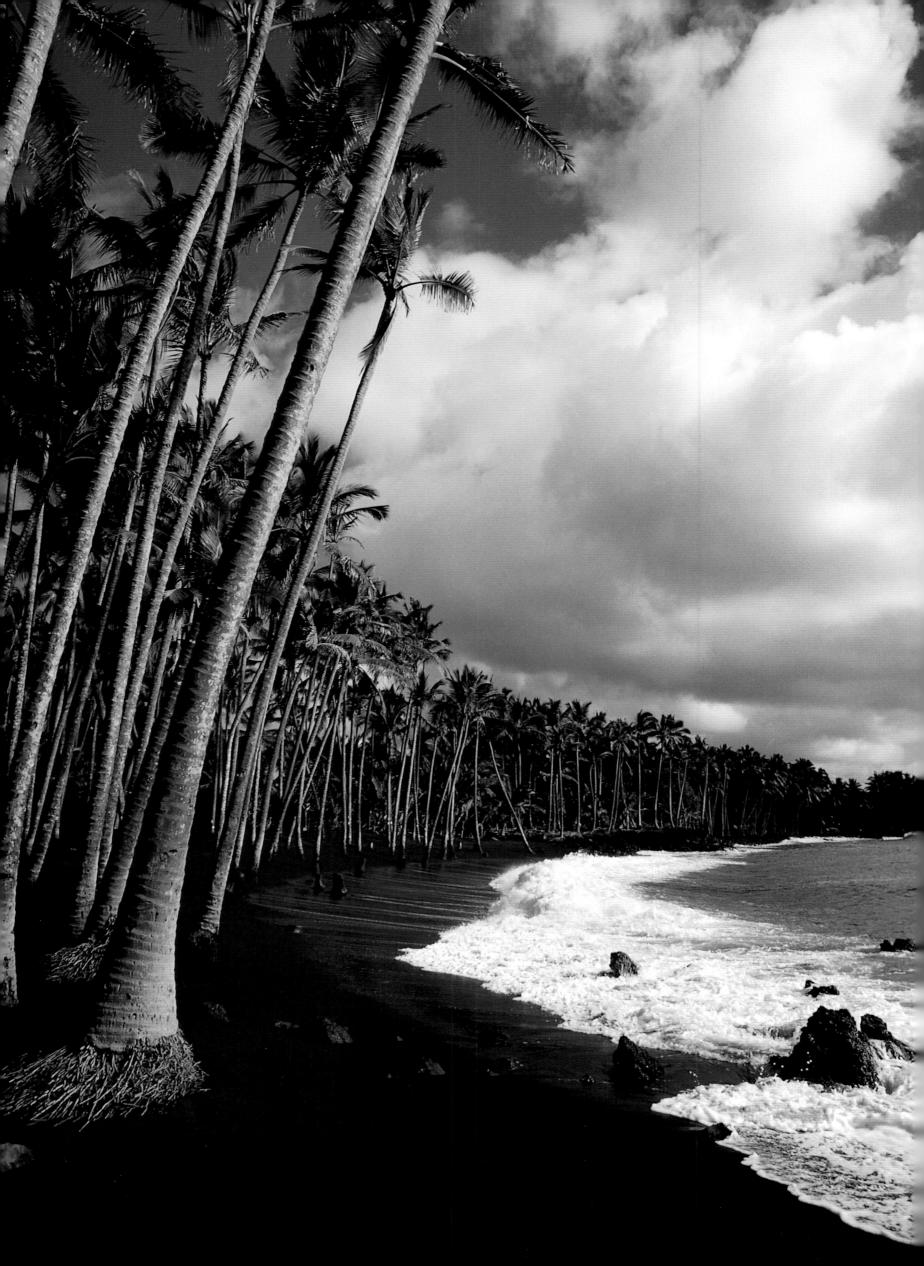

Big Island

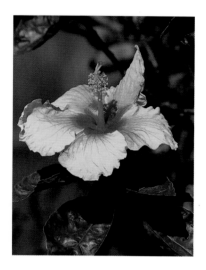

Long ago, when the Polynesians first landed on this huge island of steaming volcanoes, they called their new home "Hawai'ia," meaning the burning Hawaii. Today, the island of Hawaii is known simply as the "Big Island." The island lives up to its name in every way. Twice the size of all the other Hawaiian Islands put together, the Big Island is the largest island in the Pacific Ocean—and with continuing volcanic activity, it continues to grow each day. The vast and unmatched diversity within its shores has prompted promotional efforts to call it such things as "The Orchid Isle," "The Volcano Island," and the "Paniolo (cowboy) Island." While each of these labels describes an important part of this amazing place, none is big enough to do the job.

A mere million or so years old, the Big Island is a youngster compared to its sibling islands, which range in age to upwards of twenty million years. Like many children, this island has not yet decided what it wants to be when it grows up. There are several options to consider.

Nothing on the Big Island is small, beginning with the great volcanoes of Mauna Loa and Kilauea, which compose Hawaii Volcanoes National Park. *Mauna Loa,* the "Long Mountain," is the most massive mountain on earth, measuring thirty-two thousand feet from its sea-floor base to its summit and containing more than ten thousand cubic miles of material. When its sister volcano, Kilauea Iki Crater, erupted in 1959, it sent a molten geyser soaring two thousand feet into the air, the highest lava blast ever recorded. Orange-hot lava has been flowing steadily from Kilauea since 1983, a record for volcanoes.

Across the island, Mauna Kea dominates the landscape, especially during the winter when its snow-covered peak lives up to its Hawaiian name, "White Mountain." Towering 13,796 feet above sea level, the top of Mauna Kea is the highest point in Hawaii and the highest point in the entire Pacific Ocean Basin. Air at the summit is clear and cool, which makes it perfect for astronomical observation. Mauna Kea is the best place in the entire Northern Hemisphere for gazing into the heavens. Giant telescopes, operated by astronomers from several countries, dot the barren landscape of lava and cinder cones. The world's most powerful telescope is here, at the Keck Observatory.

Below Hawaii's majestic heights, a variety of landscapes and climates coexist on the Big Island. Most prominent are the deep green rain forests, with their sparkling and lofty waterfalls, that surround the charming harbor city of Hilo on the eastern shore. Under a deluge of approximately 130 inches of rain each year, Hilo is the wettest city in the United States. In return for the copious rainfall, the island yields a bounty of tropical fruit, and endless gardens of exotic orchids and flaming anthurium seem to float amid a sea of sugarcane fields and pasture lands. When the sun shines, it brings billowing white clouds, blue skies, and a multitude of rainbows. As we travel south, the lush vegetation eventually melts away into the blackness of volcanic residue. To the north, cattle graze in the luxuriant, deep emerald valleys of cowboy country.

The blazing sun and a dry, desert landscape dominate the western coastline. Extraordinary resorts in Kona and Kohala draw tourists to their warm tropical climate and the deep blue waters of the Pacific. The city of Kailua-Kona is filled with a variety of shopping boutiques and restaurants, and is noted for its coffee, its sunsets, the night life, and the thousand-pound marlin that may be caught offshore.

Just south of Kona, the small, rural city of Captain Cook is blessed with cool, moist air, an abundance of sunshine, and absorbent volcanic soil. The island's famous coffee plantations and macadamia-nut farms are found here. The surrounding hillsides are lined with Polynesian-style villas, which house writers, artists, and corporate executives trying to escape the stress of the big cities on the U. S. mainland. Far below these slopes, the Bay of

◁ *Kilauea Volcano on the Big Island sends lava flows into the sea, creating black sand beaches such as this one at Kalapana.*
△ *There are numerous varieties of hibiscus, the floral emblem of Hawaii.*

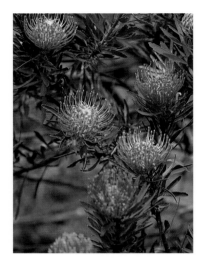

Kealakekua is where Captain James Cook, the city's namesake, met his demise. A state marine-conservation district, the bay is a favorite for snorkeling and scuba diving.

One of Hawaii's most sacred and spiritual places is only a few minutes away. Known as the "Place of Refuge," *Puuhonua O Honaunau* is where criminals and violators of the royal *kapu* once sought sanctuary. Set along a beautiful cove and painstakingly restored, this sacred village is the resting place of several ancient chiefs. The lava rocks here are said to cause great amounts of *mana,* or spiritual power.

Near the Place of Refuge, St. Benedict's Painted Church is a reminder of the arrival of new religions in Hawaii a century ago. The inside of the chapel is painted with scenes from the Bible, which allows visitors who are unable to read English to understand the missionaries' message.

The road leading north from Kailua-Kona cuts its way through the flows of old lava, looking like a moonscape. Every few miles, an oasis of coconut palms announces the entrance to one of Kohala's resort destinations. A generation ago, imaginative land-developers purchased huge plots of seemingly useless, nearly inaccessible coastal territory from the owners of the nearby Parker cattle ranch. To create some of the world's finest luxury resorts, they brought in fresh water and golden beach sand; built secluded bungalows, opulent hotels, and gourmet restaurants; and constructed challenging, emerald green golf courses.

Above Kohala, the Parker Ranch still looks and operates much the same way it did in the 1880s, when New Englander John Palmer Parker domesticated wild cattle and sheep that had been ravaging royal property. King Kamehameha gave him two acres for the task. The ranch is a little larger today, running some fifty thousand head of cattle over two hundred thousand acres of green pasture nestled along the slopes of Mauna Kea. Parker coined the word *Paniolo* for his cowboys, which the Hawaiians used to describe the Spanish-speaking imported ranch hands. The small cow town of Waimea is the center of activity in the ranch area. It is also called *Kamuela,* Hawaiian for "Samuel," who was one of the early Parkers. Waimea is a quiet place that supports the ranch business, with a ranch museum and a steak house.

Although the Big Island is not very well known for its beaches, the few it does have are equal to its other natural wonders. They range in color from coal black, to gray, to golden, to *green.* In the bright afternoon sun, recently created volcanic black sand beaches are nothing short of spectacular. Such beaches regularly appear and disappear according to the fickle lava flows from which they are spawned. Several old-flow black sand beaches along the west coast require a jeep, boat, or helicopter to reach. Their privacy has made them a favorite for skinny-dippers and *au naturel* sunbathers. The island's largest beach is a huge expanse of natural golden sand along the Kohala Coast at Hapuna State Park. Most tourists are content to enjoy the smaller man-made beaches and pools at the major resorts.

The Big Island has played a very important role in the history of the Hawaiian Islands. The island was the birth place of Hawaii's greatest king, Kamehameha the Great, and where he began his quest to unite all Hawaiians. The Hawaiian Islands have witnessed an extraordinary history of human and geologic evolution and development. Geologically, most of the islands are now complete. In contrast, the Big Island is still growing. With each passing day, the island's physical wonders expand and change, offering new marvels to be discovered and explored. Hawaiians and outsiders alike, especially those with cameras, often have the pleasure of watching many of these changes as they take place. More than a few people have pondered what manner of beauty and wonders will exist fifteen or twenty million years from now when the Big Island of Hawaii finally reaches the current age of its lush brothers and sisters.

△ *The stunning orange pin cushion protea makes a striking addition to any flower arrangement.*
▷ *Golf courses along the Kohala Coast wind their way through harsh, dramatic lava flows.*

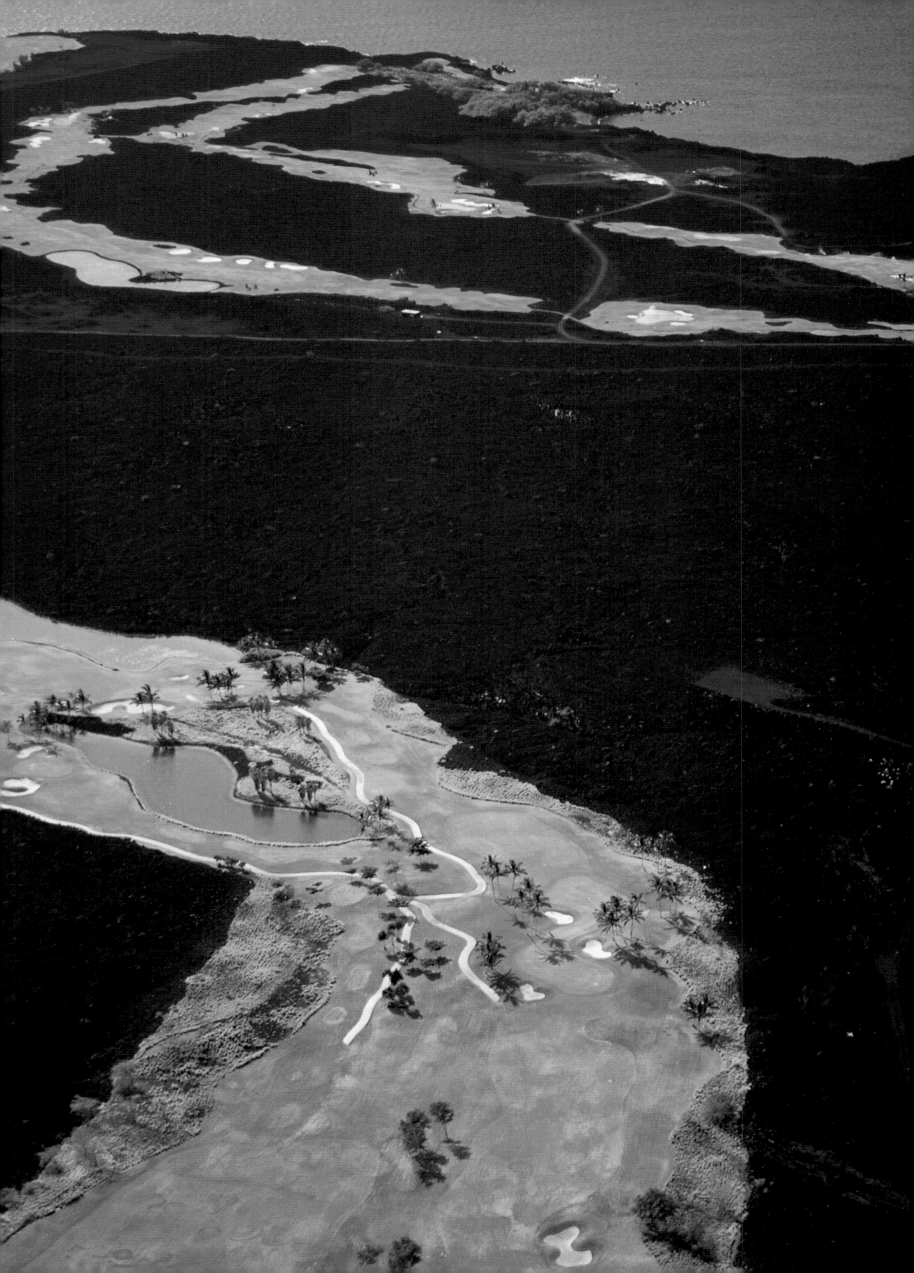

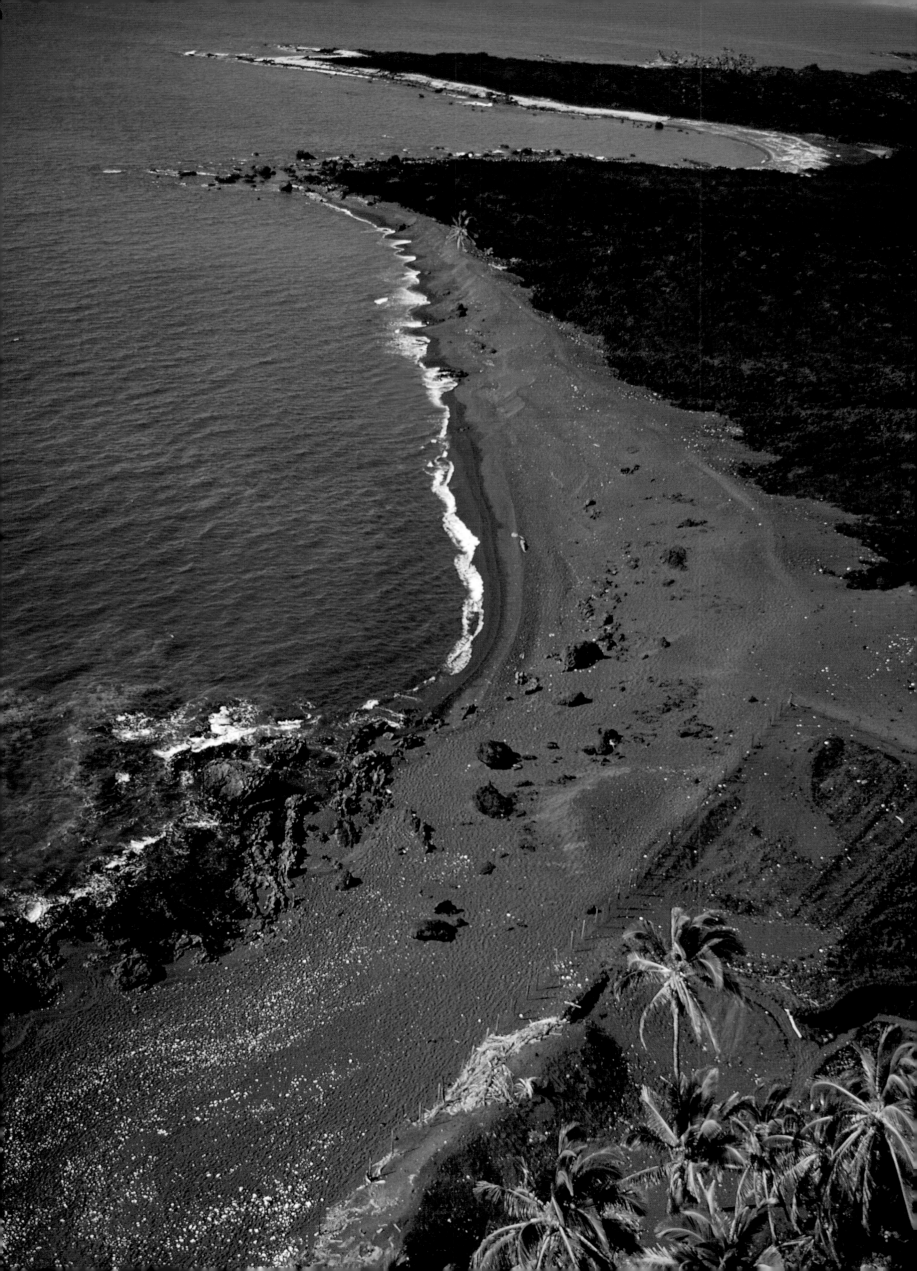

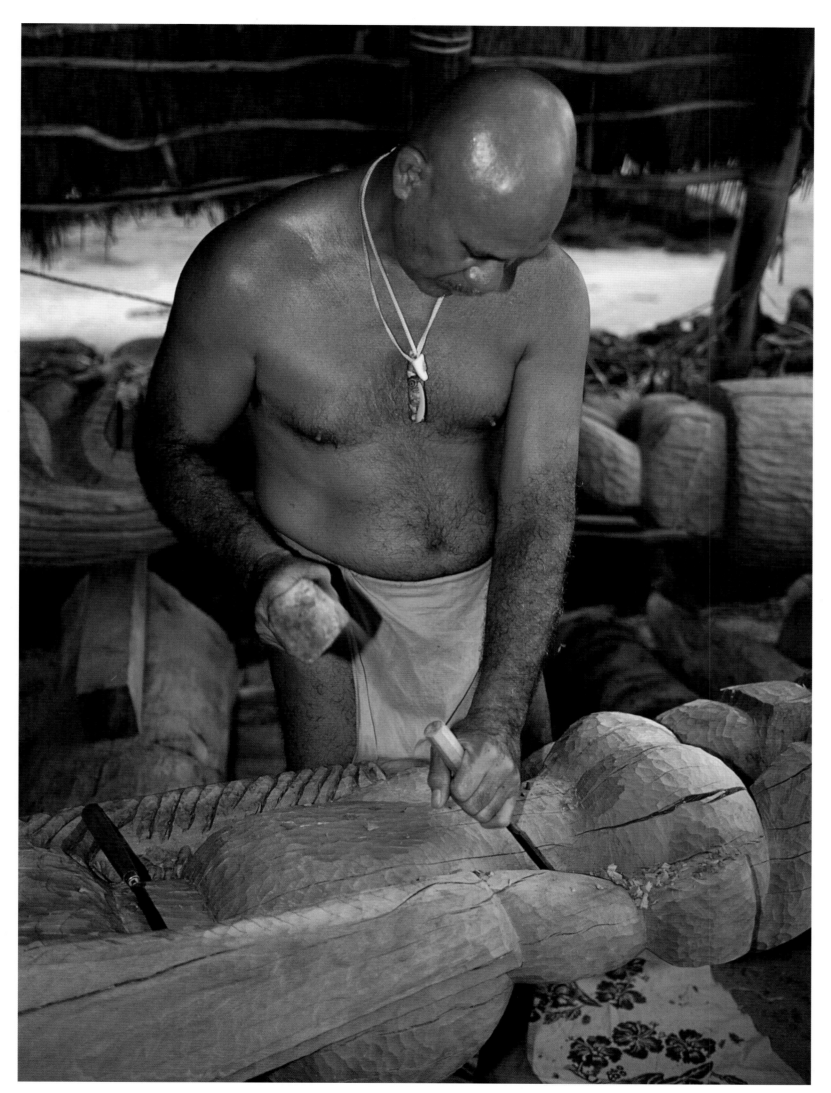

◁ Black sand edges a lava flow along the Kohala Coastline. Black sand results from the sea breaking the lava into coarse sand.
△ At Puuhonua o Honaunau National Historical Park, the Place of Refuge, a carver creates replicas of ancient Hawaiian characters.
▷ ▷ Snorkeling is wonderful in the clear emerald and blue waters of Kealakekua Bay, a state marine conservation district.

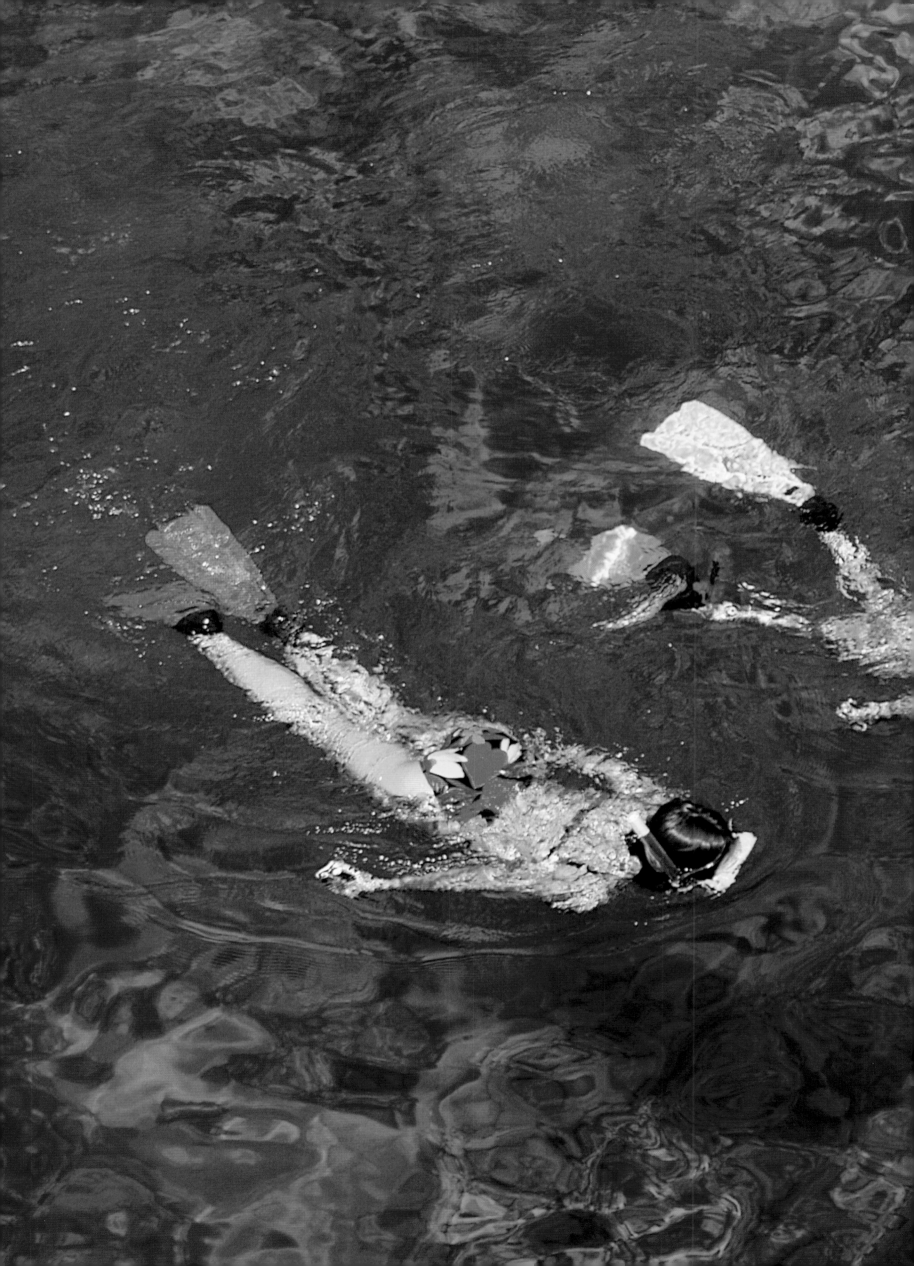

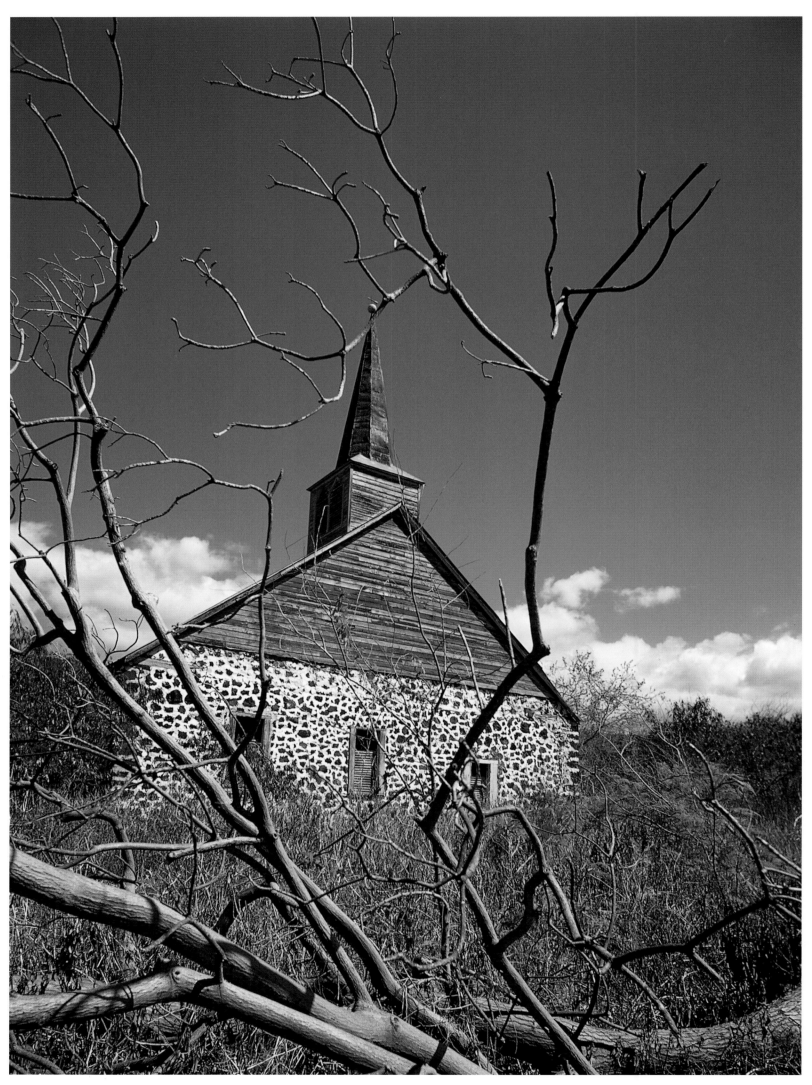

△ Kahikolua Church, located on the hill at Keei overlooking Kealakekua Bay, was completed in 1841.
▷ Cowboys, called *Paniolos*, work cattle on the Parker Ranch, one of the largest privately owned ranches in the United States.

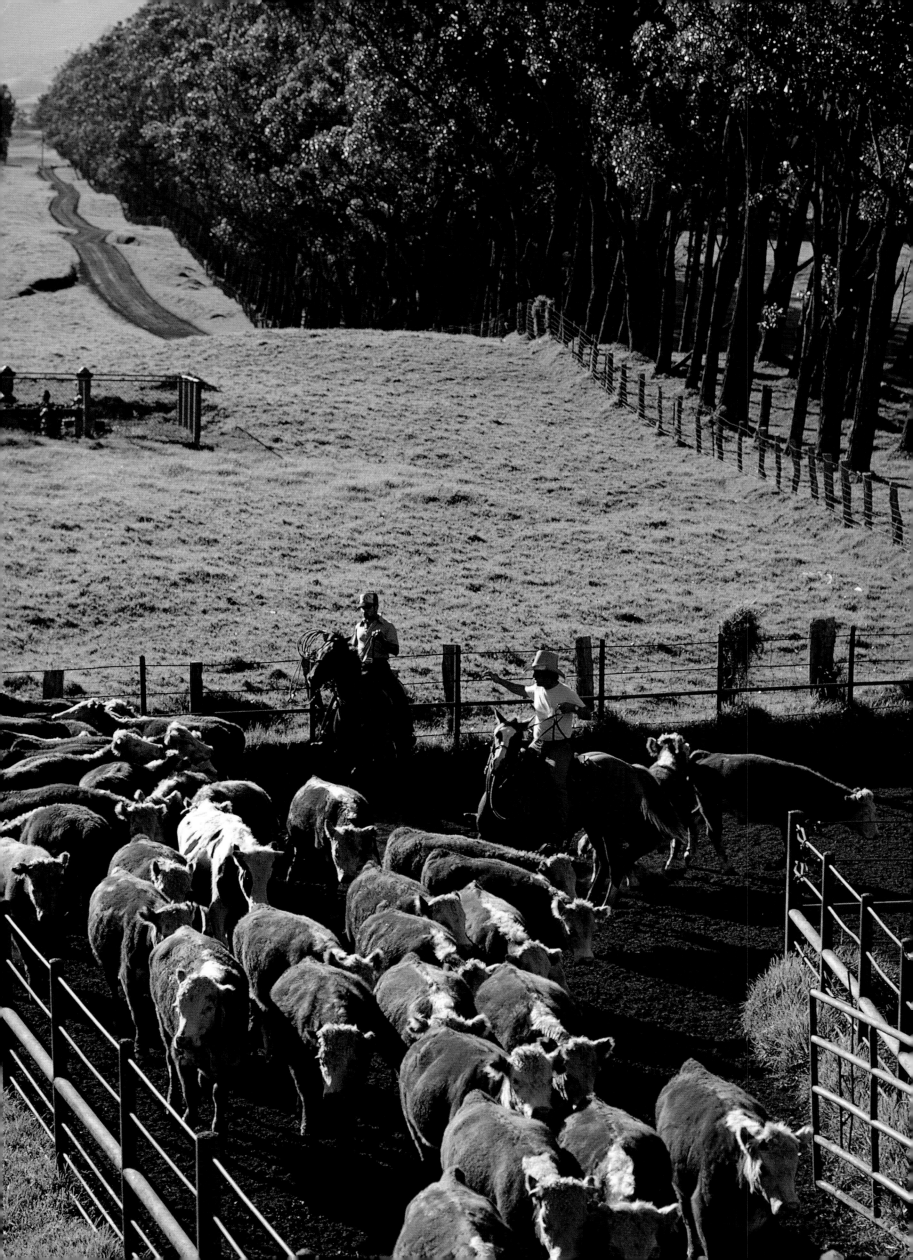

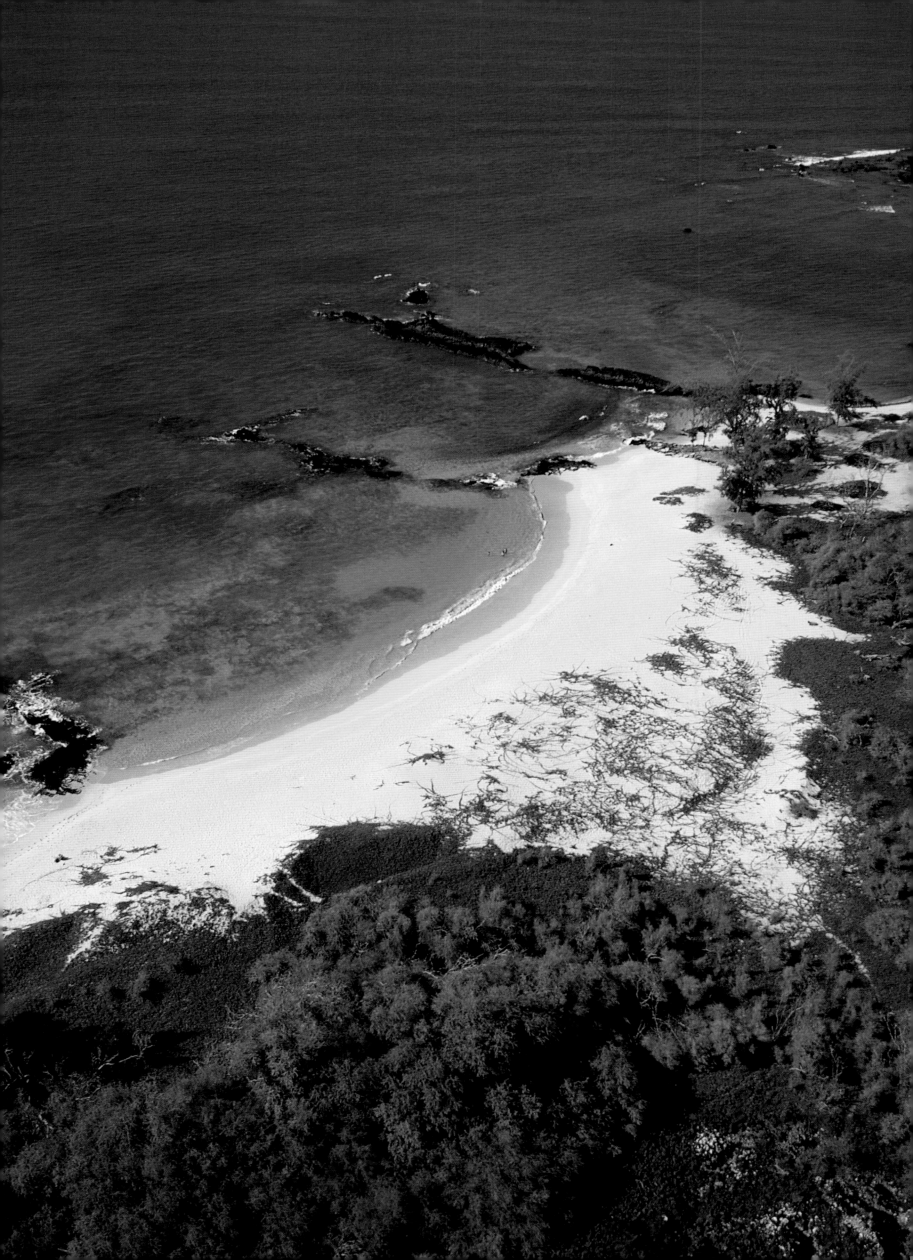

◁ Kea Beach, located along the
Kohala Coastline, is reached
either by water or by four-
wheel-drive vehicles crossing
the lava flow. This golden sand
stretch of beach is a secluded
get-away for local residents.

▽ A fisherman casts his net into
the waters off Hapuna Beach
State Park. The Big Island's
largest beach, the golden sands
stretch for more than half a
mile. Its waters are gentle in
the summer, but winter brings
waves too strong for swimming.

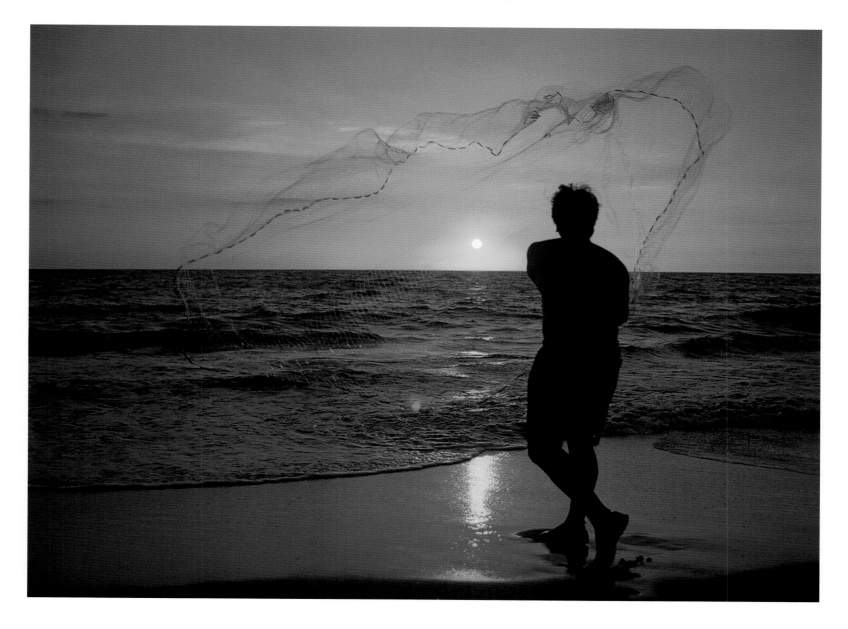

▽ Kehena Black Sand Beach
is not far down the coast from
Hilo, the Big Island's largest city.
A steep hike down a rocky path
from a neighborhood street,
the beach is not easily found.

▷ Kii, glowering wooden images
of old Hawaii, guard the temple
and grounds of Puuhonua o
Honaunau, the Place of Refuge.
Centuries ago, defeated warriors
and breakers of the *kapu,* the
strict system of social codes,
could escape the wrath of local
chiefs, or *alii,* if they could make
it to a sacred "place of refuge."
After absolution, the offender
could return to society.

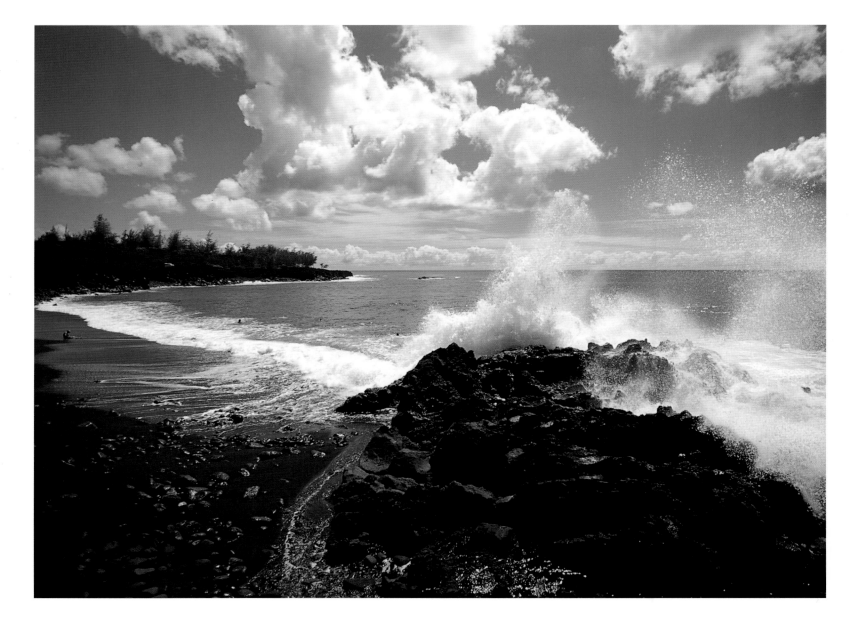

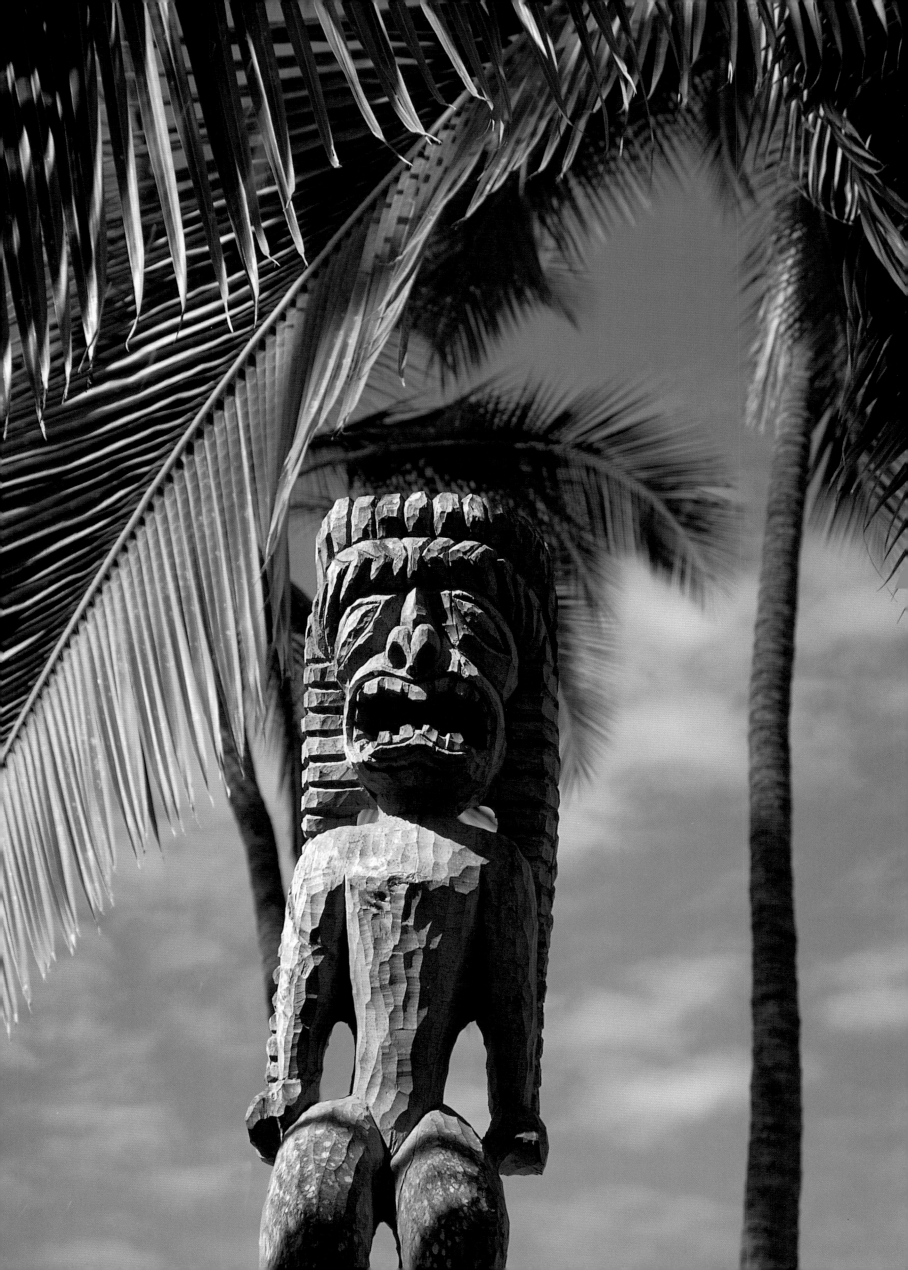

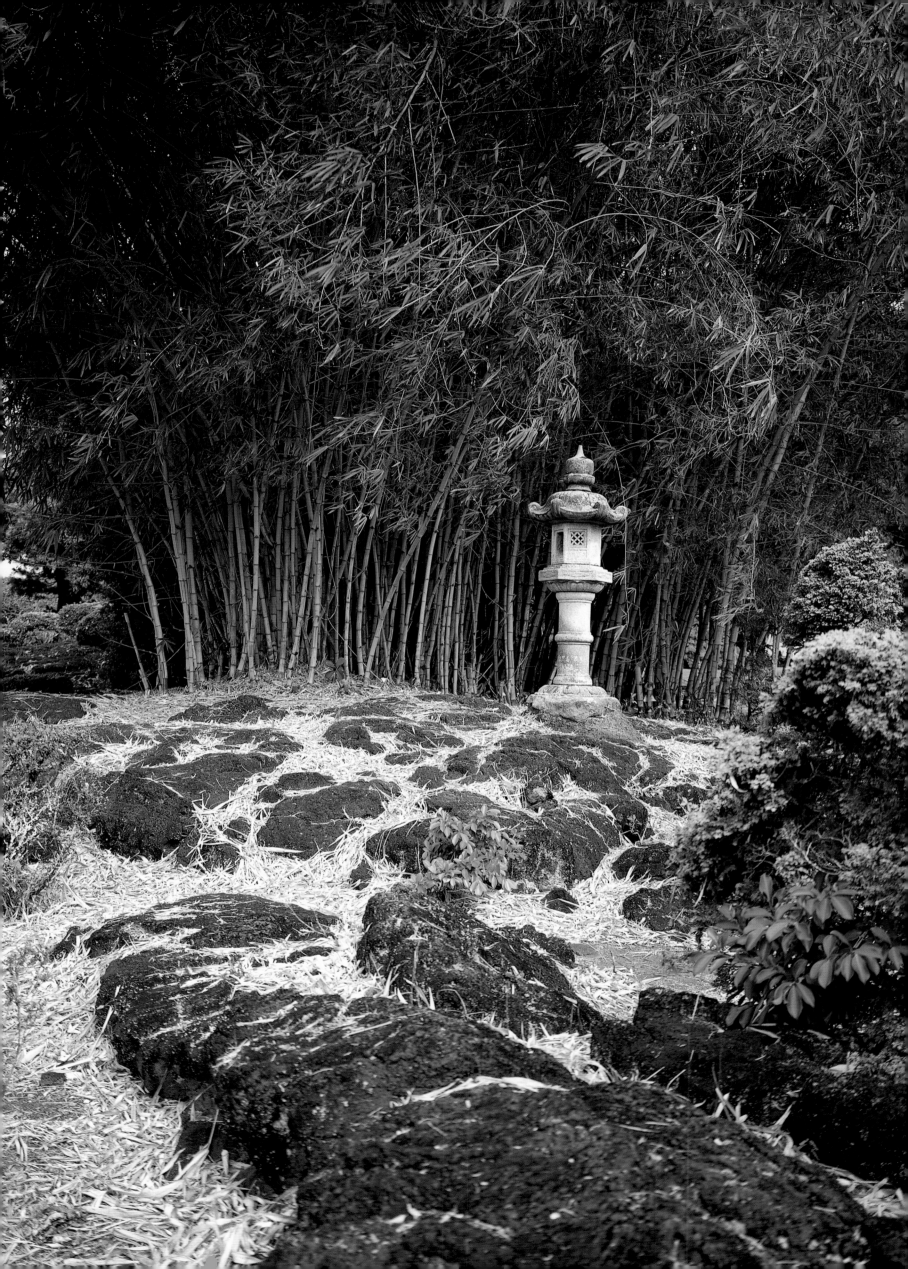

◁ The Liliuokalani Gardens, a thirty-acre park in downtown Hilo on the Big Island, is named for Hawaii's last queen. It is the largest formal Japanese garden outside of Tokyo.

▽ A scuba diver descends into a lava tube off the Kona coast. Reefs here offer an abundance of sea life and exciting formations to explore. Night dives off the coast are equally thrilling, with many creatures only appearing after the sun goes down.

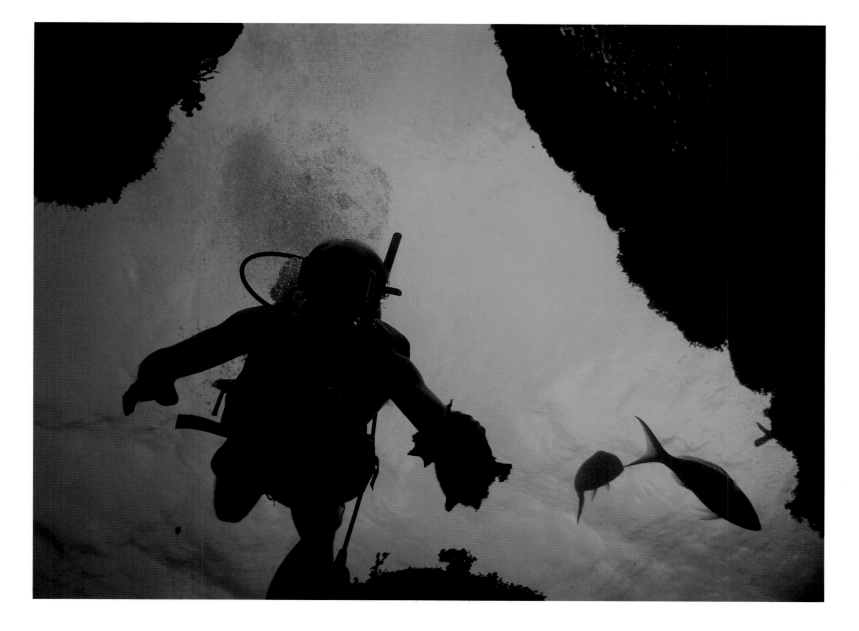

▽ A young Japanese boy floats
in a resort's pool. From the first
official group of Japanese
workers who arrived with labor
contracts in 1868, the Japanese
population has thrived
and contributed a great deal
to the lifestyle of Hawaii.

▷ The fragrance and beauty of
Hawaii's flowers, the gentle
tropical breezes, the spectacular
sunsets, and the sight of
torches glowing in the night
are part of the ambience that
makes Hawaii unforgettable.

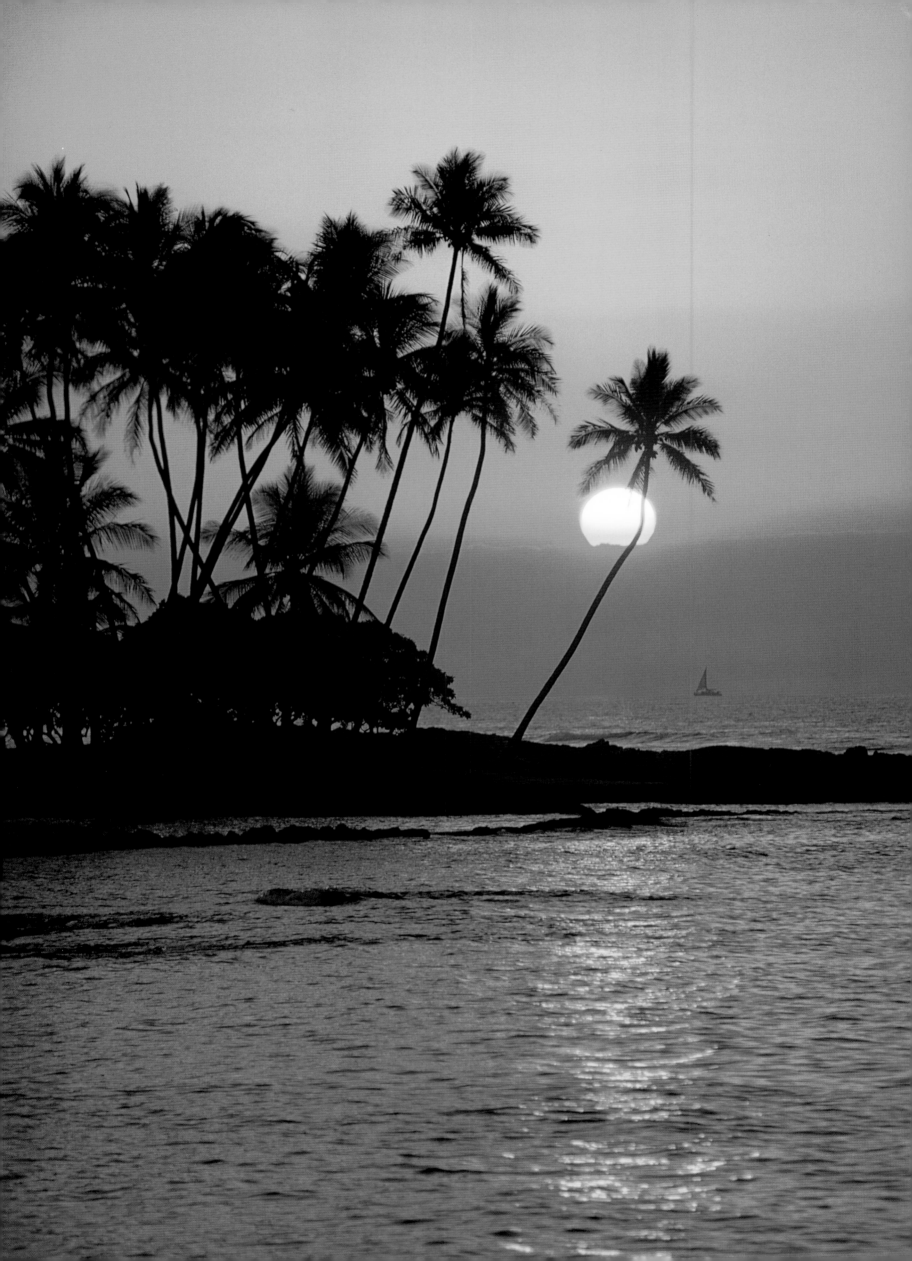

◁ The Kohala coast appears to be a barren lava flow, but it is dotted with some of the world's most beautiful and extravagant resorts. Incredible golf courses, world-class restaurants, astonishing architecture, and rare natural beauty keep many tourists here for their entire visit to Hawaii.

▽ Although the islands began as barren lava rock, today they abound with flora and fauna. Many plants have been imported, beginning when Polynesians brought along what they needed to survive.

▽ St. Benedict's Church, or
the Painted Church, is located
in Honaunau. Biblical scenes
are painted on the walls
for those unable to read.

▷ Wearing a *haku* head lei
made of ferns and a black
kukui nut necklace, a young
hula girl displays the sweet
beauty of the Hawaiians.
There is a renaissance of
hula and other aspects of
ancient Hawaiian culture.

▷ ▷ A traffic sign stands
alone amid a lava flow,
trying vainly to request order
where none can exist.

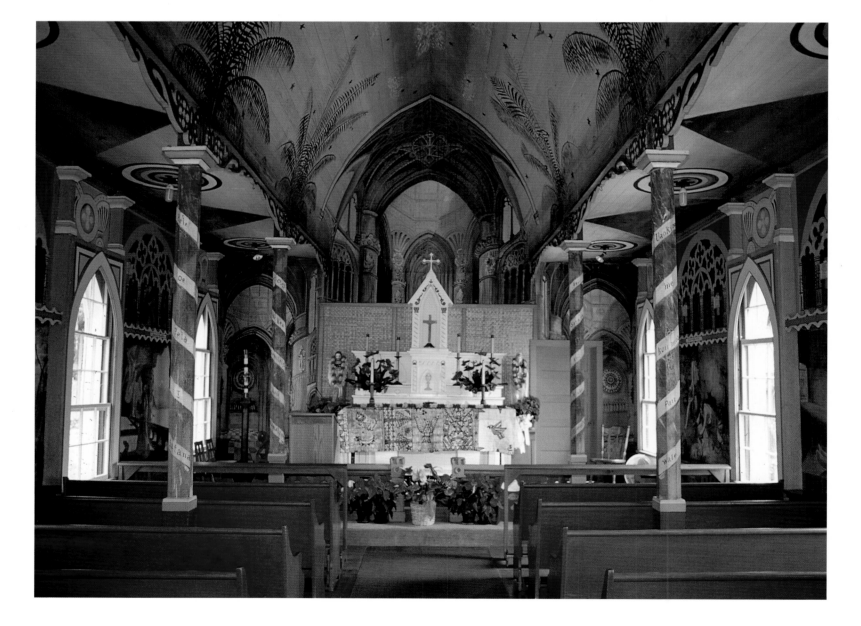

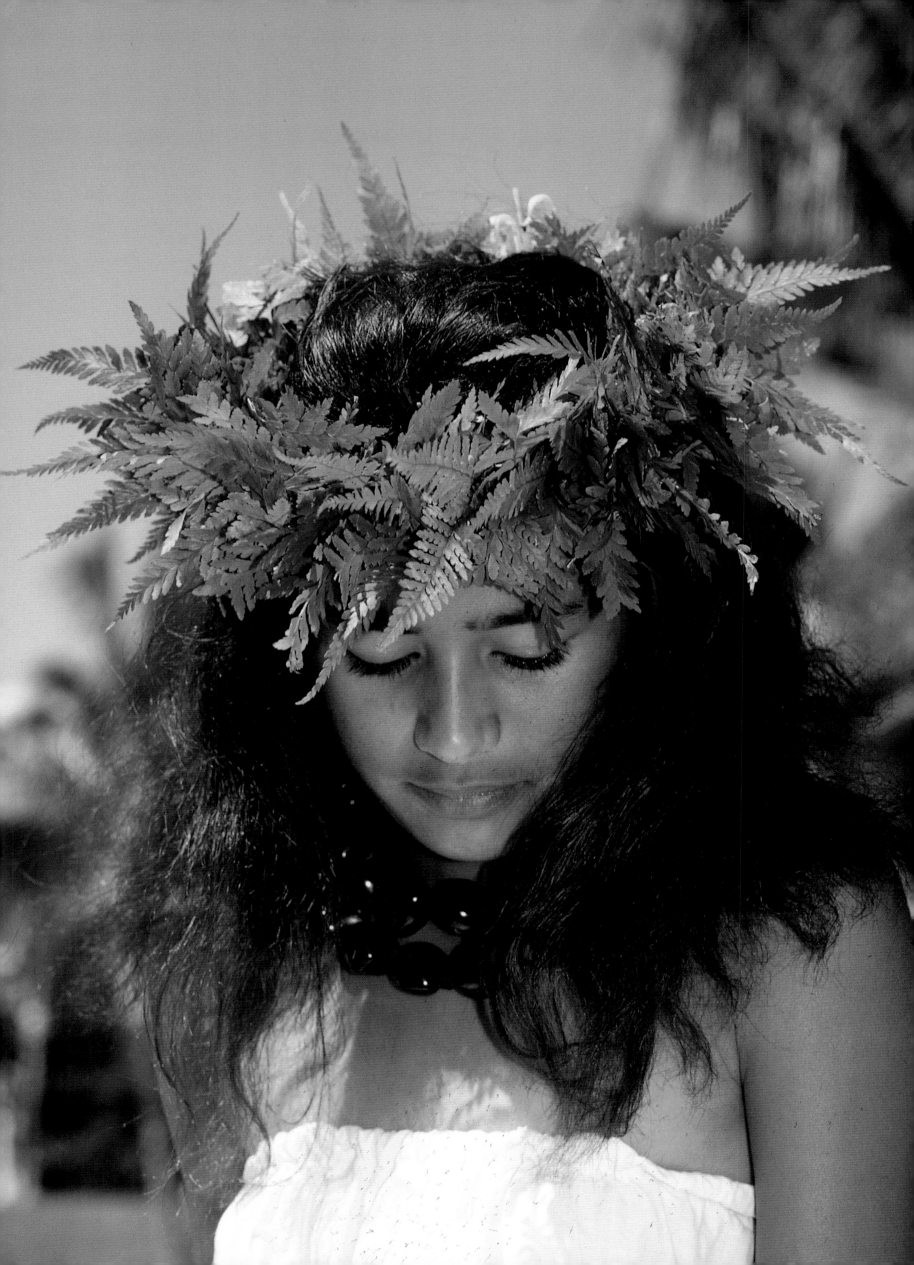

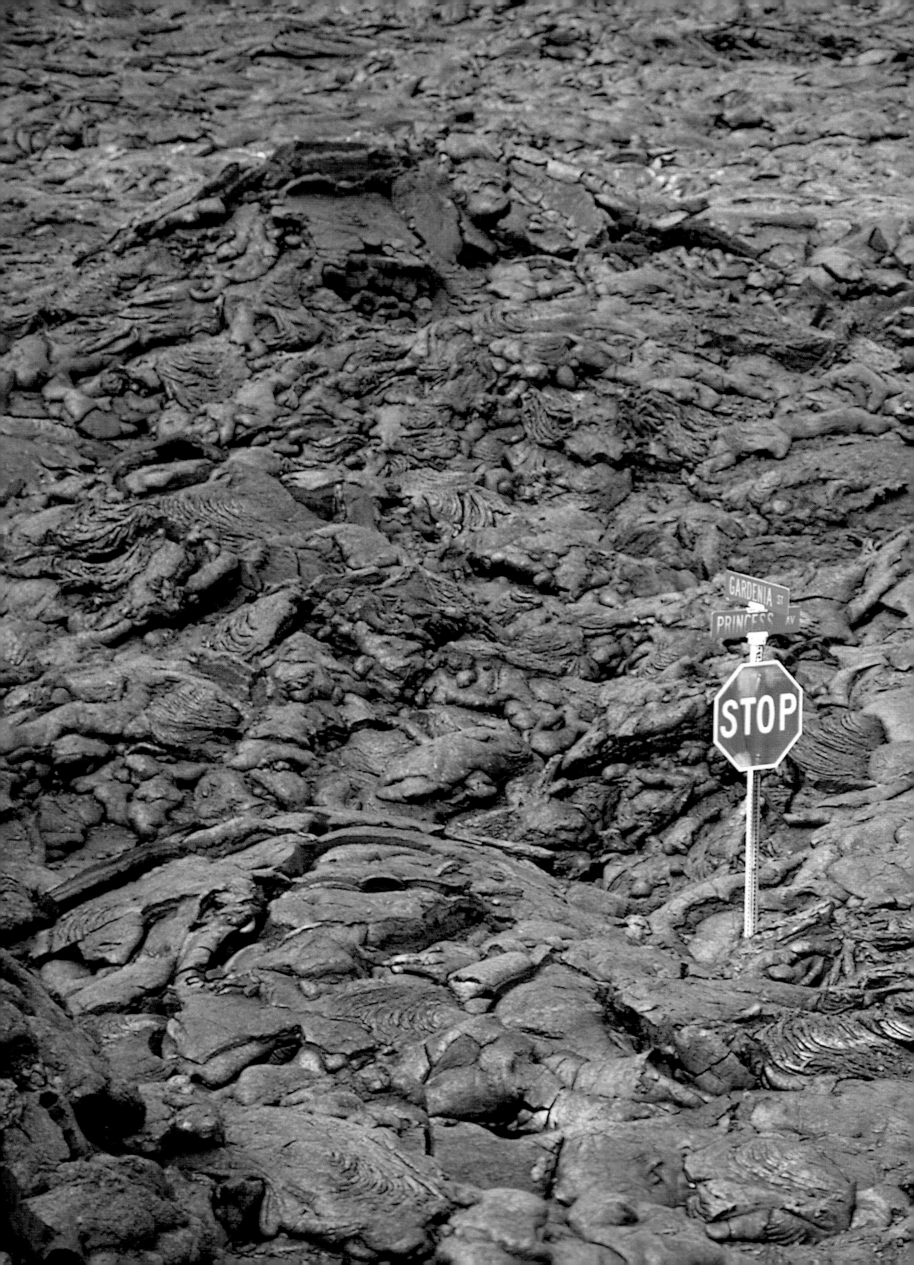

◁ The older of the two largest volcanoes on the Big Island, Mauna Kea is extinct, last erupting about 1500 B.C.

▽ A helicopter hovers above flowing red-hot lava of Kilauea Volcano at the Big Island's Volcano National Park. The surface of the lava cools and hardens quickly, forming a crust of rock. At times, the molten lava inside this rocky crust breaks a hole and flows through, leaving a huge lava cave or tunnel behind.

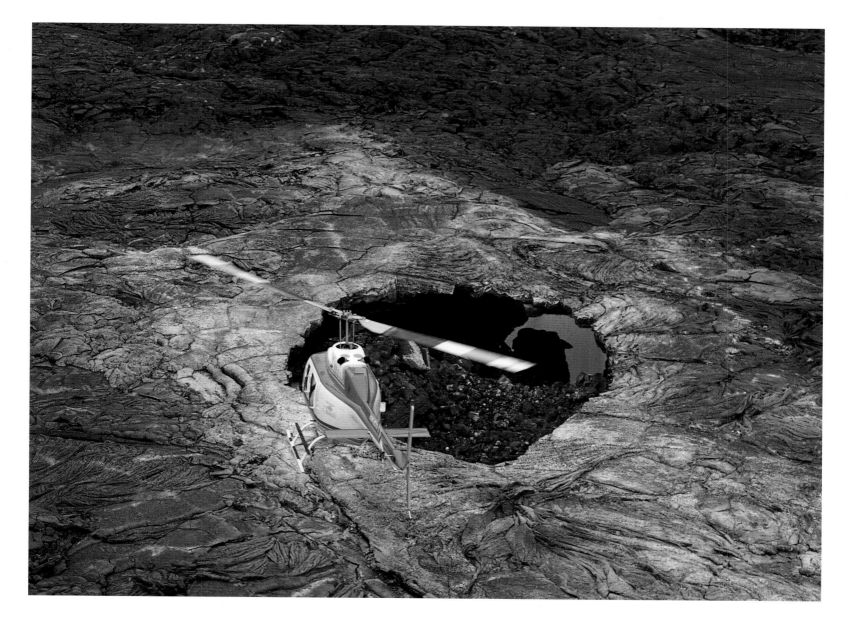

▽ The Mauna Kea Observatory complex is the most important astronomical site in the world. Nine giant telescopes have been built on summit cinder cones. The Keck Observatory houses the world's most powerful optical telescope.

▷ Located on the leeward side of the Big Island, the quaint fishing town of Kailea-Kona is synonymous with great coffee, sunshine, and big game fishing. Alii Drive is a two-mile strip of tourist shops and restaurants.

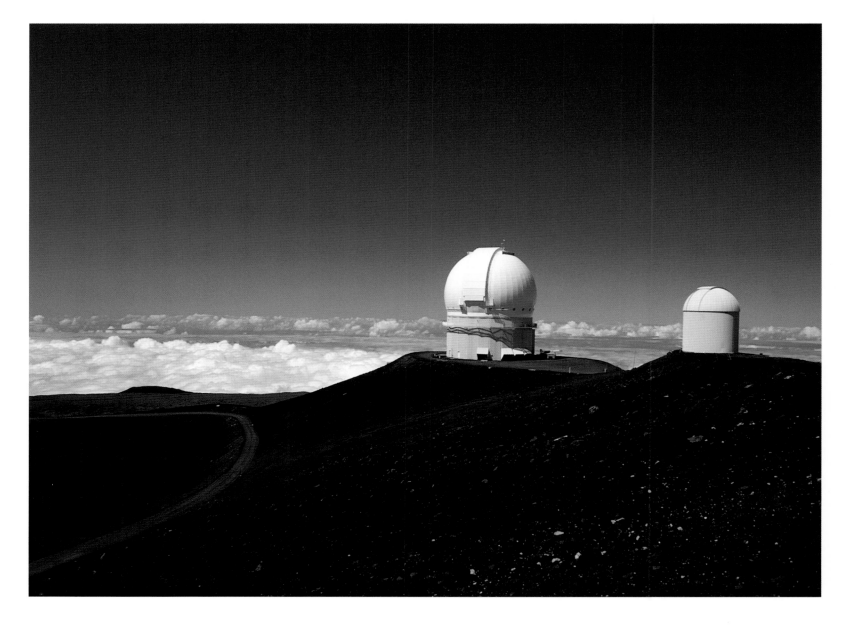

Lanai,
Molokai,
& Niihau

LANAI. Hawaiian legend claims that, when the Polynesians arrived, the island of Lanai was haunted by evil spirits, making it unsafe for humans. No one lived there until an early Maui king banished his prankish son to the island for destroying breadfruit trees. Sleeping in caves at night and hunting the spirits by day, the young prince was able to eliminate all of them. He built bonfires atop Lanai's highest ridges, which could be seen from all of the other islands, announcing its safety for human habitation.

The first human residents stayed mostly along the west coast, where the weather was accommodating and fishing was abundant. Future generations raised crops on the fertile plain left behind by the volcano (long extinct) that had built Lanai. The island remained sparsely populated until the early 1800s when Charles Gay, grandson of Niihau owner Eliza Sinclair, purchased it and attempted to raise sugarcane. He gave up after a three-year drought bankrupted him. Several others began enterprises to cultivate crops and raise ranch animals; these also failed for lack of sufficient water.

Harry Baldwin, a missionary's grandson, solved the problem by developing a twenty-mile, gravity delivery pipeline. About the same time, Norfolk and Cook Island pine trees, which now dot the island, were planted by New Zealander George Munro to catch the water from passing clouds. Happy with the new agricultural prospects, James Dole purchased Lanai to raise pineapples in the early 1920s. Using imported laborers, mostly from the Philippines, Dole's Hawaiian Pineapple Company was prosperous, shipping more than a million pineapples a day at the height of production.

Castle and Cooke, one of Hawaii's original major corporations, purchased Lanai from the Dole Company and operated the plantation until 1987, when all commercial pineapple cultivation was moved to the Philippines and Southeast Asia. Today, only a few acres are in production, mostly to fulfill the needs of guests.

California investor David Murdock bought a controlling interest in Lanai and everything on it except a few privately owned homes in the small plantation town of Lanai City. Murdock built two world-class resorts, an incredible golf course, and several homes. Microsoft genius Bill Gates rented most of the island in order to honeymoon at Murdock's new Manele Bay Resort. The exclusive resort overlooks Hulopoe Beach, a wide expanse of golden sand that forms one of the world's most beautiful beaches.

With its tin-roofed cottages and towering pine trees, the city of Lanai, set high in the island's center, still looks much the same as it did in plantation days. Many former pineapple laborers, descendants of the original immigrants, have stayed on to live and work in the new hotels. Other than what is available at the grocery stores, a hamburger stand, or a few small craft stores, there is not much for visitors to see or buy in the small city.

For more than fifty years, the rusting hulk of the *Helen Port Townsend* has tossed and turned on the shallow reef at the northern end of Lanai. Its namesake, Shipwreck Beach, has become a popular place to gather shells and glass net-balls that float in from the sea. On most of the beaches, nearby tide pools in the lava rock are exciting to explore. At low tide, their clear water is full of small shrimp, starfish, sea cucumbers, and Hawaiian *opihi*, a tiny limpet the islanders consider a delicacy.

Hikers and "jeepers" enjoy the views and cool breezes found along the Munro Trail. Named after the island's famous pine tree planter, the trail has many stately examples of the Norfolk and Cook Island pines he brought to Lanai. On a clear day, all of the major Hawaiian Islands can be seen from the trail's high point.

Visitors to Lanai's Garden of the Gods may find it hard to believe the ancient spirits were driven off the island. The garden's strange, orange-colored desert is dotted by small temples of piled rocks, whose shadows cast inexplicable images. Just before sunset, when the rock formations look like burnt offerings and the ground takes on a golden glow, breezes from the ocean below seem to carry the voices of those ancient spirits.

◁ *Luahiwa Petroglyph Field, just outside Lanai City, has fine examples of prehistoric rock art.*
△ *Hibiscus flowers are found throughout the islands.*

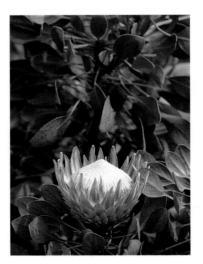

MOLOKAI. Among Molokai's remote valleys, when the evening sea and winds are calm, it is said the voices of Hawaiian *Kahunas* can be heard chanting ancient legends. Those who listen carefully say this is where the Hawaiian spirit of *Ohana* and the hula were born. This is Molokai . . . where you will find the real Hawaii.

The mostly native Hawaiian residents are indifferent to what outsiders think about their island home. In fact, they seem not to care whether tourists come at all. They prefer to live a simple and traditional lifestyle of fishing, raising vegetables, and hunting.

The west end of Molokai is where most visitors congregate. Here, the Kaluakoi Resort offers a nice golf course and the only ocean-front accommodations. Kepuhi Beach, at the resort, is a fine place to do a little shell hunting, sunbathing, and sunset watching. However, less than five minutes' drive away is Papaohaku Beach, which offers three miles of golden beach that stretches a hundred yards wide in places. A person can frequently walk the beach for hours without encountering another person.

Nearby, the Molokai Ranch Wildlife Conservation Park is the island's top attraction. Probably one of the best game preserves of its kind, it has more than one hundred exotic wild animals that roam freely across four hundred acres.

On the rugged north coast of Molokai is a tiny peninsula that was once called *Makanalua,* meaning "the Given Grave." King Kamehameha V sent a dozen lepers into exile here in 1866. The revered Belgian missionary and priest Joseph de Veuster, better known as Father Damien, established a church in Kamalo to help the forsaken lepers. Visitors are welcome to tour the beautiful community, which has been restored to its original condition and is now a national historic park. Fewer than one hundred former patients choose to remain in the small village.

Molokai has no fancy resorts, no Hawaiian extravaganzas, no big-name restaurants. The absence of such synthetic amenities is what makes Molokai one of the last genuine Hawaiian places.

NIIHAU. About ten minutes by helicopter from Kauai's western coast lies the tiny island of Niihau, Hawaii's most mysterious and private place. Eliza Sinclair, the widow of a wealthy New Zealand rancher, purchased the island in 1864 from King Kamehameha V for ten thousand dollars in gold and her prized grand piano. Her children, including Helen Sinclair Robinson, whose descendants still own the island, transformed it into a cattle and sheep ranch.

Almost from the beginning, the Robinsons limited island access to residents and invited guests. As a result, the entire population consists of about three hundred pure Hawaiians, who live in a small village that is much the same as it was more than a century ago.

There really is little mystery to Niihau. It is a small island, only about seventy-five square miles of mostly arid terrain that is one of the driest places in Hawaii. Lake Halalii, the largest body of water on any of the islands, provides most of the natural green vegetation.

There are no paved roads, no public electricity, no shopping malls, no jail, and no television, except for the few families who have purchased a generator and satellite dish. What residents are unable to grow in small gardens, catch from the sea, or hunt on the island is provided by the Robinson Ranch or supplied by an old Navy landing craft that journeys from Kauai once or twice a month. Medical and other emergency needs are supplied by a ranch-owned helicopter. Short visits to Niihau's cattle landing, but not the village, are occasionally offered to tourists.

The only separate industry is the hand-making of Niihau leis. An authentic Niihau shell lei is considered a precious work of art. The best ones sell for thousands of dollars on Kauai and Oahu.

Niihau's primary language is Hawaiian, although young children attend a small grammar school that includes English in the curriculum. Students continue their higher education off island, generally at the Kamehameha Schools for Hawaiians. Sadly, many of Niihau's children are captivated by the outside world, seldom returning to reside there as adults.

△ *Protea, a tropical flower related to the macadamia nut, is a popular Hawaiian souvenir. It is grown in at least sixty varieties.*
▷ *A plantation home in Lanai City, the island's only town, sits seventeen hundred feet above sea level.*

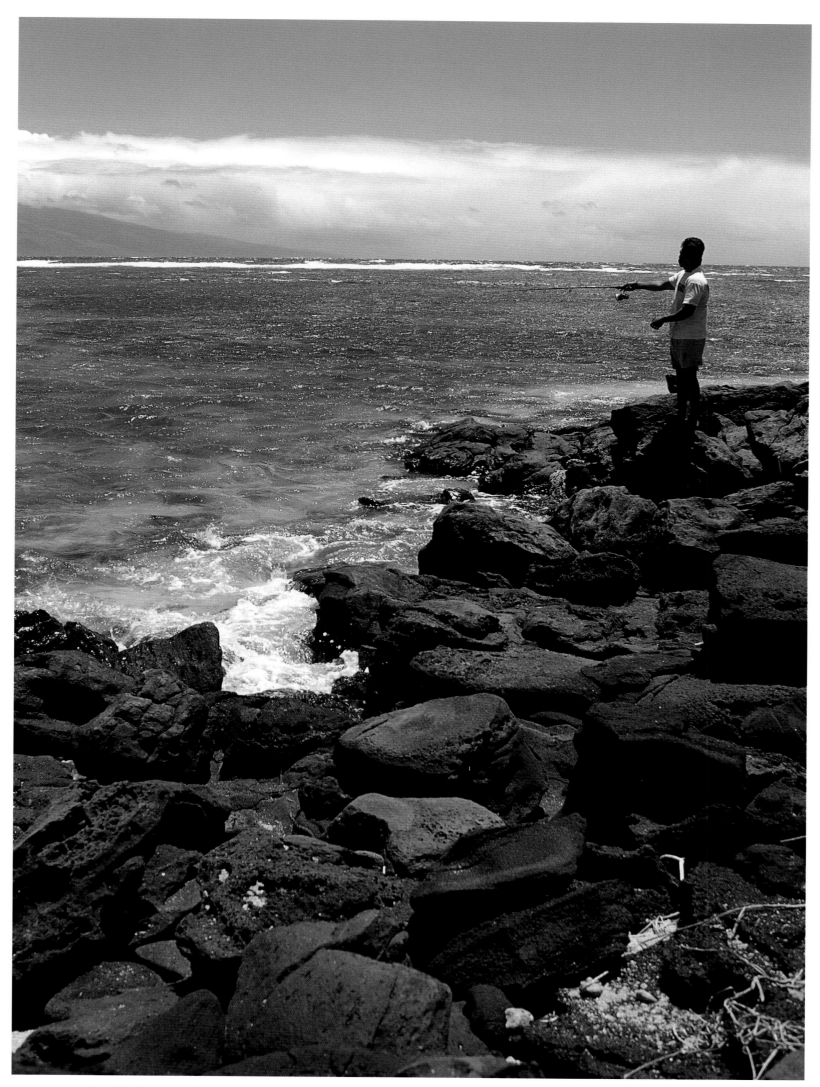

◁ The Challenge at Manele, a world-famous golf course designed by Jack Nicklaus, is part of the Manele Bay Hotel.
△ Fishing is good off Shipwreck Beach, along the Kalohi Channel between the islands of Lanai and Molokai.

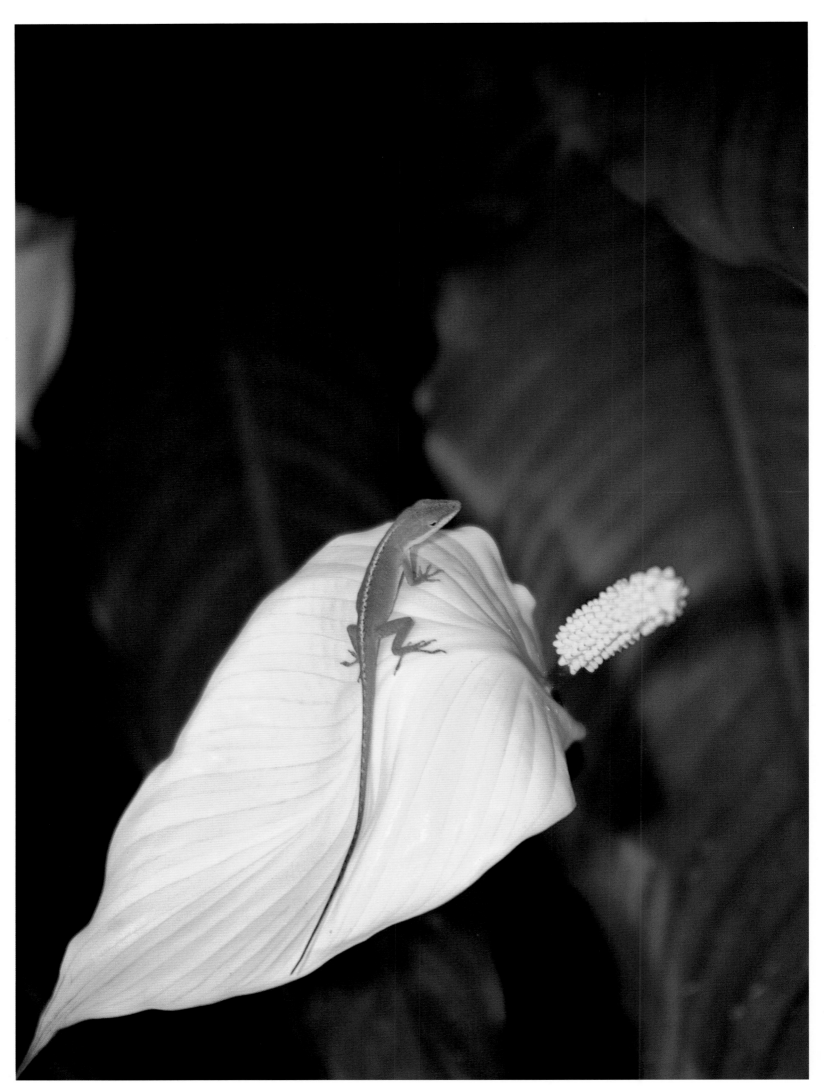

△ A small green anole, a soft-skinned, harmless lizard, sits on a Mauna Loa flower.
▷ Garden of the Gods glows with earthen tints of red, burnt orange, ochre, and yellow, contrasted with brilliant green yucca plants.

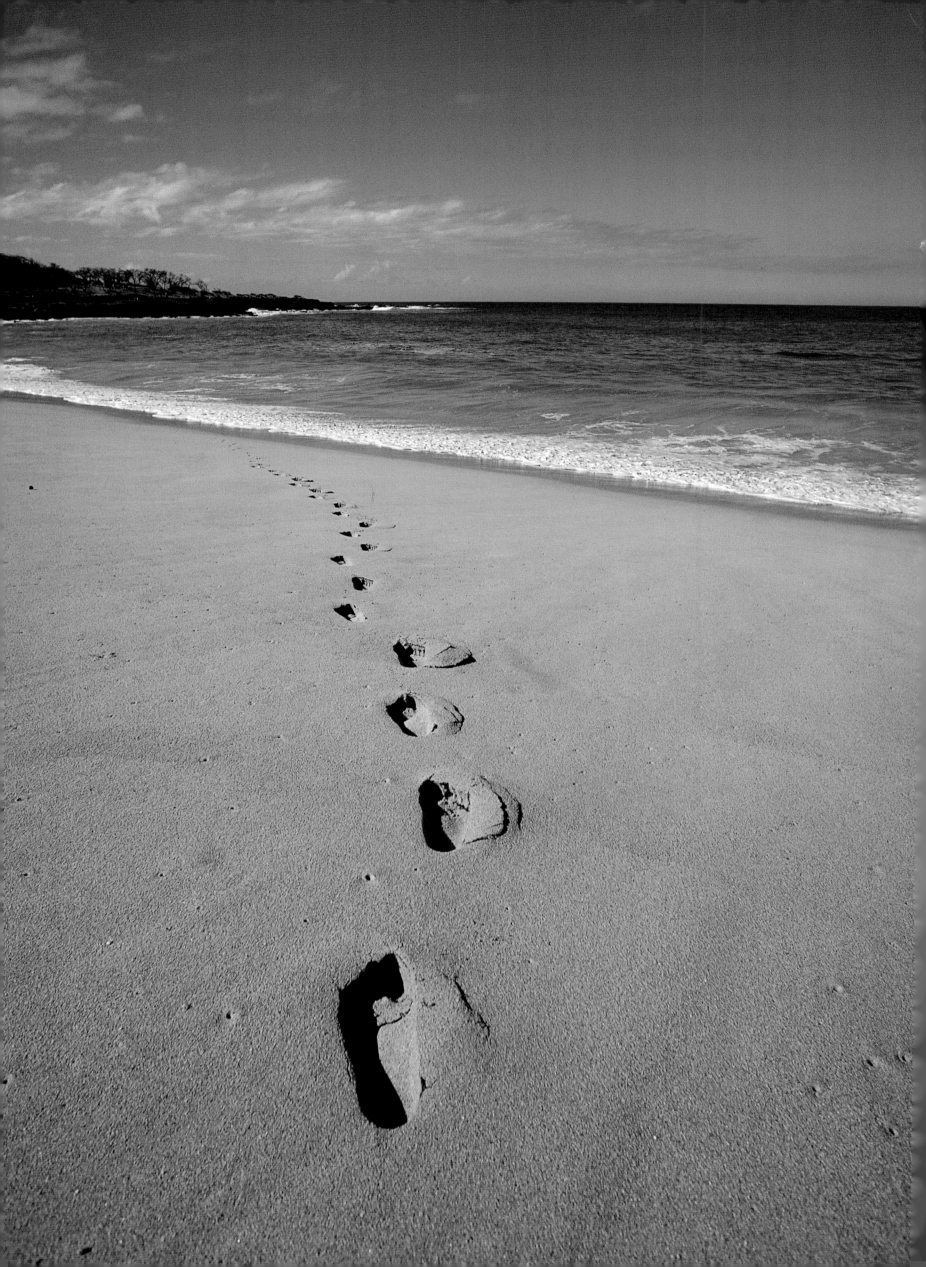

◁ Footprints cross the smooth, soft sand of Lanai's Hulope Beach, and lead into the water.

▽ Locals and visitors pile rocks on top of one another, forming altar-like structures that add to the strange setting at the Garden of the Gods.

▷ ▷ On the Kalaupapa Peninsula, this huge white cross pays tribute to the eleven thousand who died here of Hansen's Disease (leprosy), and to saintly Father Damien, who gave his life in their service.

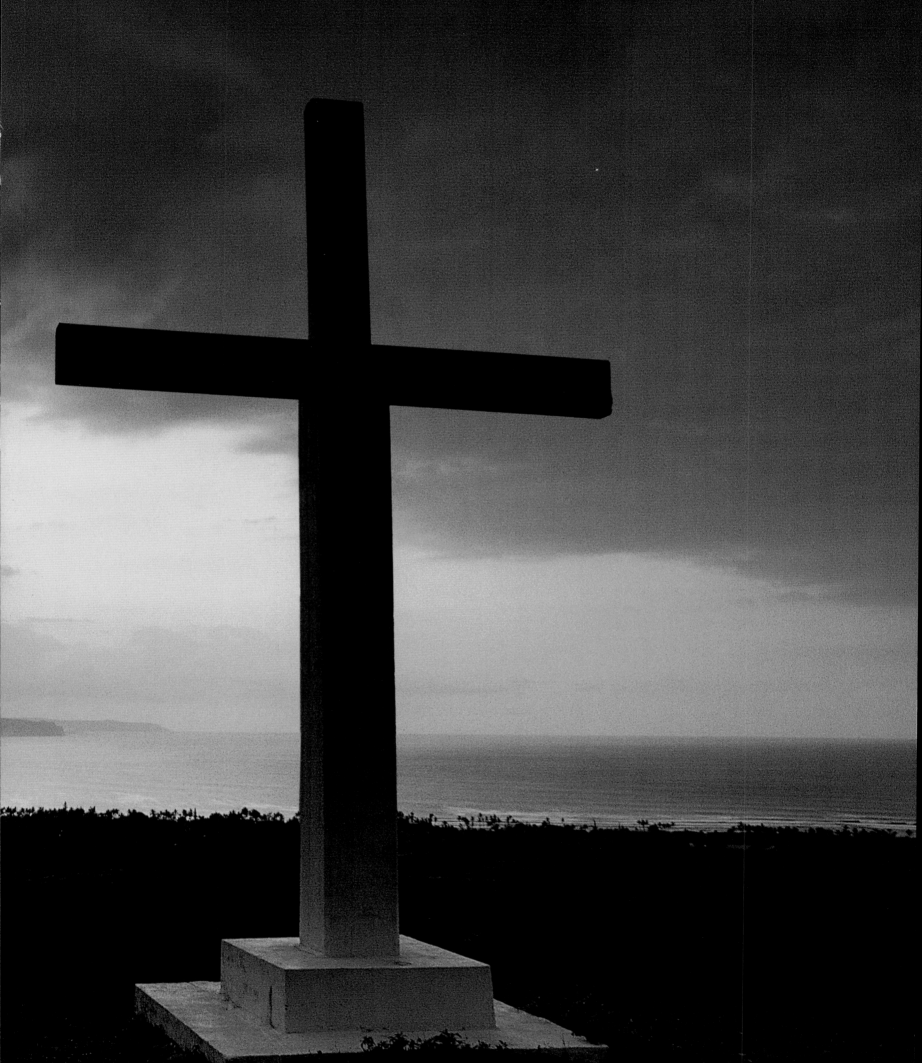

▽ Zebra are one of a variety of exotic animals in residence at Molokai Ranch Wildlife Park, part of the forty-thousand-acre Molokai Ranch on the leeward side of the island.

▷ With golden sands three miles long and a hundred yards wide, Papahaku Beach is one of Hawaii's largest and prettiest. Sunbathing and beach combing are great, but with an undercurrent nicknamed "the Oahu Express," swimming is only for the strong and experienced.

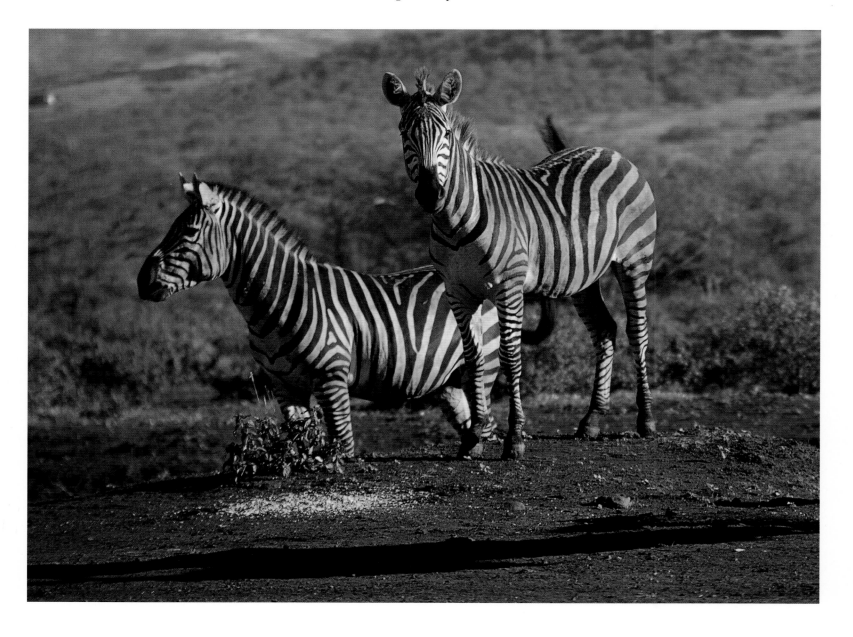

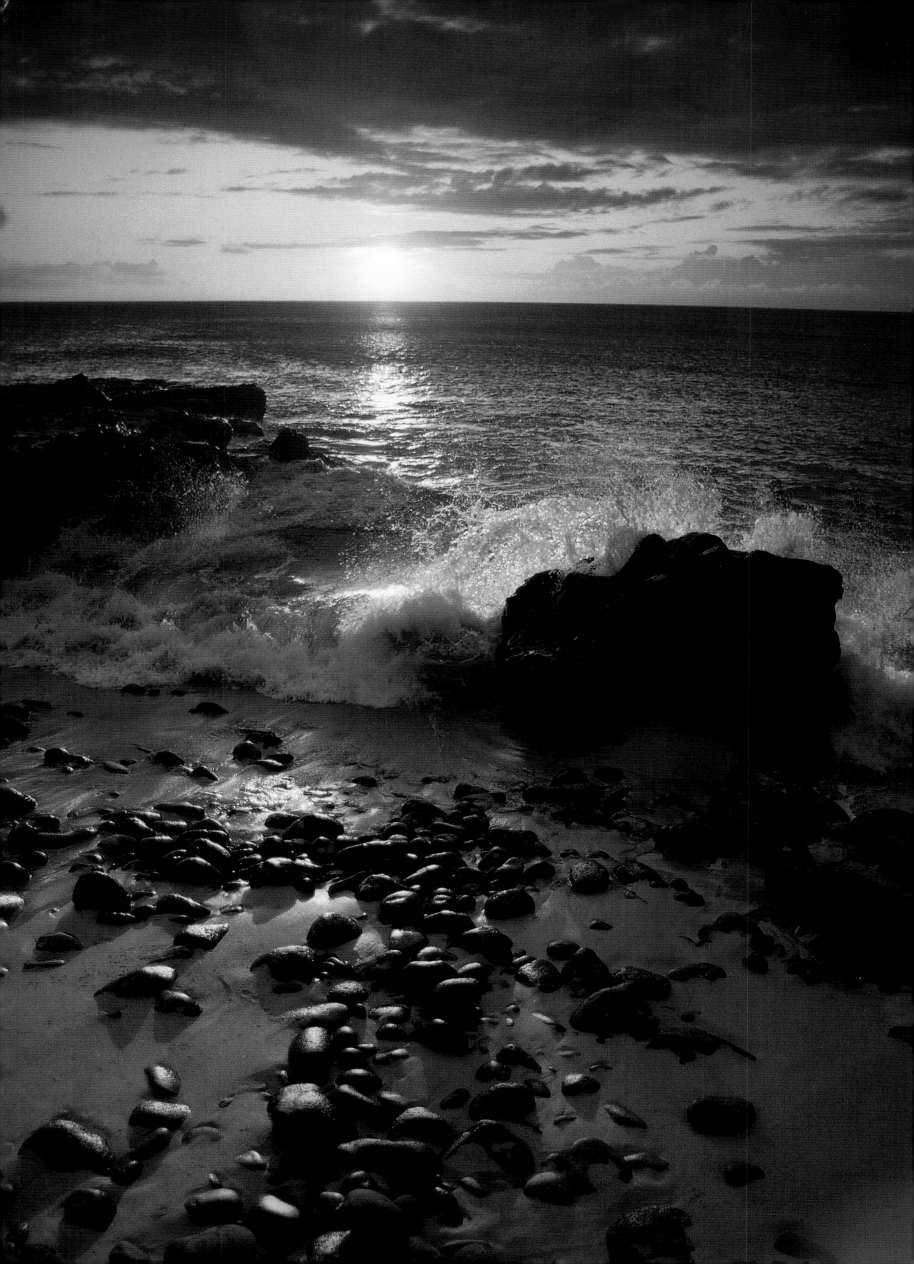

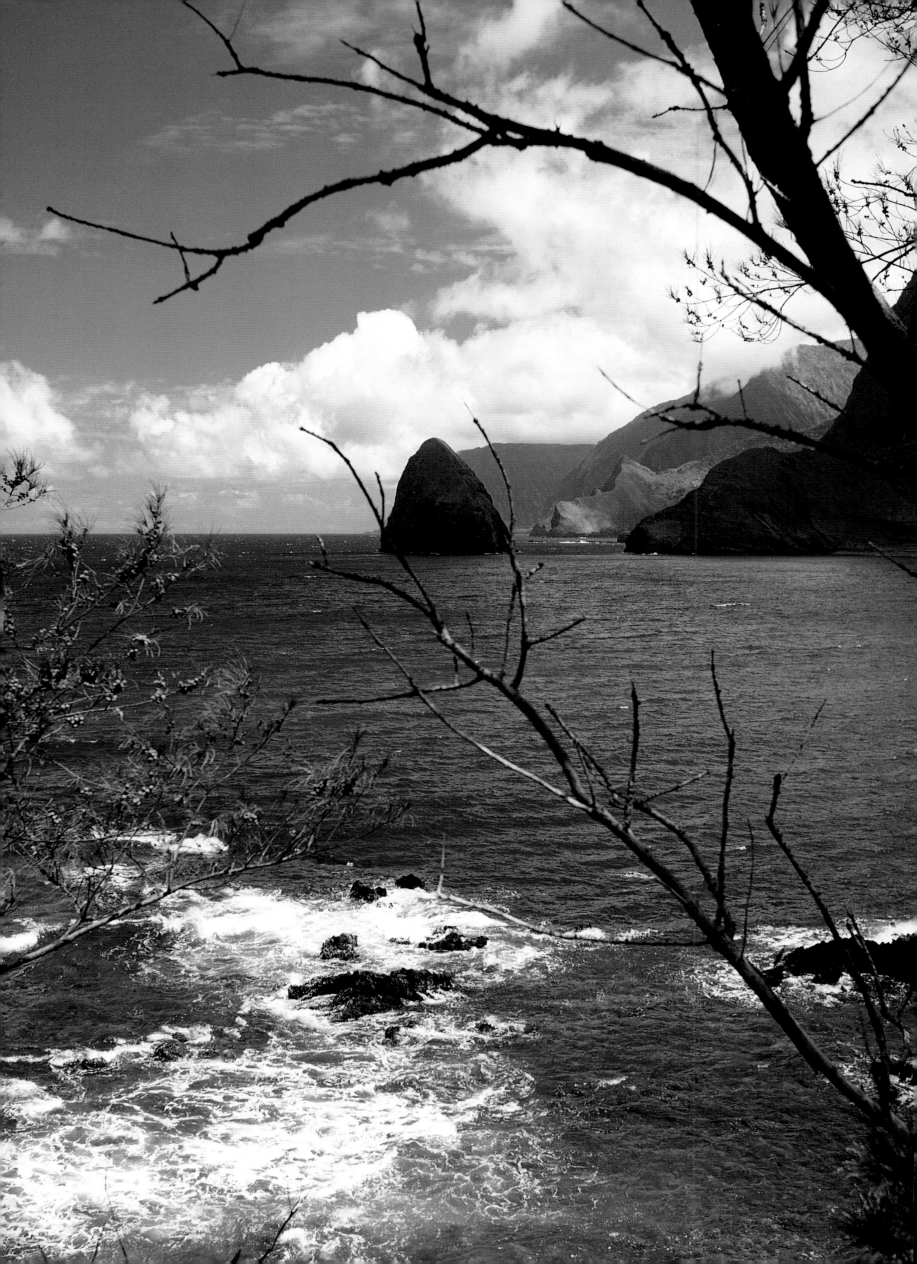

◁ The tiny island of Okala accentuates the dramatic land-mass of Point Leina o Papio and Molokai's rugged northern coast. The breath-taking remote coves, valleys, and beaches along this shore are popular with kayakers and boaters.

▽ *Kaiolohia Bay,* which means "choppy or changing sea," is commonly called Shipwreck Beach because of the rusting hulk of a tanker that ran aground on Lanai's coral reef more than fifty years ago.

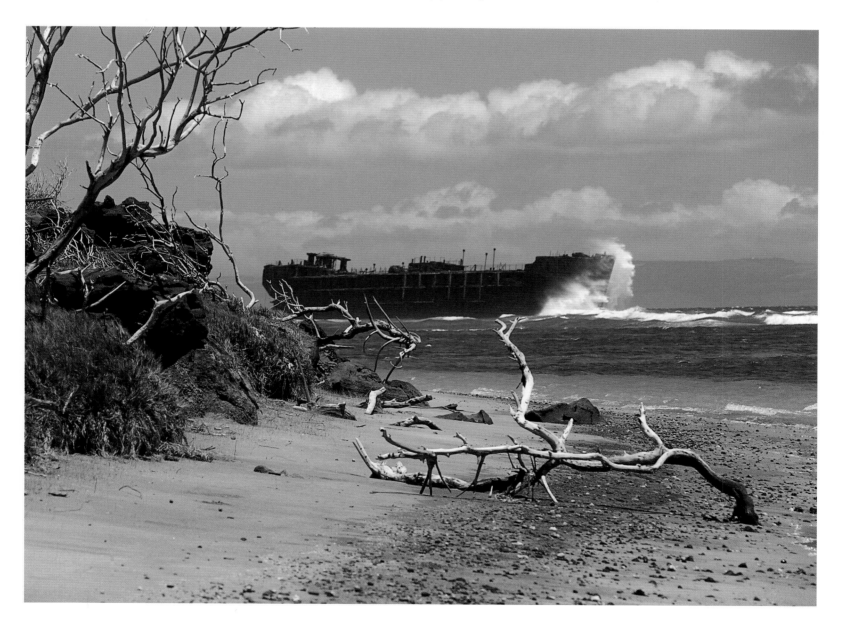

▽ Called the "Forbidden Island," Niihau is a privately owned island just seventeen miles across the Kaulakahi Channel from Kauai's west side. It is the only island where Hawaiian is the primary language.

▷ A helicopter lands on the rugged coastline of Niihau, an island that has no airfield. Tourists who take the expensive trip are only allowed to visit a remote and uninhabited part of the island. The helicopter service was started to provide emergency medical care.

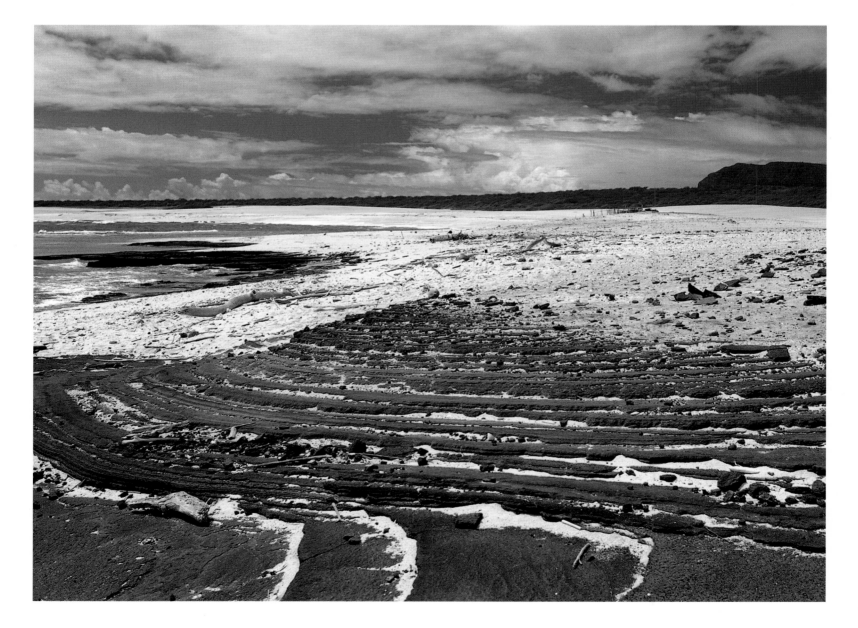

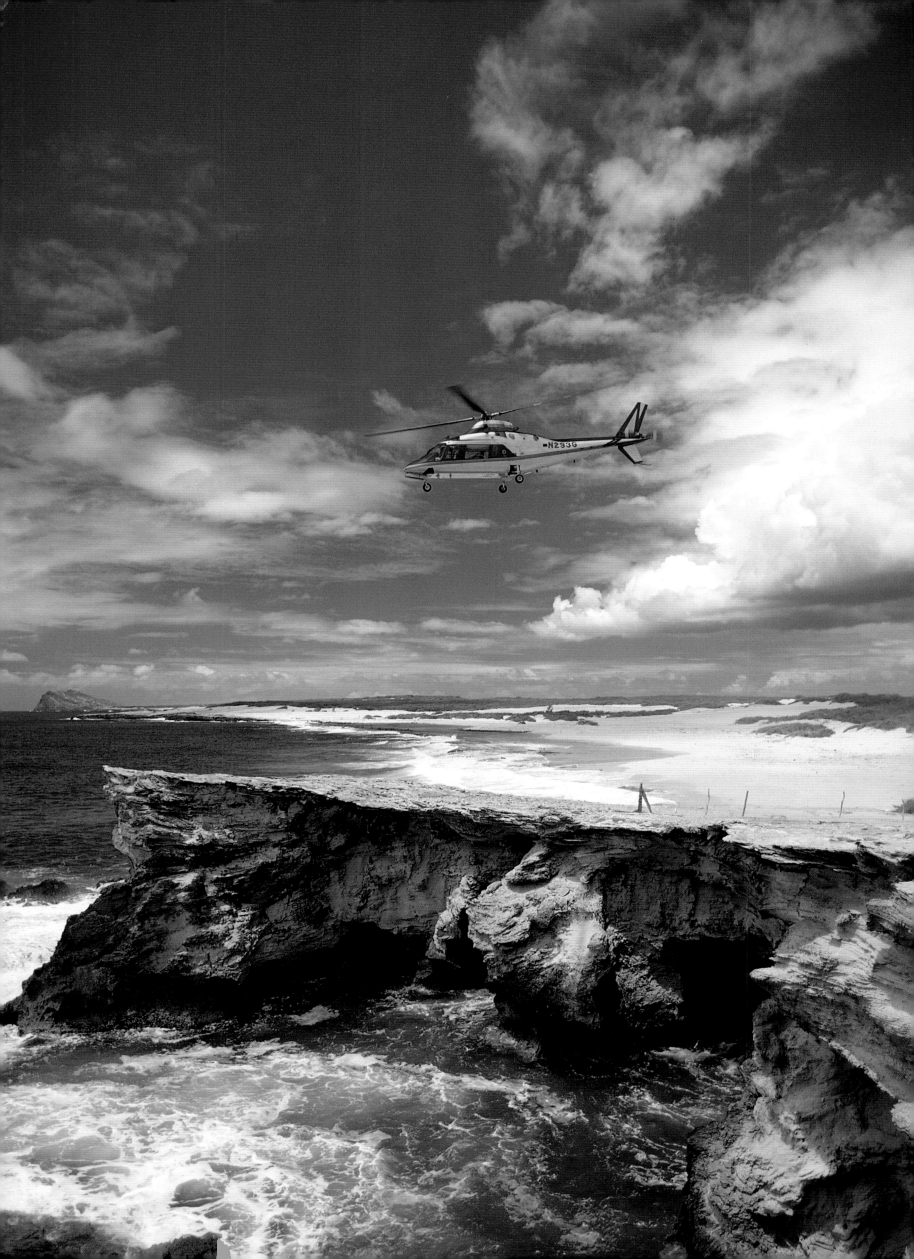

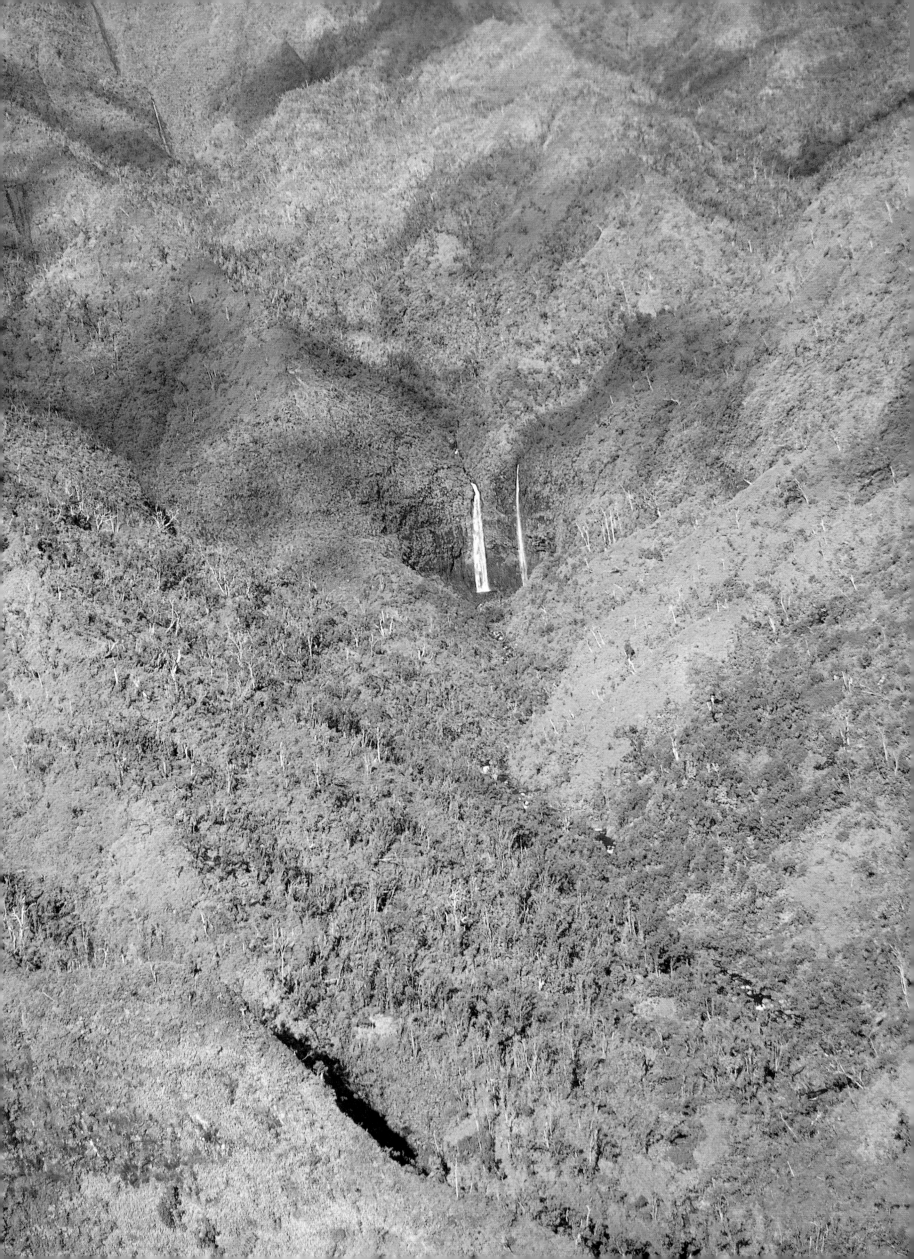

Kauai

While Kamehameha the Great was fighting to unit his Hawaiian kingdom in ruthless battles with the kings of Maui, Oahu, and the Big Island, Kauai stood alone and successfully resisted. Their resistance was enhanced by rough seas and an epidemic, which spared that island a physical invasion. Following a generation of negotiations, threats, and even a royal kidnapping, Kauai reluctantly became a semi-independent part of the sovereignty. The island's free spirit lives on to this day, causing outsiders to labeled Kauai the "Separate Kingdom."

Twenty million years after Kauai rose from the waters of the Pacific, the oldest Hawaiian island is a place of unusual beauty and character. The "Garden Isle" is blessed with emerald green rain forests, majestic cliffs and valleys, prolific coconut palms, brightly colored flowers, and lush tropical vegetation. Kauai is a picture of paradise for anyone who has ever strolled its unsurpassed beaches and smelled the fragrance of plumeria flowers in the soft tropical air; snoozed the afternoon away in a hammock; dined in a funky little fish restaurant; or watched small children dance the hula.

When Captain James Cook encountered the Hawaiian Islands in 1778, his ships dropped anchor at Waimea on the southwestern coast of Kauai. His men found a sleepy village of grass shacks and friendly people. With plentiful exotic fruit, wild pigs, beautiful women, and balmy weather, it was the land of their dreams. The only things missing were money, disease, dishonesty, and clothing. Offering teachings of a less visible paradise, the first missionaries chose this same village as their landing place fifty years later.

When Hollywood moguls need an authentic paradise for their fantasy movies, Kauai is often their choice. The Garden Isle has served as a backdrop for movies like *South Pacific* and *Jurassic Park,* and the TV series *Fantasy Island.* More than a few actors and entertainers have chosen the idyllic lagoons and beaches along the shores of the island as the perfect spot for a multimillion-dollar waterfront home.

The heart of Kauai, if not the centerpiece, is Mount Waialeale. A cloud-shrouded, 5,150-foot extinct volcano, Waialeale is the wettest place on earth, with some five hundred inches of yearly rain. Ancient Hawaiians called it the "Mountain of Flowing Waters," and they believed it was a meeting place of the gods. The flowing water creates countless waterfalls and dozens of rivers and streams that mostly feed the island's luxuriant northern side. In contrast, the mountain shields the island's south side, allowing less than twenty inches of rain and keeping it hot and sunny most days.

Slashing ten miles through the western third of Kauai, is a breathtaking deep gorge called Waimea Canyon. Viewed from the air, which is the only way to appreciate its true size and beauty, the canyon is desert colored with an artist's palette of iron-rich orange earth and pale, green gray foliage. Enveloped in a shroud of mist four thousand feet below the highest rim, the valley's creator, the Waimea River, appears as a tiny band of silver cutting its way from the mountainsides and swamps to the distant sea.

Centuries of rain, wind, pounding surf, and erosion from Mount Waialeale have worn Kauai's windward side into fifteen miles of deep valleys, towering cliffs, virgin beaches, and hidden caves. The Hawaiian name *Na Pali,* which simply means "the Cliffs," offers little to prepare the first-time observer for the dazzling beauty of this area. Isolated and inaccessible to all but the most adventurous hikers and boaters, Na Pali's untamed beauty is like a high-strung wild animal. From the safety of a helicopter, the pounding surf and jutting cliffs are awe-inspiring to see and photograph.

The sunny south coast at Poipu is a docile contrast to the rugged cliffs and valleys of Kauai. Under nearly perpetual sunshine, with its sandy beaches, and first-class low-rise resorts, Poipu is a paradise that attracts many tourists. Most days, the sun is high and very hot, making it difficult to choose among water sports, tropical drinks, palm-strung hammocks, and coconut tanning oils. Facing the calm Pacific on one side, Poipu is bordered by green sugarcane

◁ *Throughout Waimea Canyon, waterfalls spill from the cliffs and blend with the Waimea River, which cuts through the canyon floor.*
△ *Parrot heliconia is found in yards throughout the islands.*

fields and a dozen tiny towns that still look much the same as they did a century ago. The nearby plantation community of Koloa, with its quaint shops and restaurants, is the only town on this coast that is not supported by the still very active sugar industry.

Heading toward Kauai's decidedly wetter and greener northern end, drivers pass lush tropical forests, deep lagoons, inviting beaches, cascading rivers, and busy cities. Often described as the "Coconut Coast," the eastern shore is home to most of the island's commerce, as well as its population—as it has been since the first Hawaiian royalty discovered the temperature-cooling falls, long beaches, and excellent surfing. Back then, commoners were forbidden to enter the Wailua area without an invitation. Today, everyone is welcome to explore its many beautiful natural and man-made places without fear. The only danger is the glare from the Aloha shirts that are brighter than the local sun.

Visitors to the North Shore of Kauai gain a new appreciation for the tropical way of life. Centered around the lazy town of Hanalei and its calm half-moon bay, nothing moves very fast here except the occasional stray golf ball at the nearby Princeville Resort. Hanalei has a few colorful shops and fascinating restaurants, a limited night life, and numerous jokes about "Puff the Magic Dragon"—referring to the long-gone hippie days of free love and expensive marijuana. What the North Shore does have is the richest bounty of natural beauty in the Pacific. Miles of green coconut palm trees line the bay where the Pali cliffs descend into the ocean, creating a rugged ridge called Bali Hai. Some of the world's most spectacular sunsets are framed by this extraordinary landmark.

The island of Kauai is surrounded by a necklace of beautiful beaches, so many in number that some have remained unnamed. Stretched out along one side of Hanalei Bay is Lumahai Beach, where the movie, *South Pacific,* was filmed. Lumahai Beach is a huge expanse of gorgeous sand surrounded by green vegetation and rolling blue green waves. Today, visitors pretty much have the

place to themselves unless surfers are attracted by an infrequent storm. Local residents think the area is too easy to find and has become too famous. For those who have seen Lumahai's beauty, it may be hard to believe that the island has a better beach—but a dozen or so other beaches are worthy rivals to Lumahai. Most are not noted on tourist maps, but the locals are happy to give directions to any visitor crazy enough to abandon Lumahai Beach.

Visitors to the island of Kauai are greeted by descendants of those friendly Hawaiians who embraced Captain Cook. Those who shun the impersonal tour bus and take time to become acquainted with Kauai's citizens will be drawn in by this welcoming committee. Kauai has been careful to limit wide-spread development, often at the expense of tourism and even their own convenience, choosing instead to preserve the beautiful terrain that enticed the early explorers. Kauai was the last of the four large islands to install a traffic light, and current zoning restrictions limit buildings to the height of a tall coconut tree.

Despite their desire for a slower, simpler, more private life, the residents of Kauai still warmly welcome tourists to the island. They greatly appreciate that outsiders are drawn by the island's natural beauty and its charming people, instead of to the luxury hotels, shows, and attractions found on other islands.

Life here for the tourist is decidedly slower, causing many outsiders to think that Kauai is always casual and easy. However, in the last decade, the island has twice been devastated by savage tropical hurricanes. Each time, the people and the island showed their true character and were able to spring back better than before the destruction. Many regular Kauai visitors gave freely of their time and money to help their island friends recover. Hawaiians call this combined strength of the land and the people working together the *Ohana,* or spirit of *Aloha.* While this spirit is found throughout the Hawaiian Islands, its presence seems especially strong on the beautiful island of Kauai.

△ *A native of Malaya, red ginger blooms most of the year on Kauai.*
▷ *The towering Waialeale volcanic ridge rises four thousand feet above the coastline of Hanalei.*

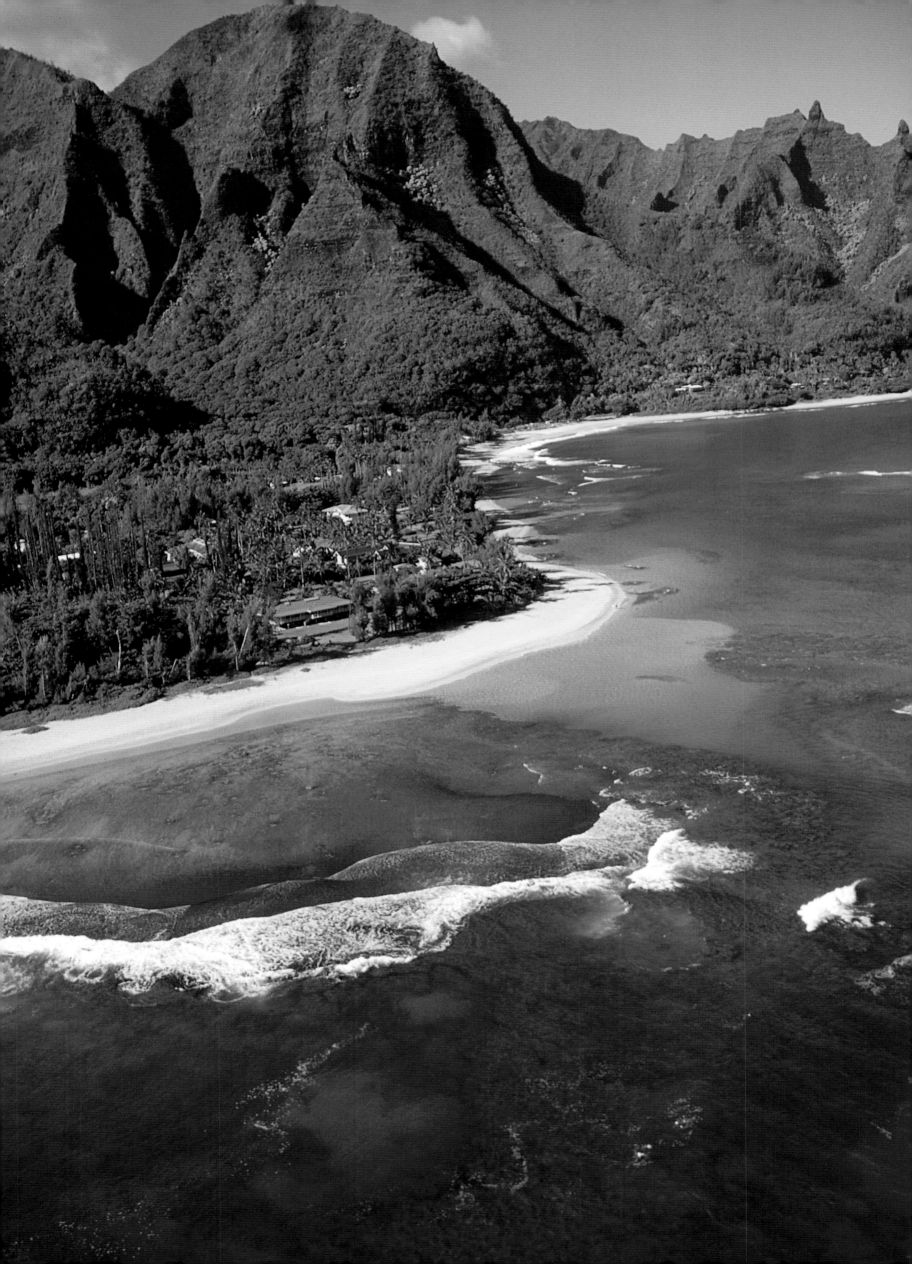

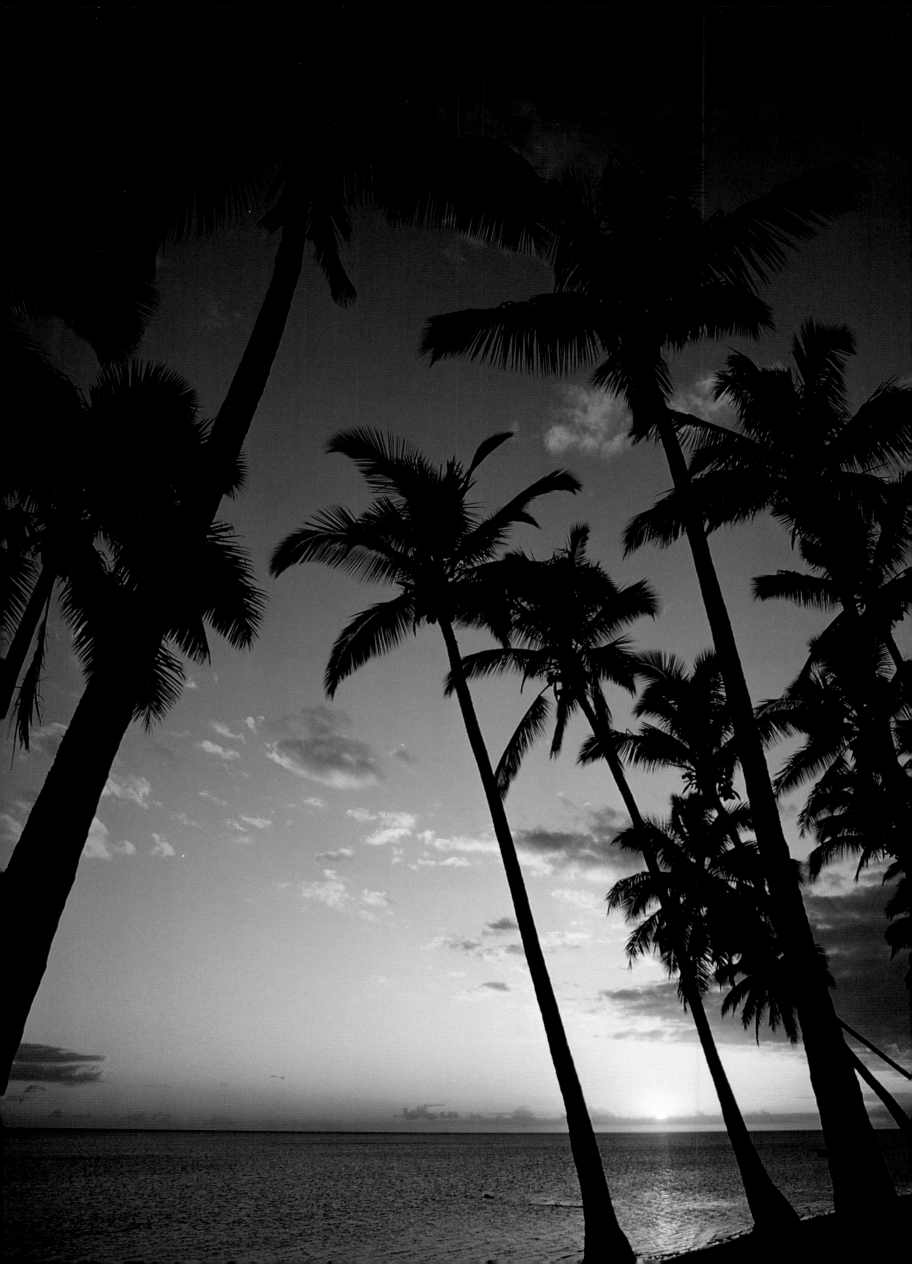

◁ Coconut palms are not native to Hawaii; they were brought centuries ago by the earliest Polynesian voyagers around A.D. 500.

▽ Golden sand, framed on either end by black lava rock, in contrast to the lush green hillside behind it, make Lumahai Beach stunning. The sparkling blue waters are somewhat protected, making swimming and surfing popular.

▽ Lumahai Beach, on Kauai's north side, is only two miles outside of Hanalei. Although it gained fame by appearing in the movie *South Pacific*, this sandy beach is rarely crowded.

▷ Waimea Canyon, known as the Grand Canyon of the Pacific, runs down the western third of the island of Kauai. Three thousand feet deep, the canyon is a breathtaking sight.

▷ ▷ Kauai's North Shore is great for surfing, with waves running ten to twenty feet high. In the winter, waves created by storms can reach thirty feet in height.

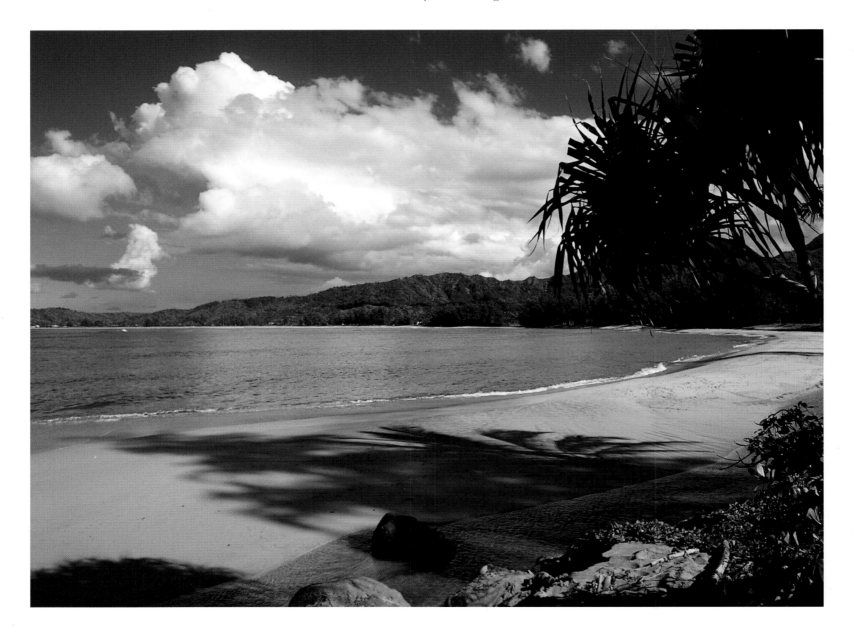

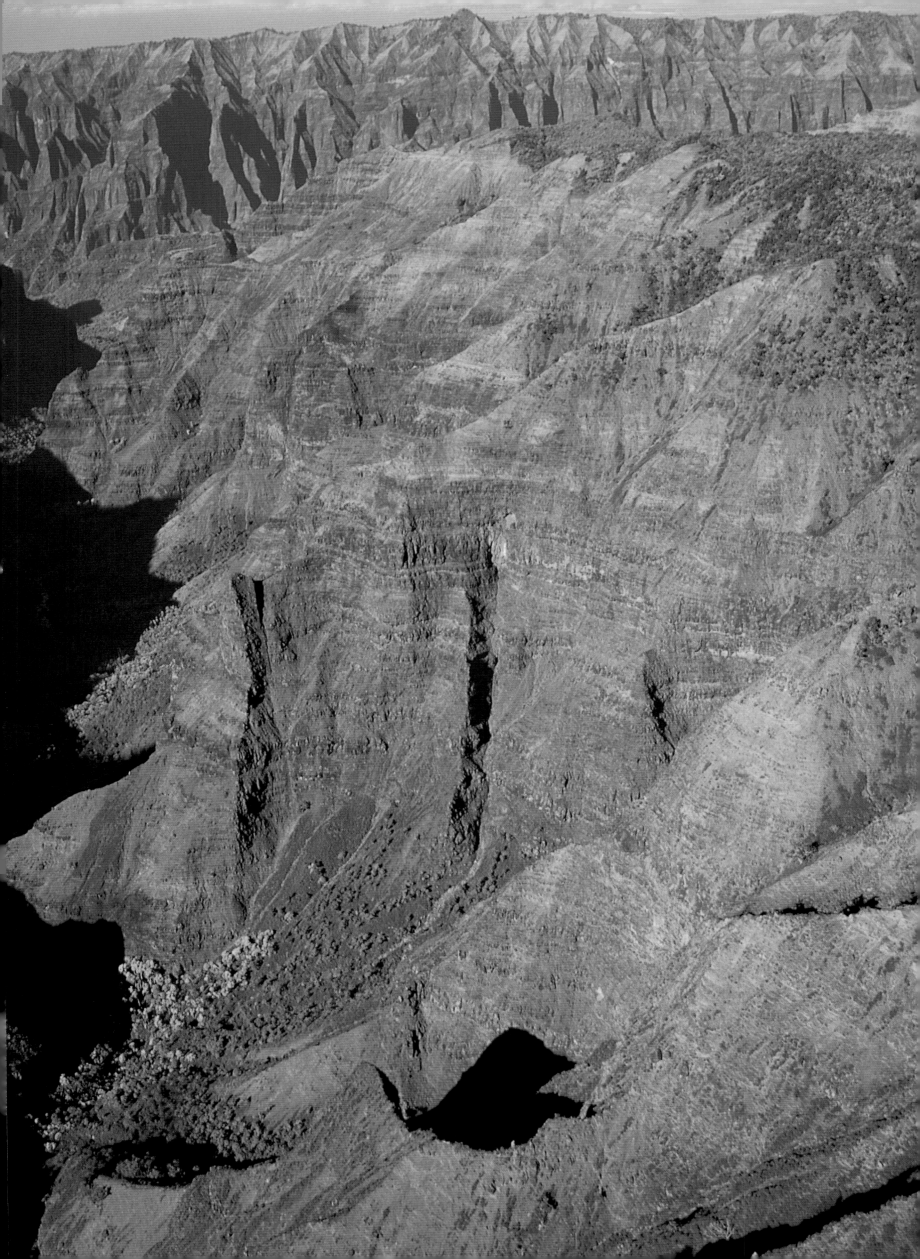

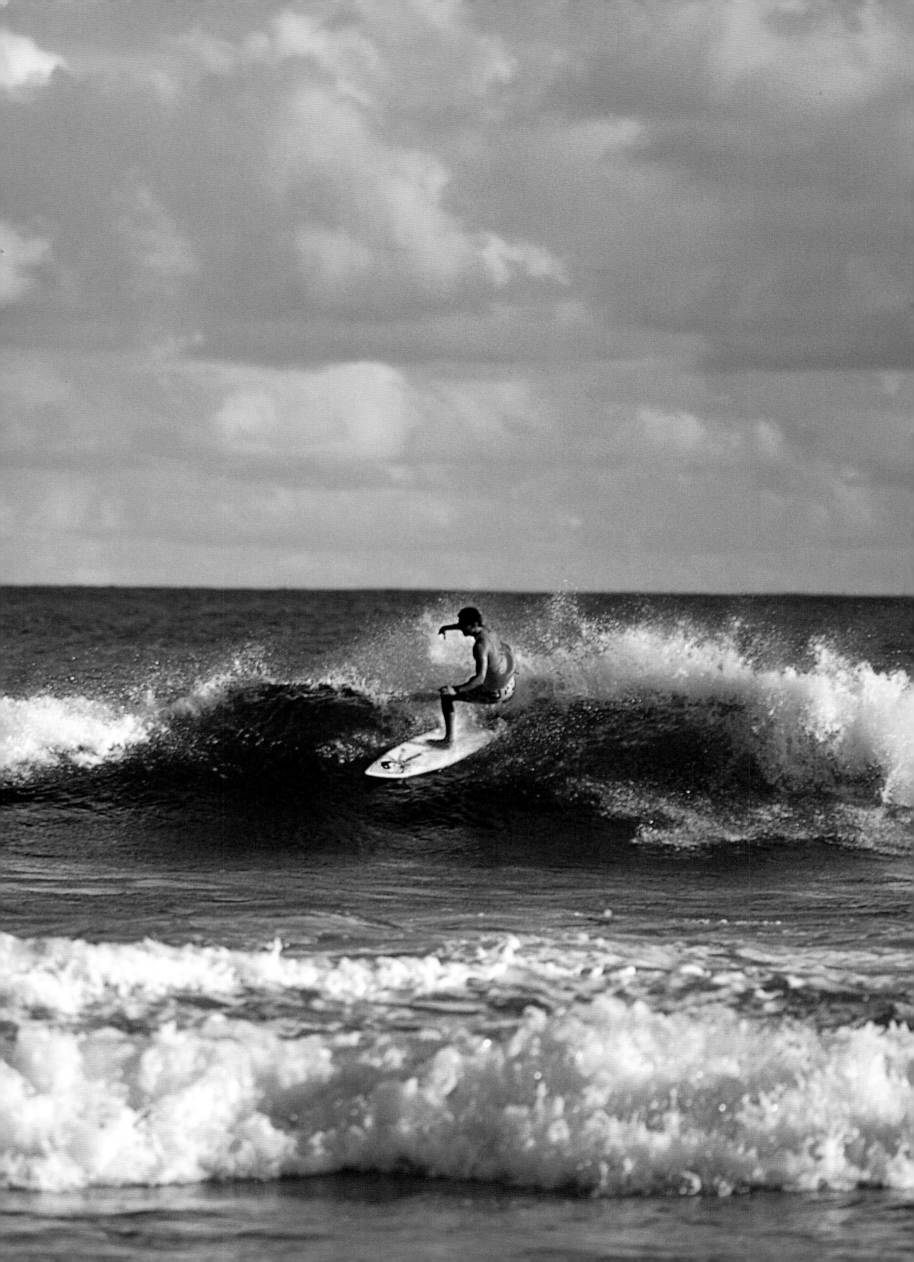

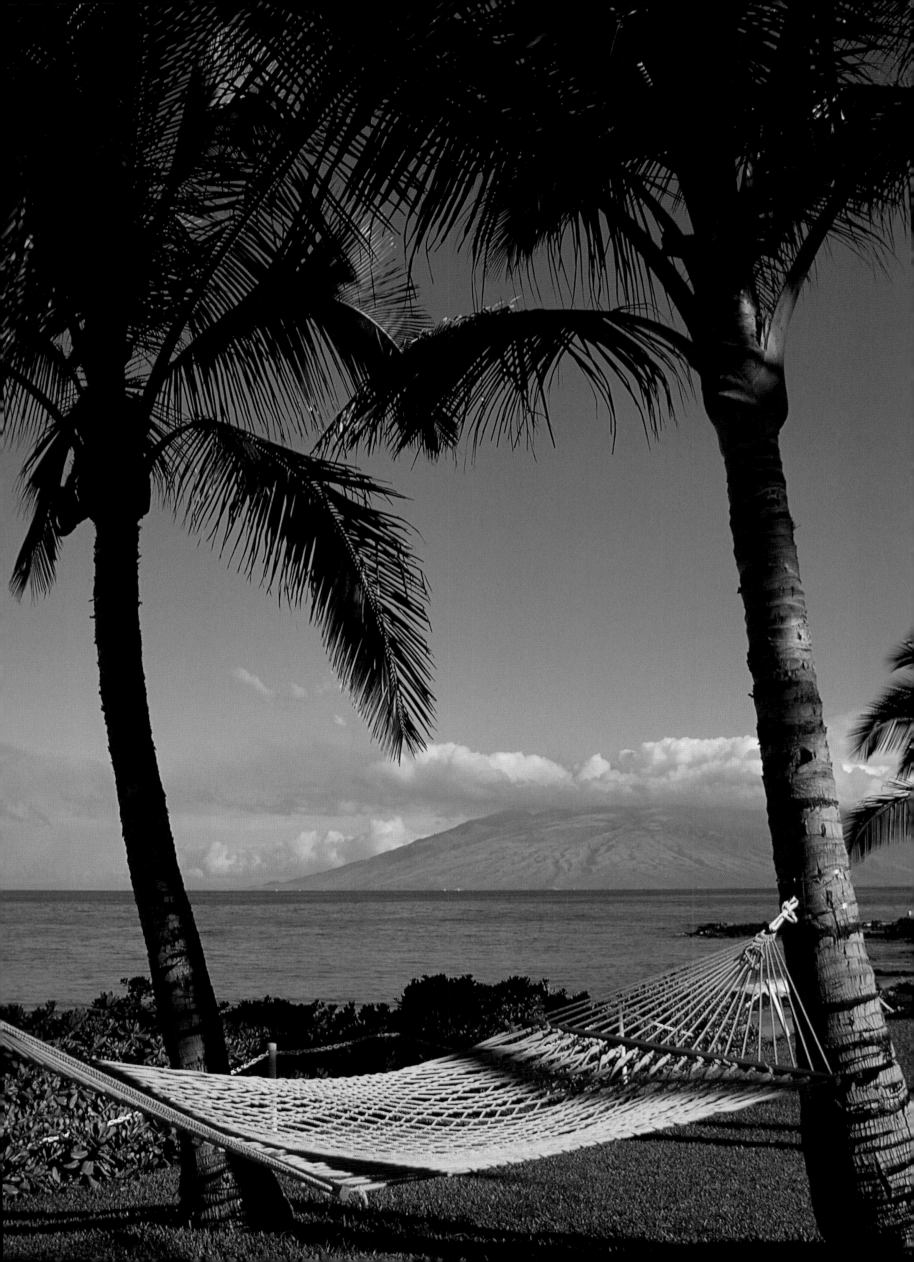

◁ A hammock strung between two palm trees is the perfect way to enjoy Hawaii. Blessed with sunshine, gentle trade winds, clear blue skies, and abundant natural beauty, Hawaii is one of the world's most beautiful treasures.

▽ Both palm tree and hula dancer seem to sway with the breeze. King Kamehameha the Great never conquered Kauai. He gained control only through diplomacy—and then only by letting the island remain semi-independent.

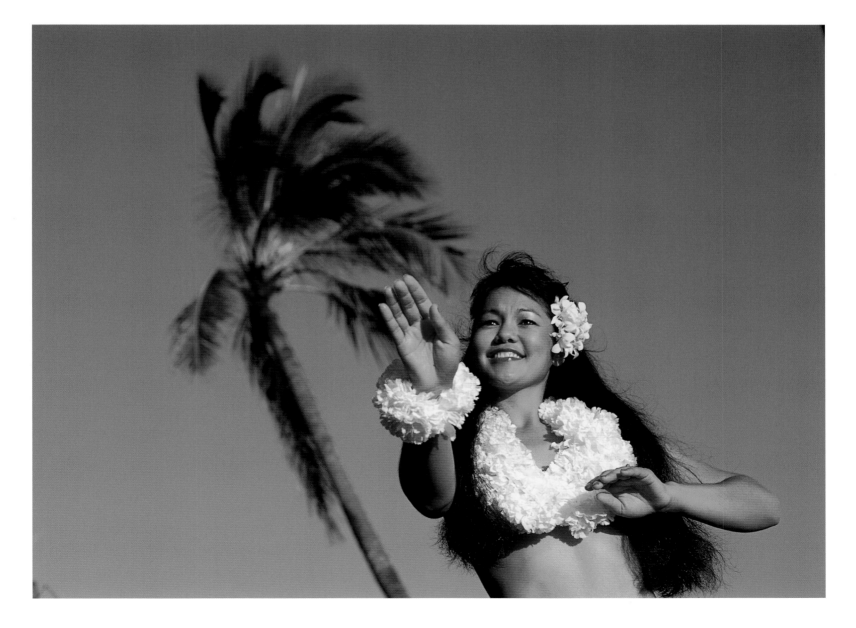

▽ A surfer takes a break
between waves and enjoys the
warm sunshine on Poipu Beach.
Kauai's southernmost point
is the sunny part of the island
and an area of low-rise hotels.

▷ Taro grows in a field in
the Hanalei Valley on the
north side of Kauai. With the
gentle Hanalei River cutting
across, the Hanalei Valley
is a patchwork of taro
fields, framed by green
mountains and Hanalei Bay.

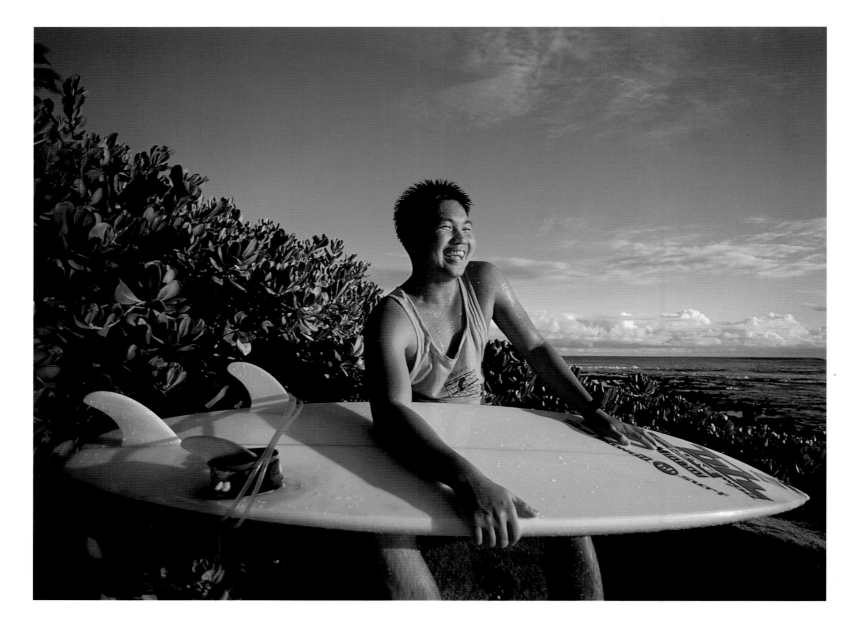

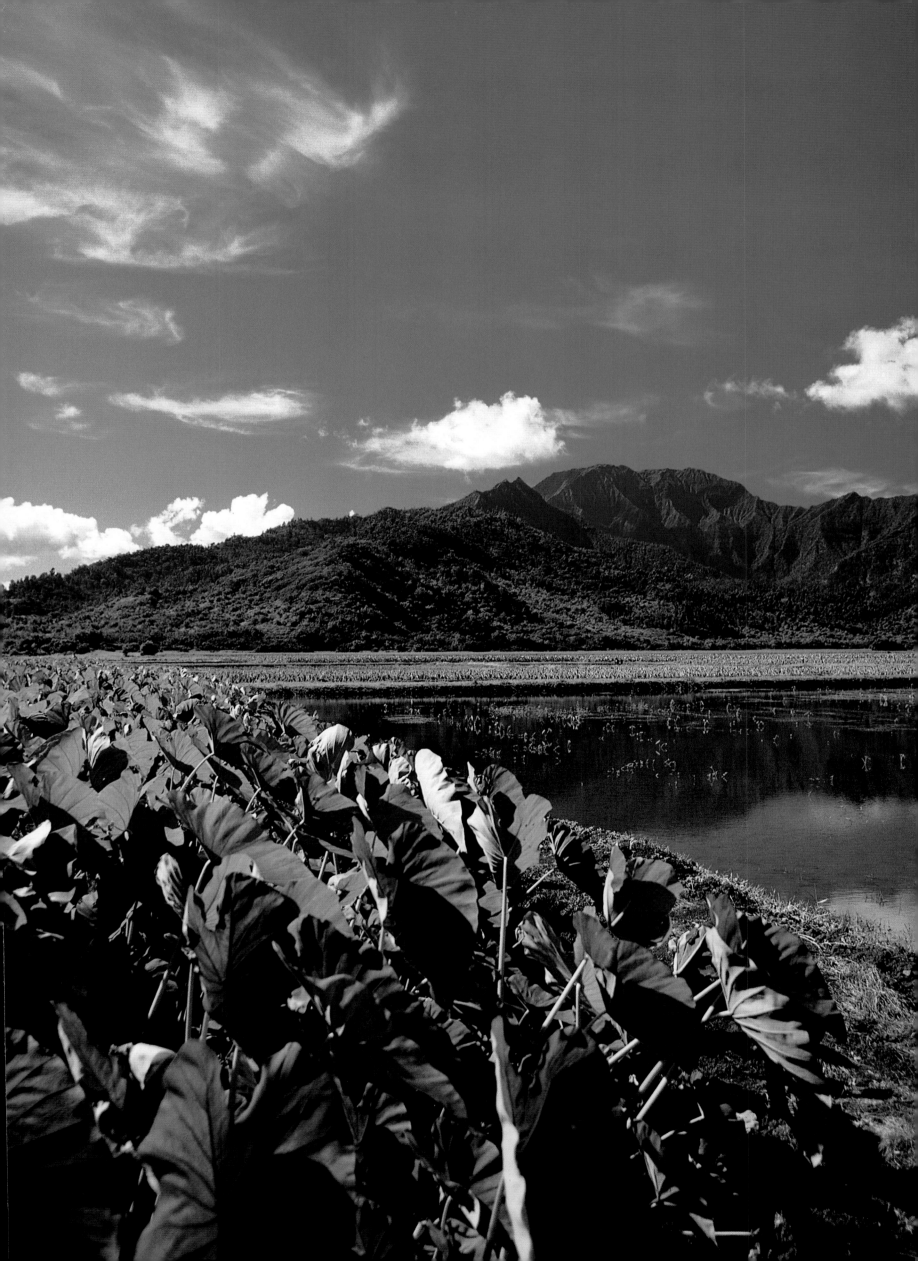

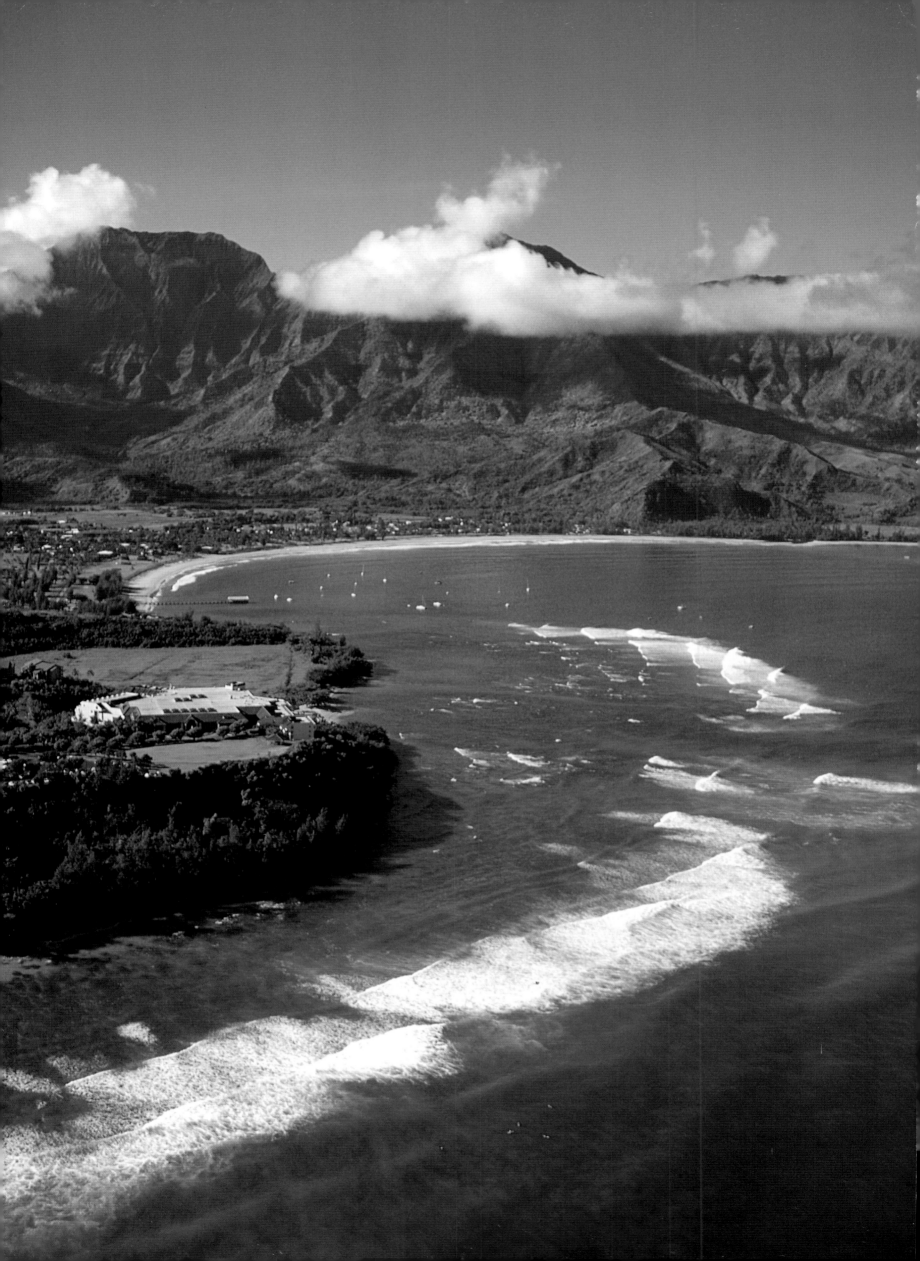

◁ This view of the stunningly
beautiful North Shore of Kauai
looks across the outstretched
Princeville Resort to the
picturesque Hanalei Bay and
the towering mountains
beyond. This side of the island
is peaceful and quiet, and
because of its damp climate,
lush with tropical vegetation.

▽ Poipu Beach glows with warm
color in the late afternoon light.
Located along the sunny south
coast of Kauai, Poipu is a series
of beaches with condominiums
and hotels facing its shoreline.

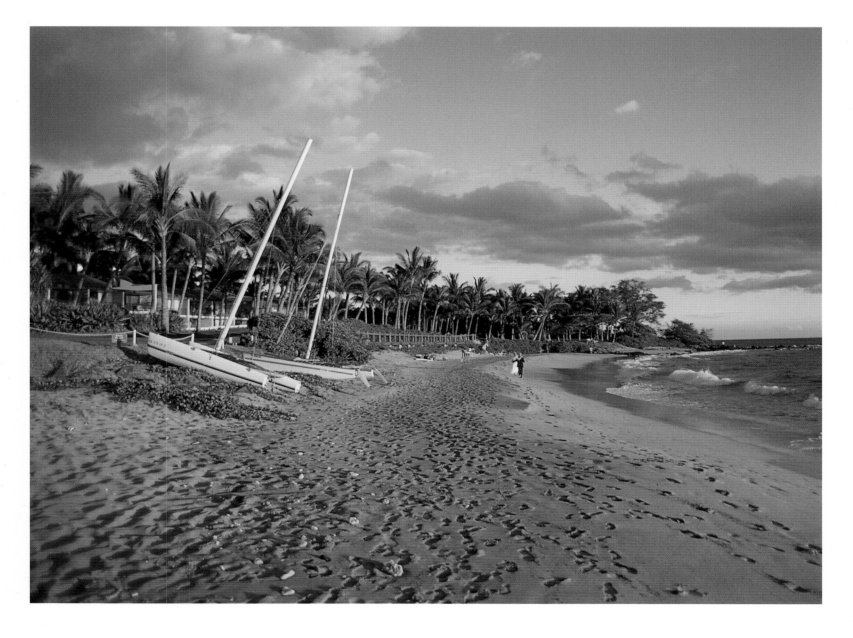

▽ A fire dancer at Oahu's
Polynesian Cultural Center
symbolizes the strength
and beauty of the islands.
As with all things Hawaiian,
it is both the beginning and
the ending of a perpetually
maturing culture and spirit.
Aloha.

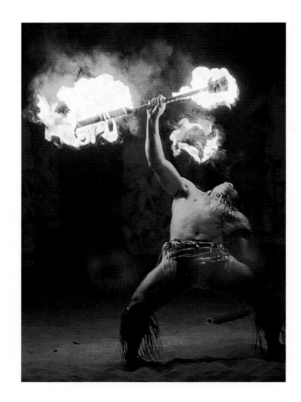